CIVILIZING RITUALS

"Do you often feel when you go to a museum, that you are entering the sacred precincts of a church or a temple, a site of arcane practices and mysterious icons? There are many reasons why you have such feelings and Carol Duncan reveals them with prescient insight, brilliance and humour in her study of the art museum and its practices."

Linda Nochlin, Institute of Fine Arts, New York University

"Carol Duncan is a thinker of enormous stature, whose reputation – deservedly – has begun to assume almost legendary proportions. In her long-awaited book, she analyzes the public art museum not as a simple receptacle for art and cultural history but as a powerful agent that has helped to shape that history through architectural symbolism, spatial dynamics, installation choices and their ritualistic associations . . . she leads her readers to question, constructively, their previously unexamined cultural assumptions and values."

Norma Broude, The American University, Washington DC

"A lively and authoritative discussion of some key issues facing museums past and present. Duncan's analysis of the role of gender, the tensions between public and private mission, and the vanities of great collectors is particularly welcome."
Andrew McClellan, Tufts University, Massachusetts

"A welcome contribution to a growing body of critical literature from one of the pioneers of work on museum culture."

Annie E. Coombs, Birkbeck College, University of London

In a groundbreaking study, Carol Duncan explores the function of art museums as ritual settings and as cultural artifacts that are much more than neutral shelters for art. She illuminates the ways in which museums in France, Britain and the United States engage their visitors in the performance of ritual scenarios and, through them, communicate and affirm ideas, values and social identities. Art museums emerge as sites in which political power and social interests and the history of cultural forms visibly intersect.

Carol Duncan teaches art history at Ramapo College of New Jersey. Her essays have been collected in *The Aesthetics of Power* (1993).

Re Visions: Critical Studies in the History and Theory of Art.

RE VISIONS: CRITICAL STUDIES IN THE HISTORY AND THEORY OF ART

Series editors: Jon Bird and Lisa Tickner, Middlesex University

Art history has been transformed as an academic discipline over the last twenty years. The 'new' art history is no longer new, and that widely used and useful label has come to seem dangerously over-tidy.

Re visions responds to the arrival of new ways of thinking in art history in a series of lucid and accessible studies by authors distinguished in their fields. Each book examines the usefulness of innovative concepts and methods, not in abstract terms but through the analysis of particular art objects, ways of writing about art, and cultural institutions and practices.

CIVILIZING RITUALS

INSIDE PUBLIC ART MUSEUMS

Carol Duncan

London and New York

First published 1995
by Routledge
11 New Fetter Lane, London EC4P 4EE

Simultaneously published in the USA and Canada
by Routledge
29 West 35th Street, New York, NY 10001

Typeset in Times by
Ponting–Green Publishing Services, Chesham, Bucks
Printed and bound in Great Britain by
Redwood Books, Trowbridge, Wiltshire

British Library Cataloguing in Publication Data
A catalogue record for this book is available from
the British Library

Library of Congress Cataloging in Publication Data
Duncan, Carol.
Civilizing rituals: inside public art museums / Carol Duncan.
p. cm.
Includes bibliographical references (p.) and index.
1. Art Museums–Social aspects. 2. Art Museums–Visitors.
I. Title.
N430.D84 1995
708–dc20 94–31251

ISBN 0–415–07011–2
ISBN 0–415–07012–0 (pbk)

CONTENTS

LIST OF ILLUSTRATIONS

PREFACE
and acknowledgments

The origins of this book go back many years. In 1976, my interest in art museums took a quantum leap forward when I joined a group of New York artists and art writers engaged in producing *an* anti-*catalog*. Originally intended as a response to a centennial year exhibition of American art held at the Whitney Museum, *an* anti-*catalog* grew into a critical look at art museums and art exhibitions in general. For the eighteen people who wrote, designed, and produced it,* *an* anti-*catalog* was also an intensive seminar about museums.

Soon after its completion, I once again immersed myself in the subject of museums. Together with Alan Wallach, I wrote two articles – one on the Museum of Modern Art, New York, and another on the Louvre Museum – arguing the idea of the museum as a ritual structure. Several years later, when I began work on this book, those articles were my starting point. Inevitably, my ideas have undergone considerable development in the intervening years, but that early collaborative work has remained for me a rich source of stimulation.

I have endeavored to write this book so that it would engage both fellow professionals in the academic and museum worlds as well as students and more general readers less experienced in art-historical matters. In the interests of a more readable, accessible text, I have used endnotes liberally both for the usual kinds of scholarly citations and also to qualify or elaborate issues primarily of interest to specialists.

Over the last few years, as the various parts of this book evolved, I benefited from the attentions of many friends and colleagues. Among those to whom I am indebted for encouragement, conversation, and bibliographic help are Michael Ames, Susan Gallagher, Janet Koenig, Adrian Rifkin, Greg Sholette, Trent Shroyer, Mimi Smith, Clare Spark, John Walsh, and Sydney

* *an* anti-*catalog* was written, designed, and produced by the Catalog Committee of Artists Meeting for Cultural Change, New York, 1977. Members of the Committee were R. Baranik, S. Bromberg, S. Charlesworth, S. Cohn, C. Duncan, S. Gargagliano, E. Golden, J. Koenig, J. Kosuth, A. McCall, P. Pechter, E. Bendock Pelosini, A. Roseman, L. Rosing, A. Rousseau, A. Wallach, and W. Weissman.

Weinberg. Several people read parts or the whole of my manuscript at one time or another and made valuable comments. For this, thanks especially to Jon Bird, Josephine Gear, Alex Potts, Beatrice Rehl, Lisa Tickner, and Gwendolyn Wright.

Were it not for the institutional support I received, this book would not have been possible. My thanks, first of all to the administration of Ramapo College and to its Director of Grants Administration, Ron Kase. A sabbatical semester in 1988 and release time in the spring of 1993 enabled me to advance my project substantially. For the latter, I am grateful to the Ramapo College Foundation. In addition, the College made it possible for me to accept a grant from the American Council of Learned Societies, which I also gratefully acknowledge. The ACLS grant gave me the kind of unbroken writing time I needed to complete the text.

Above all, I wish to express my gratitude to Andrew Hemingway, who, over the last few years, has given me invaluable help, constant encouragement, and, most importantly, thoughtful and incisive criticism.

New York City
June, 1994

INTRODUCTION

Since their appearance in the late eighteenth century, art museums* have become steadily richer, more numerous, and, lately, more glamorous, as sites of cultural activity. The Museum Age, as Germain Bazin called our era,[1] seems still not to have peaked, at least judging from the ever-increasing amounts of square footage that art museums can claim.

This book looks at a series of collections from what I believe to be a new perspective, namely, as ritual structures. The literature about art museums tends to represent them either as collections of things or as distinctive works of architecture. Museum catalogues, for example, normally treat only the contents of a collection. The "collection" is not conceptualized as a place but rather as an accumulation of valuable and unique objects. Books about famous collectors do something similar, usually narrating the how and when a collector gained his possessions. There is even a kind of adventure literature in which collectors or curators appear as clever sleuths or dashing heroes who track down and bag their art treasures like hunters or Don Juans.[2] Meanwhile, architectural writers focus on the kind of artistic statement a museum building makes, or, more practically, on how its architect handled such problems as lighting or traffic flow. Where the focus is on collecting or a collection, the museum environment itself is often ignored, as if its spaces were neutral or invisible. Most guidebooks sold in museums take this approach, representing the museum experience as almost solely a series of encounters with discrete art objects.

In this study, I consider art museums neither as neutral sheltering spaces for objects nor primarily as products of architectural design. Like the traditional temples and palaces they so often emulate, art museums are complex entities in which both art and architecture are parts of a larger whole. I propose to treat this ensemble like a script or score – or better, a dramatic field. That is, I see the totality of the museum as a stage setting that prompts

* In Great Britain, there is an understood distinction between the *art gallery* and the *museum* that does not exist in the United States, where art galleries and museums of art are the same kind of thing. In this book, I am following American usage and will use the terms art gallery, art museum, or even just plain museum interchangeably.

1

visitors to enact a performance of some kind, whether or not actual visitors would describe it as such (and whether or not they are prepared to do so). From this perspective, art museums appear as environments structured around specific ritual scenarios – various examples of which different chapters of this book will explore.

My intent in this is not to argue a theory of ritual or a universal definition of it in the manner of comparative anthropology. Nor is my primary interest to establish museum-going as something akin to older ritual situations, although there *are* formal parallels to which I shall point. Rather, I am concerned with the way art museums offer up values and beliefs – about social, sexual and political identity – in the form of vivid and direct experience. If, in the chapters that follow, I insist on the existence of museum rituals, it is because I believe that a museum's central meanings, its meanings *as a museum*, are structured through its ritual.

Chapter 1 of this book argues the idea of the art museum as a ritual, drawing on anthropological literature, philosophical notions about the aesthetic experience, and art historical and museological writings about the nature and mission of art museums. Using specific examples, some European, most of them American, the remaining four chapters explore some of the most common ritual scenarios that museums construct. These have been chosen either for their importance in museum history or because they exemplify a common type of museum. As much as possible, each example (or group of examples) is situated within its relevant historical context. Chapter 2 treats the Louvre Museum in Paris and the National Gallery in London and is concerned mainly with the transformation of the European princely gallery into the public art museum – a transformation that served the ideological needs of emerging bourgeois nation-states by providing them with a new kind of civic ritual. The third chapter discusses the creation of major art museums in the United States in the late nineteenth and early twentieth centuries, and looks at how, in New York, Chicago, and Boston, the ritual forms of European national galleries were adapted to new political and social circumstances. Chapter 4 examines private collections that have become separate museums or separate museum wings (among them the collections of Wallace, Frick, Lehman, Getty, and the Dulwich Picture Gallery in South London). In these collections, museum-goers are most often prompted to enact a visit to an idealized donor, who, in the ritual of the museum visit, may achieve a kind of eternal (and eternally aristocratic) life. The fifth and final chapter takes up museums (and museum wings) dedicated to modern art. The focus here is on the construction of a gendered ritual space that – ultimately – accords with the consumerist culture outside. The emphasis on gender at this point should not be construed to imply that earlier museums are any less gendered as ritual spaces. It does recognize, however, the atmosphere of urgency and crisis with which modern museums have surrounded the question of sexual identity, an

atmosphere that distinguishes them from older types of art museums, which, for the most part, could pursue patriarchal traditions unchallenged.

As the above makes clear, I have limited the scope of this book to western democracies and have slanted it heavily toward Anglo-American examples, the majority being American. Without doubt, different boundaries could have been drawn, both geographically and conceptually. Were this a history of art museums, the absence of Italy and Germany, both of which set important museological precedents for the rest of Europe and America, would not be admissible. My purpose, however, has not been to write a history of art museums, but rather to explore the ritual content of a selected group of them.[3] Even within the limits I have drawn, this study took me into more historical periods and across more disciplinary and national lines than I had originally anticipated.

As for crossing national lines: art museums are, if anything, a very international subject. However much they are shaped by particular historical conditions – the politics of their ruling founders or the collecting habits of their patrons – art museums also belong to the larger, international history of bourgeois culture. It is safe to say that all the big national and municipal public art museums in the West were and are meant to be internationally visible. Certainly their planners always looked across national boundaries for both conceptual models and examples of museum management. Given the historical origins of art museums, this internationalism is not surprising. They appeared just at the moment when notions of the public and public space were first being defined throughout western Europe (or rather redefined in terms of new, bourgeois forms of the state). If the various capitals of Europe and, later, America ended up with similarly conceived art museums, it was because, from the start, those nation-states and cities had similar ideological needs, and public art museums afforded them similar ideological benefits.[4] This internationalism is still a striking feature of the museum world. Today's museums continue to be valued – and supported – as potent engines of ideology, and the forms they adopt still have international currency.

Besides its scope, this study is limited in yet another respect. It deals hardly at all with the issue of how western museums represent other cultures – how their displays of "primitive," "Third World," or non-western art often misrepresent or even invent foreign cultures for what are ultimately ideological purposes. The issue of what western museums do to other cultures, including the minority cultures within their own societies, has become especially urgent as post-colonial nations attempt to define and redefine their cultural identities and as minority cultures in the West seek cultural recognition. However pressing these issues, the question I am asking here is, although parallel, a different one: what fundamental purposes do western museums serve in the context of western societies? My book is, in the immediate sense, concerned not with the representations of foreign or non-western cultures, but with what art museums say to and about our own culture.

Nevertheless, the two questions are ultimately not separate; western representations of western culture hold implications for the way non-western cultures are seen.[5]

Let me add one or two more things that distinguish this book from other studies of art museums. First, it does not argue a concept of what art museums should be. Advocates of art museums almost always argue one of two ideals: the educational museum or the aesthetic museum.[6] In the educational model, works of art are framed as historical or art-historical objects, while in the aesthetic model, their unique and transcendent qualities are primary, and the museum space is expected to provide a sanctuary for their contemplation. Usually (but not always) the educational museum is considered by its advocates to be more democratic and popular, while the aesthetic museum is seen (even by its advocates, but not always) as more elitist. Both ideals are advanced as *socially* valuable, and museum professionals almost always use them, alone or in combination, to articulate their goals. What may at first seem relevant to my study is that within this debate, detractors of the aesthetic museum often object to it as a pseudo-sacred kind of place filled with a ritual-like atmosphere. In their analysis, "ritual" means something empty and meaningless, or it implies an elitist content – effects, they maintain, that art museums can and should avoid.[7] In my view, the educational museum is no less a ritual space than the aesthetic museum, and, in its way, generates as much ideology. I cannot therefore, take sides in this debate, since I share neither the terms nor the assumptions in which it is usually conducted and on which it proceeds – even though I have often benefited from the insights of writers on both of its sides.[8] Rather than arguing a concept of what art museums should be, my study tries to understand what they are. Or, to say it another way, it seeks a critical position outside the established terms of museum culture, articulating what happens in the space between what museums say they do and what they do without saying. It will, I hope, contribute at least indirectly to the debate about museums, if only by insisting that art museums, *whatever* their stated aims and potentials, must function within existing political and ideological limits.

Secondly, this book is not a sociological study of art. How real visitors subjectively engage with art museums is beyond its scope. I have no findings to report about how an "average" or representative sample of visitors reads or misreads museums. The "visitors" I am after are hypothetical entities – ideal types implicit in the museum's galleries. There is, however, one sociology-of-art current, that practiced by Pierre Bourdieu, with which I share certain concerns (if not methods). In the 1960s, in collaboration with Alain Darbel, Bourdieu interviewed hundreds of people, documenting what others had deduced or observed informally – that art museums give some a feeling of cultural ownership and belonging while they make others feel inferior and excluded.[9] Their conclusions support the notion of the art museum as a setting for ritual. However, the performance they identify is understood almost

wholly as an exercise in class identity. Despite my admiration for Bourdieu's work, my concept of what happens in art museums does not coincide with his – at least not entirely. Without rejecting his valuable sociological insights, I treat museums not only as socially distinguishing forms but also as structures with substantive cultural content, a content that is not always or not entirely subject to sociological or political description. That is to say, in what follows, while art museums are understood to be both producers of ideology and products of social and political interests, they are not entirely reducible to these categories. It is, in my view, precisely the complexity of the art museum – its existence as a profoundly symbolic cultural object as well as a social, political, and ideological instrument – that makes the notion of the museum as ritual so attractive.

In a similar way, this book makes use of certain terms, especially "ritual" and "artifact," that traditionally have belonged to anthropology. In these interdisciplinary times, such borrowing hardly needs the theoretical justification it might once have required. Even so, I want to say something about it here, because the importing of terms like these into an art-historical work is not unproblematic. Chapter 1 will have more to say about my use of the term "ritual." For the moment I shall confine my comments to the term "artifact." As a category, artifacts are normally distinguished from works of art both conceptually and as objects of museum display.[10] The art/artifact distinction marks the divide between the disciplines of anthropology on the one hand and art history and criticism on the other. At the same time, the dichotomy has provided a rationale for putting western and non-western societies on a hierarchical scale, with the western ones (plus a few far eastern courtly cultures) on top as producers of art and non-western ones below as producers of artifacts. This scale is built on the assumption that only works of art are philosophically and spiritually rich enough to merit isolated aesthetic contemplation, while "artifacts," as products of presumably less evolved societies, lack such richness. It follows, according to the terms of this logic, that while art belongs in the more contemplative space of an art museum, artifacts are best seen in anthropological, ethnographic, or natural history collections where they may be studied as scientific specimens. Recently, this hierarchical practice has been challenged by "elevating" the culture of others to the status of art; hence, the introduction of "primitive art" wings into art museums or the creation of separate art museums specializing in such art. My own effort is related, but rather than choose between the terms of the dichotomy, I have collapsed its central distinction. I treat art-museum art as a species of ritual artifact, not in order to oppose it to some higher (or, for that matter, lower) category, but, as I will argue in the next chapter, to understand better the way in which art museums construct and communicate meaning.

Like the term "artifact," the term "ritual" has also been treated as a lower term in a hierarchy. And, just as this study rejects the art/artifact dichotomy,

so it refuses to position rituals as the kind of cultural "other" familiar in classical anthropological studies. Thus, it is not structured around the traditional anthropological or ethnographic distinction between "us" – we students of rituals – and "them" – those who engage in rituals as an enlightening or therapeutic practice. After all, I am not an anthropologist exploring rituals in an exotic culture. Rather, I look at some of the most prestigious spaces in my own – and what I assume will be my readers' – culture. The "us" implicit in this study – the learning subjects who look at rituals through a distancing and objectifying intellectual lens – are also the "them" – the most likely users and students of art and art museums.[11]

I have so far emphasized the problems raised by approaching art museums as ritual structures. The main body of this book, however, will not treat museum rituals as isolated objects of study. It will certainly argue the ritual character of art museums, describe them as ritual settings, and analyze them as ritual scenarios. But, it will also discuss – often in considerable detail – the social and historical circumstances in which specific museum rituals have been formed. Its larger argument is not simply that art museums are ritual structures, but rather that, *as ritual structures*, museums are rich and interesting objects of social and political history. As we shall see, the question of how they should be organized often has been a matter of serious concern in the highest circles of power. Indeed, in the modern world, art museums constitute one of those sites in which politically organized and socially institutionalized power most avidly seeks to realize its desire to appear as beautiful, natural, and legitimate. Museums are therefore excellent fields in which to study the intersection of power and the history of cultural forms. To that end, much of what follows will weave back and forth between the ritual structures themselves – how they work and what they look like – and the historical pressures and tensions in and around which they took shape.

A final caveat. The museum world is never static. While I have been writing this book, some of my chapter subjects changed dramatically. Besides the opening of important new wings or new museums, several of the installations I analyze have been significantly altered or, on occasion, dismantled entirely. The fact is that even permanent installations are eventually changed. Although I have tried to keep up with the changes, I have not always been able to, and the disappearance of a particular installation that I had already written about did not make me banish it from my text; if it makes a point and demonstrates an idea I want to argue, I kept it. My thesis does not depend on the permanence of any particular museum installations, but rather on their ritual coherence.

1

THE ART MUSEUM AS RITUAL

This chapter sets forth the basic organizing idea of this study, namely, the idea of the art museum as a ritual site. Unlike the chapters that follow, where the focus is on specific museums and the particular circumstances that shaped them, this chapter generalizes more broadly about both art museums and ritual. Besides introducing the concept of ritual that informs the book as a whole, it argues that the ritual character of art museums has, in effect, been recognized for as long as public art museums have existed and has often been seen as the very fulfillment of the art museum's purpose.

Art museums have always been compared to older ceremonial monuments such as palaces or temples. Indeed, from the eighteenth through the mid-twentieth centuries, they were deliberately designed to resemble them. One might object that this borrowing from the architectural past can have only metaphoric meaning and should not be taken for more, since ours is a secular society and museums are secular inventions. If museum facades have imitated temples or palaces, is it not simply that modern taste has tried to emulate the formal balance and dignity of those structures, or that it has wished to associate the power of bygone faiths with the present cult of art? Whatever the motives of their builders (so the objection goes), in the context of our society, the Greek temples and Renaissance palaces that house public art collections can signify only secular values, not religious beliefs. Their portals can lead to only rational pastimes, not sacred rites. We are, after all, a post-Enlightenment culture, one in which the secular and the religious are opposing categories.

It is certainly the case that our culture classifies religious buildings such as churches, temples, and mosques as different in kind from secular sites such as museums, court houses, or state capitals. Each kind of site is associated with an opposite kind of truth and assigned to one or the other side of the religious/secular dichotomy. That dichotomy, which structures so much of the modern public world and now seems so natural, has its own history. It provided the ideological foundation for the Enlightenment's project of breaking the power and influence of the church. By the late eighteenth

century, that undertaking had successfully undermined the authority of religious doctrine – at least in western political and philosophical theory if not always in practice. Eventually, the separation of church and state would become law. Everyone knows the outcome: secular truth became authoritative truth; religion, although guaranteed as a matter of personal freedom and choice, kept its authority only for voluntary believers. It is secular truth – truth that is rational and verifiable – that has the status of "objective" knowledge. It is this truest of truths that helps bind a community into a civic body by providing it a universal base of knowledge and validating its highest values and most cherished memories. Art museums belong decisively to this realm of secular knowledge, not only because of the scientific and humanistic disciplines practiced in them – conservation, art history, archaeology – but also because of their status as preservers of the community's official cultural memory.

Again, in the secular/religious terms of our culture, "ritual" and "museums" are antithetical. Ritual is associated with religious practices – with the realm of belief, magic, real or symbolic sacrifices, miraculous transformations, or overpowering changes of consciousness. Such goings-on bear little resemblance to the contemplation and learning that art museums are supposed to foster. But in fact, in traditional societies, rituals may be quite unspectacular and informal-looking moments of contemplation or recognition. At the same time, as anthropologists argue, our supposedly secular, even anti-ritual, culture is full of ritual situations and events – very few of which (as Mary Douglas has noted) take place in religious contexts.[1] That is, like other cultures, we, too, build sites that publicly represent beliefs about the order of the world, its past and present, and the individual's place within it.[2] Museums of all kinds are excellent examples of such microcosms; art museums in particular – the most prestigious and costly of these sites[3] – are especially rich in this kind of symbolism and, almost always, even equip visitors with maps to guide them through the universe they construct. Once we question our Enlightenment assumptions about the sharp separation between religious and secular experience – that the one is rooted in belief while the other is based in lucid and objective rationality – we may begin to glimpse the hidden – perhaps the better word is disguised – ritual content of secular ceremonies.

We can also appreciate the ideological force of a cultural experience that claims for its truths the status of objective knowledge. To control a museum means precisely to control the representation of a community and its highest values and truths. It is also the power to define the relative standing of individuals within that community. Those who are best prepared to perform its ritual – those who are most able to respond to its various cues – are also those whose identities (social, sexual, racial, etc.) the museum ritual most fully confirms. It is precisely for this reason that museums and museum practices can become objects of fierce struggle and impassioned debate. What

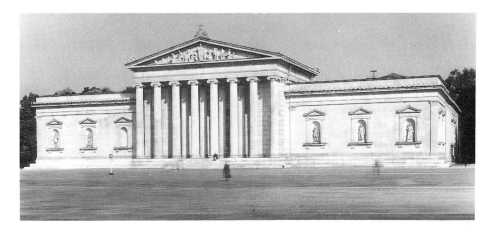

Figure 1.1 Munich, the Glyptothek (photo: museum).

Figure 1.2 The National Gallery of New South Wales, Sydney (photo: author).

we see and do not see in art museums – and on what terms and by whose authority we do or do not see it – is closely linked to larger questions about who constitutes the community and who defines its identity.

I have already referred to the long-standing practice of museums borrowing architectural forms from monumental ceremonial structures of the past (Figures 1.1, 1.2, 4.13). Certainly when Munich, Berlin, London, Washington, and other western capitals built museums whose facades looked like Greek or Roman temples, no one mistook them for their ancient prototypes. On the contrary, temple facades – for 200 years the most popular source for

9

public art museums[4] – were completely assimilated to a secular discourse about architectural beauty, decorum, and rational form. Moreover, as coded reminders of a pre-Christian civic realm, classical porticos, rotundas, and other features of Greco-Roman architecture could signal a firm adherence to Enlightenment values. These same monumental forms, however, also brought with them the spaces of public rituals – corridors scaled for processions, halls implying large, communal gatherings, and interior sanctuaries designed for awesome and potent effigies.

Museums resemble older ritual sites not so much because of their specific architectural references but because they, too, are settings for rituals. (I make no argument here for historical continuity, only for the existence of comparable ritual functions.) Like most ritual space, museum space is carefully marked off and culturally designated as reserved for a special quality of attention – in this case, for contemplation and learning. One is also expected to behave with a certain decorum. In the Hirshhorn Museum, a sign spells out rather fully the dos and don'ts of ritual activity and comportment (Figure 1.3). Museums are normally set apart from other structures by their monumental architecture and clearly defined precincts. They are approached by impressive flights of stairs, guarded by pairs of monumental marble lions, entered through grand doorways. They are frequently set back from the street and occupy parkland, ground consecrated to public use. (Modern museums are equally imposing architecturally and similarly set apart by sculptural markers. In the United States, Rodin's *Balzac* is one of the more popular signifiers of museum precincts, its priapic character making it especially appropriate for modern collections – as we shall see in Chapter 5.[5])

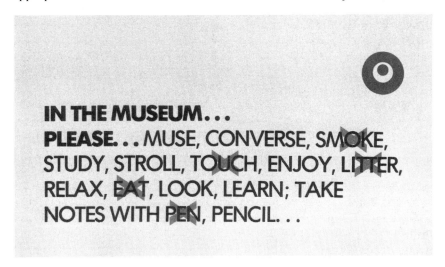

Figure 1.3 Instructions to visitors to the Hirshhorn Museum, Washington, DC (photo: author).

10

By the nineteenth century, such features were seen as necessary prologues to the space of the art museum itself:

> Do you not think that in a splendid gallery . . . all the adjacent and circumjacent parts of that building should . . . have a regard for the arts, . . . with fountains, statues, and other objects of interest calculated to prepare [visitors'] minds before entering the building, and lead them the better to appreciate the works of art which they would afterwards see?

The nineteenth-century British politician asking this question[6] clearly understood the ceremonial nature of museum space and the need to differentiate it (and the time one spends in it) from day-to-day time and space outside. Again, such framing is common in ritual practices everywhere. Mary Douglas writes:

> A ritual provides a frame. The marked off time or place alerts a special kind of expectancy, just as the oft-repeated 'Once upon a time' creates a mood receptive to fantastic tales.[7]

"Liminality," a term associated with ritual, can also be applied to the kind of attention we bring to art museums. Used by the Belgian folklorist Arnold van Gennep,[8] the term was taken up and developed in the anthropological writings of Victor Turner to indicate a mode of consciousness outside of or "betwixt-and-between the normal, day-to-day cultural and social states and processes of getting and spending."[9] As Turner himself realized, his category of liminal experience had strong affinities to modern western notions of the aesthetic experience – that mode of receptivity thought to be most appropriate before works of art. Turner recognized aspects of liminality in such modern activities as attending the theatre, seeing a film, or visiting an art exhibition. Like folk rituals that temporarily suspend the constraining rules of normal social behavior (in that sense, they "turn the world upside-down"), so these cultural situations, Turner argued, could open a space in which individuals can step back from the practical concerns and social relations of everyday life and look at themselves and their world – or at some aspect of it – with different thoughts and feelings. Turner's idea of liminality, developed as it is out of anthropological categories and based on data gathered mostly in non-western cultures, probably cannot be neatly superimposed onto western concepts of art experience. Nevertheless, his work remains useful in that it offers a sophisticated general concept of ritual that enables us to think about art museums and what is supposed to happen in them from a fresh perspective.[10]

It should also be said, however, that Turner's insight about art museums is not singular. Without benefit of the term, observers have long recognized the liminality of their space. The Louvre curator Germain Bazin, for example, wrote that an art museum is "a temple where Time seems suspended"; the visitor enters it in the hope of finding one of "those momentary cultural epiphanies" that give him "the illusion of knowing intuitively his essence and his strengths."[11] Likewise, the Swedish writer Goran Schildt has noted

that museums are settings in which we seek a state of "detached, timeless and exalted" contemplation that "grants us a kind of release from life's struggle and . . . captivity in our own ego." Referring to nineteenth-century attitudes to art, Schildt observes "a religious element, a substitute for religion."[12] As we shall see, others, too, have described art museums as sites which enable individuals to achieve liminal experience – to move beyond the psychic constraints of mundane existence, step out of time, and attain new, larger perspectives.

Thus far, I have argued the ritual character of the museum experience in terms of the kind of attention one brings to it and the special quality of its time and space. Ritual also involves an element of performance. A ritual site of any kind is a place programmed for the enactment of something. It is a place designed for some kind of performance. It has this structure whether or not visitors can read its cues. In traditional rituals, participants often perform or witness a drama – enacting a real or symbolic sacrifice. But a ritual performance need not be a formal spectacle. It may be something an individual enacts alone by following a prescribed route, by repeating a prayer, by recalling a narrative, or by engaging in some other *structured* experience that relates to the history or meaning of the site (or to some object or objects on the site). Some individuals may use a ritual site more knowledgeably than others – they may be more educationally prepared to respond to its symbolic cues. The term "ritual" can also mean habitual or routinized behavior that lacks meaningful subjective context. This sense of ritual as an "empty" routine or performance is not the sense in which I use the term.

In art museums, it is the visitors who enact the ritual.[13] The museum's sequenced spaces and arrangements of objects, its lighting and architectural details provide both the stage set and the script – although not all museums do this with equal effectiveness. The situation resembles in some respects certain medieval cathedrals where pilgrims followed a structured narrative route through the interior, stopping at prescribed points for prayer or con-templation. An ambulatory adorned with representations of the life of Christ could thus prompt pilgrims to imaginatively re-live the sacred story. Similarly, museums offer well-developed ritual scenarios, most often in the form of art-historical narratives that unfold through a sequence of spaces. Even when visitors enter museums to see only selected works, the museum's larger narrative structure stands as a frame and gives meaning to individual works.

Like the concept of liminality, this notion of the art museum as a performance field has also been discovered independently by museum profes-sionals. Philip Rhys Adams, for example, once director of the Cincinnati Art Museum, compared art museums to theatre sets (although in his formulation, objects rather than people are the main performers):

> The museum is really an impresario, or more strictly a *régisseur*, neither actor nor audience, but the controlling intermediary who sets the scene,

induces a receptive mood in the spectator, then bids the actors take the stage and be their best artistic selves. And the art objects do have their exits and their entrances; motion – the movement of the visitor as he enters a museum and as he goes or is led from object to object – is a present element in any installation.[14]

The museum setting is not only itself a structure; it also constructs its *dramatis personae*. These are, ideally, individuals who are perfectly pre-disposed socially, psychologically, and culturally to enact the museum ritual. Of course, no real visitor ever perfectly corresponds to these ideals. In reality, people continually "misread" or scramble or resist the museum's cues to some extent; or they actively invent, consciously or unconsciously, their own programs according to all the historical and psychological accidents of who they are. But then, the same is true of any situation in which a cultural product is performed or interpreted.[15]

Finally, a ritual experience is thought to have a purpose, an end. It is seen as transformative: it confers or renews identity or purifies or restores order in the self or to the world through sacrifice, ordeal, or enlightenment. The beneficial outcome that museum rituals are supposed to produce can sound very like claims made for traditional, religious rituals. According to their advocates, museum visitors come away with a sense of enlightenment, or a feeling of having been spiritually nourished or restored. In the words of one well-known expert,

> The only reason for bringing together works of art in a public place is that . . . they produce in us a kind of exalted happiness. For a moment there is a clearing in the jungle: we pass on refreshed, with our capacity for life increased and with some memory of the sky.[16]

One cannot ask for a more ritual-like description of the museum experience. Nor can one ask it from a more renowned authority. The author of this statement is the British art historian Sir Kenneth Clark, a distinguished scholar and famous as the host of a popular BBC television series of the 1970s, "Civilization." Clark's concept of the art museum as a place for spiritual transformation and restoration is hardly unique. Although by no means uncontested, it is widely shared by art historians, curators, and critics everywhere. Nor, as we shall see below, is it uniquely modern.

We come, at last, to the question of art museum objects. Today, it is a commonplace to regard museums as the most appropriate places in which to view and keep works of art. The existence of such objects – things that are most properly used when contemplated as art – is taken as a given that is both prior to and the cause of art museums. These commonplaces, however, rest on relatively new ideas and practices. The European practice of placing objects in settings designed for contemplation emerged as part of a new and, historically speaking, relatively modern way of thinking. In the course of the

eighteenth century, critics and philosophers, increasingly interested in visual experience, began to attribute to works of art the power to transform their viewers spiritually, morally, and emotionally. This newly discovered aspect of visual experience was extensively explored in a developing body of art criticism and philosophy. These investigations were not always directly concerned with the experience of art as such, but the importance they gave to questions of taste, the perception of beauty, and the cognitive roles of the senses and imagination helped open new philosophical ground on which art criticism would flourish. Significantly, the same era in which aesthetic theory burgeoned also saw a growing interest in galleries and public art museums. Indeed, the rise of the art museum is a corollary to the philosophical invention of the aesthetic and moral powers of art objects: if art objects are most properly used when contemplated as art, then the museum is the most proper setting for them, since it makes them useless for any other purpose.

In philosophy, Immanuel Kant's *Critique of Judgment* is one of the most monumental expressions of this new preoccupation with aesthetics. In it, Kant definitively isolated and defined the human capacity for aesthetic judgment and distinguished it from other faculties of the mind (practical reason and scientific understanding).[17] But before Kant, other European writers, for example, Hume, Burke, and Rousseau, also struggled to define taste as a special kind of psychological encounter with distinctive moral and philosophical import.[18] The eighteenth century's designation of art and aesthetic experience as major topics for critical and philosophical inquiry is itself part of a broad and general tendency to furnish the secular with new value. In this sense, the invention of aesthetics can be understood as a transference of spiritual values from the sacred realm into secular time and space. Put in other terms, aestheticians gave philosophical formulations to the condition of liminality, recognizing it as a state of withdrawal from the day-to-day world, a passage into a time or space in which the normal business of life is suspended. In philosophy, liminality became specified as the aesthetic experience, a moment of moral and rational disengagement that leads to or produces some kind of revelation or transformation. Meanwhile, the appearance of art galleries and museums gave the aesthetic cult its own ritual precinct.

Goethe was one of the earliest witnesses of this development. Like others who visited the newly created art museums of the eighteenth century, he was highly responsive to museum space and to the sacral feelings it aroused. In 1768, after his first visit to the Dresden Gallery, which housed a magnificent royal art collection.[19] he wrote about his impressions, emphasizing the powerful ritual effect of the total environment:

> The impatiently awaited hour of opening arrived and my admiration exceeded all my expectations. That *salon* turning in on itself, magnificent and so well-kept, the freshly gilded frames, the well-waxed

parquetry, the profound silence that reigned, created a solemn and unique impression, akin to the emotion experienced upon entering a House of God, and it deepened as one looked at the ornaments on exhibition which, as much as the temple that housed them, were objects of adoration in that place consecrated to the holy ends of art.[20]

The historian of museums Niels von Holst has collected similar testimony from the writings of other eighteenth-century museum-goers. Wilhelm Wackenroder, for example, visiting an art gallery in 1797, declared that gazing at art removed one from the "vulgar flux of life" and produced an effect that was comparable to, but better than, religious ecstasy.[21] And here, in 1816, still within the age when art museums were novelties, is the English critic William Hazlitt, aglow over the Louvre:

> Art lifted up her head and was seated on her throne, and said, All eyes shall see me, and all knees shall bow to me. . . . There she had gathered together all her pomp, there was her shrine, and there her votaries came and worshipped as in a temple.[22]

A few years later, in 1824, Hazlitt visited the newly opened National Gallery in London, then installed in a house in Pall Mall. His description of his experience there and its ritual nature – his insistence on the difference between the quality of time and space in the gallery and the bustling world outside, and on the power of that place to feed the soul, to fulfill its highest purpose, to reveal, to uplift, to transform and to cure – all of this is stated with exceptional vividness. A visit to this "sanctuary," this "holy of holies," he wrote, "is like going on a pilgrimage – it is an act of devotion performed at the shrine of Art!"

> It is a cure (for the time at least) for low-thoughted cares and uneasy passions. We are abstracted to another sphere: we breathe empyrean air; we enter into the minds of Raphael, of Titian, of Poussin, of the Caracci, and look at nature with their eyes; we live in time past, and seem identified with the permanent forms of things. The business of the world at large, and even its pleasures, appear like a vanity and an impertinence. What signify the hubbub, the shifting scenery, the fantoccini figures, the folly, the idle fashions without, when compared with the solitude, the silence, the speaking looks, the unfading forms within? Here is the mind's true home. The contemplation of truth and beauty is the proper object for which we were created, which calls forth the most intense desires of the soul, and of which it never tires.[23]

This is not to suggest that the eighteenth century was unanimous about art museums. Right from the start, some observers were already concerned that the museum ambience could change the meanings of the objects it held, redefining them as works of art and narrowing their import simply by

removing them from their original settings and obscuring their former uses. Although some, like Hazlitt and the artist Philip Otto Runge, welcomed this as a triumph of human genius, others were – or became – less sure. Goethe, for example, thirty years after his enthusiastic description of the art gallery at Dresden, was disturbed by Napoleon's systematic gathering of art treasures from other countries and their display in the Louvre as trophies of conquest. Goethe saw that the creation of this huge museum collection depended on the destruction of something else, and that it forcibly altered the conditions under which, until then, art had been made and understood. Along with others, he realized that the very capacity of the museum to frame objects as art and claim them for a new kind of ritual attention could entail the negation or obscuring of other, older meanings.[24]

In the late eighteenth and early nineteenth centuries, those who were most interested in art museums, whether they were for or against them, were but a minority of the educated – mostly poets and artists. In the course of the nineteenth century, the serious museum audience grew enormously; it also adopted an almost unconditional faith in the value of art museums (see below, Chapters 2 and 3). By the late nineteenth century, the idea of art galleries as sites of wondrous and transforming experience became commonplace among those with any pretensions to "culture" in both Europe and America.

Through most of the nineteenth century, an international museum culture remained firmly committed to the idea that the first responsibility of a public art museum is to enlighten and improve its visitors morally, socially, and politically. In the twentieth century, the principal rival to this ideal, the aesthetic museum, would come to dominate. In the United States, this new ideal was advocated most forcefully in the opening years of the century. Its main proponents, all wealthy, educated gentlemen, were connected to the Boston Museum of Fine Arts and would make the doctrine of the aesthetic museum the official creed of their institution.[25] The fullest and most influential statement of this doctrine is Benjamin Ives Gilman's *Museum Ideals of Purpose and Method*, published by the museum in 1918 but drawing on ideas developed in previous years. According to Gilman, works of art, once they are put in museums, exist for one purpose only: to be looked at as things of beauty. The first obligation of an art museum is to present works of art as just that, as objects of aesthetic contemplation and not as illustrative of historical or archaeological information. As he expounded it (sounding much like Hazlitt almost a century earlier), aesthetic contemplation is a profoundly transforming experience, an imaginative act of identification between viewer and artist. To achieve it, the viewer "must make himself over in the image of the artist, penetrate his intention, think with his thoughts, feel with his feelings."[26] The end result of this is an intense and joyous emotion, an overwhelming and "absolutely serious" pleasure that contains a profound spiritual revelation. Gilman compares it to the "sacred conversations" depicted in Italian Renaissance altarpieces – images in which saints who lived in different centuries

miraculously gather in a single imaginary space and together contemplate the Madonna. With this metaphor, Gilman casts the modern aesthete as a devotee who achieves a kind of secular grace through communion with artistic geniuses of the past – spirits that offer a life-redeeming sustenance. "Art is the Gracious Message pure and simple," he wrote, "integral to the perfect life," its contemplation "one of the ends of existence."[27]

The museum ideal that so fascinated Gilman would have a compelling appeal to the twentieth century. Most of today's art museums are designed to induce in viewers precisely the kind of intense absorption that he saw as the museum's mission, and art museums of all kinds, both modern and historical, continue to affirm the goal of communion with immortal spirits of the past. Indeed, the longing for contact with an idealized past, or with things imbued by immortal spirits, is probably pervasive as a sustaining impetus not only of art museums but many other kinds of rituals as well. The anthropologist Edmond Leach noticed that every culture mounts some symbolic effort to contradict the irreversibility of time and its end result of death. He argued that themes of rebirth, rejuvenation, and the spiritual recycling or perpetuation of the past deny the fact of death by substituting for it symbolic structures in which past time returns.[28] As ritual sites in which visitors seek to re-live spiritually significant moments of the past, art museums make splendid examples of the kind of symbolic strategy Leach described.[29] Later sections of this book (especially Chapter 4), will examine several museums in which a wish for immortality is given strong ritual expression.

Nowhere does the triumph of the aesthetic museum reveal itself more dramatically than in the history of art gallery design. Although fashions in wall colors, ceiling heights, lighting, and other details have over the years varied with changing museological trends, installation design has consistently and increasingly sought to isolate objects for the concentrated gaze of the aesthetic adept and to suppress as irrelevant other meanings the objects might have. The wish for ever closer encounters with art have gradually made galleries more intimate, increased the amount of empty wall space between works, brought works nearer to eye level, and caused each work to be lit individually.[30] Most art museums today keep their galleries uncluttered and, as much as possible, dispense educational information in anterooms or special kiosks at a tasteful remove from the art itself. Clearly, the more "aesthetic" the installations – the fewer the objects and the emptier the surrounding walls – the more sacralized the museum space. The sparse installations of the National Gallery in Washington, DC, take the aesthetic ideal to an extreme (Figure 1.4), as do installations of modern art in many institutions (Figure 1.5). As the sociologist César Graña once suggested, modern installation practices have brought the museum-as-temple metaphor close to the fact. Even in art museums that attempt education, the practice of isolating important originals in "aesthetic chapels" or niches – but never hanging them to make an historical point – undercuts any educational effort.[31]

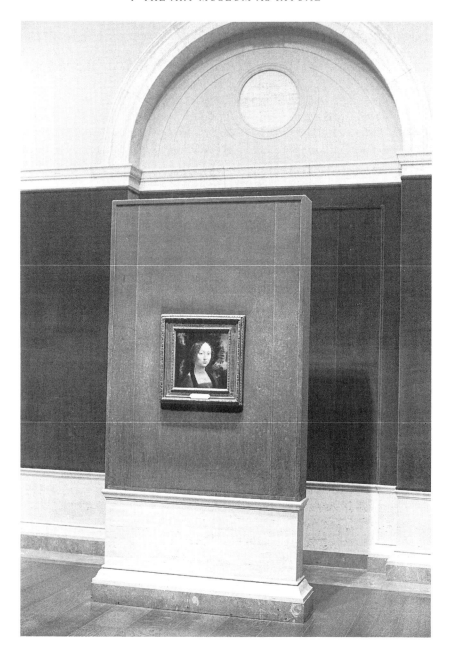

Figure 1.4 National Gallery, Washington, DC, gallery with a work by Leonardo da Vinci (photo: author).

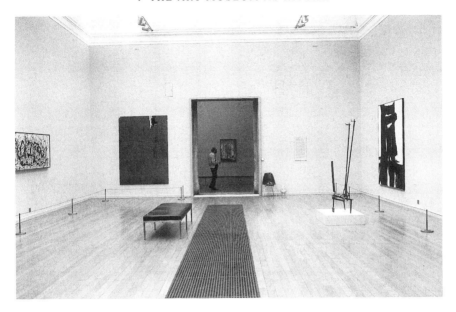

Figure 1.5 Modern art in the Tate Gallery, London (photo: author).

The isolation of objects for visual contemplation, something that Gilman and his colleagues in Boston ardently preached, has remained one of the outstanding features of the aesthetic museum and continues to inspire eloquent advocates. Here, for example, is the art historian Svetlana Alpers in 1988:

> Romanesque capitals or Renaissance altarpieces are appropriately looked at in museums (*pace* Malraux) even if not made for them. When objects like these are severed from the ritual site, the invitation to look attentively remains and in certain respects may even be enhanced.[32]

Of course, in Alpers' statement, only the original site has ritual meaning. In my terms, the attentive gazing she describes belongs to another, if different, ritual field, one which requires from the performer intense, undistracted visual contemplation.

In *The Museum Age*, Germain Bazin described with penetrating insight how modern installations help structure the museum as a ritual site. In his analysis, the isolation and illumination of objects induces visitors to fix their attention onto things that exist seemingly in some other realm. The installations thus take visitors on a kind of mental journey, a stepping out of the present into a universe of timeless values:

> Statues must be isolated in space, paintings hung far apart, a glittering jewel placed against a field of black velvet and spot-lighted; in

19

principle, only one object at a time should appear in the field of vision. Iconographic meaning, overall harmony, aspects that attracted the nineteenth-century amateur, no longer interest the contemporary museum goer, who is obsessed with form and workmanship; the eye must be able to scan slowly the entire surface of a painting. The act of looking becomes a sort of trance uniting spectator and masterpiece.[33]

One could take the argument even farther: in the liminal space of the museum, everything – and sometimes anything – may become art, including fire-extinguishers, thermostats, and humidity gauges, which, when isolated on a wall and looked at through the aesthetizing lens of museum space, can appear, if only for a mistaken moment, every bit as interesting as some of the intended-as-art works on display, which, in any case, do not always look very different.

In this chapter, I have been concerned mainly with arguing the general ritual features of art museums. These are: first, the achievement of a marked-off, "liminal" zone of time and space in which visitors, removed from the concerns of their daily, practical lives, open themselves to a different quality of experience; and second, the organization of the museum setting as a kind of script or scenario which visitors perform. I also have argued that western concepts of the aesthetic experience, generally taken as the art museum's *raison d'être*, match up rather closely to the kind of rationales often given for traditional rituals (enlightenment, revelation, spiritual equilibrium or rejuvenation). In the chapters that follow, liminality will be assumed as a condition of art museum rituals, and attention will shift to the specific scenarios that structure the various museums discussed. As for the purposes of art museums – what they do and to whom or for whom they do it – this question, too, will be addressed, directly or indirectly, throughout much of what follows. Indeed, it is hardly possible to separate the purposes of art museums from their specific scenario structures. Each implies the other, and both imply a set of surrounding historical contingencies.

2

FROM THE PRINCELY GALLERY TO THE PUBLIC ART MUSEUM
The Louvre Museum and the National Gallery, London

The Louvre was the prototypical public art museum. It first offered the civic ritual that other nations would emulate.[1] It was also with the Louvre that public art museums became signs of politically virtuous states. By the end of the nineteenth century, every western nation would boast at least one important public art museum. In the twentieth century, their popularity would spread even to the Third World, where traditional monarchs and military despots create western-style art museums to demonstrate their respect for western values, and – consequently – their worthiness as recipients of western military and economic aid.[2] Meanwhile in the West, museum fever continues unabated. Clearly, from the start, having a public art museum brought with it political advantages.

This chapter will look at two of the most important public art museums in Europe, the Louvre Museum in Paris and the National Gallery in London. However different their histories and collections, both of these institutions stand as monuments to the new bourgeois state as it was emerging in the age of democratic revolutions. If the Louvre, whose very establishment was a revolutionary act, states the central theme of public art museums, the story of the National Gallery in London elaborates its ideological meanings. Its details were spelled out in the political discourse that surrounded its founding and early years, a discourse in which bourgeois and aristocratic modes of culture, including the new art-historical culture, were clearly pitted against each other. The larger question here is what made the Louvre and the other museums it inspired so politically attractive, and how did they differ from older displays of art? Or, to rephrase the question in terms of the theme of this book, what kind of ritual does the public art museum stage, and what was (and is) its ideological usefulness to modern states?

I

Ceremonial displays of accumulated treasure go back to the most ancient of times. Indeed, it is tempting to extend our notion of "the museum" backwards into earlier eras and discover museum-like functions in the

21

treasuries of ancient temples or medieval cathedrals or in the family chapels of Italian Baroque churches. Some of these older types of display come surprisingly close to modern museum situations.[3] Yet, however they may resemble today's public art museums, historically, the modern institution of the museum grew most directly out of sixteenth-, seventeenth-, and eighteenth-century princely collections. These collections, which were often displayed in impressive halls or galleries built especially for them, set certain precedents for later museums.[4]

Typically, princely galleries functioned as reception rooms, providing sumptuous settings for official ceremonies and framing the figure of the prince. By the eighteenth century, it was standard practice everywhere in Europe for princes to install their collections in lavishly decorated galleries and halls, often fitting individual works into elaborate wall schemes of carved and gilt panelling. The point of such show was to dazzle and overwhelm both foreign visitors and local dignitaries with the magnificence, luxury, and might of the sovereign, and, often – through special iconographies – the rightness or legitimacy of his rule. Palace rooms and galleries might also be decorated with iconographic programs that drew flattering analogies to the ruler – galleries of portrait busts of legendary emperors or depictions of the deeds of great monarchs of the past. A ruler might also surround himself with sculptures, paintings, and tapestries of a favorite classical god to add luster to his image – Louis XIV's appropriation of the sun-god Apollo is the most famous; in Madrid it was Hercules, celebrated in a series of paintings by Rubens, whose exploits were linked to the throne. In one way or another, these various displays of objects and paintings demonstrated something about the prince – his splendor, legitimacy, or the wisdom of his rule.[5] As we shall see, public art museums both perpetuated and transformed the function of these princely reception halls wherein the state idealized and presented itself to the public.

The Louvre was not the first royal collection to be turned into a public art museum, but its transformation was the most politically significant and influential. In 1793 the French revolutionary government, seizing an opportunity to dramatize the creation of the new republican state, nationalized the king's art collection and declared the Louvre a public institution.[6] The Louvre, once the palace of kings, was now reorganized as a museum for the people, to be open to everyone free of charge. It thus became a lucid symbol of the fall of the Old Regime and the rise of a new order. The new meaning that the Revolution gave to the old palace was literally inscribed in the heart of the seventeenth-century palace, the Apollo Gallery, built by Louis XIV as a princely gallery and reception hall. Over its entrance is the revolutionary decree that called into existence the Museum of the French Republic and ordered its opening on 10 August, to commemorate "the anniversary of the fall of tyranny" (Figure 2.1). Inside the gallery, a case holds crowns from the royal and imperial past, now displayed as public property.[7]

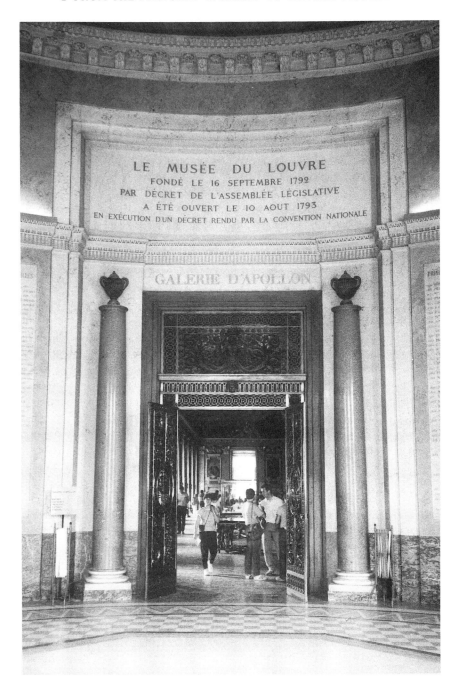

Figure 2.1 Louvre Museum, Paris, entrance to the Apollo Gallery (photo: author).

The new museum proved to be a producer of potent symbolic meanings. The transformation of the palace into a public space accessible to everyone made the museum an especially pointed demonstration of the state's commitment to the principle of equality. As a public space, the museum also made manifest the public it claimed to serve: it could produce it as a visible entity by literally providing it a defining frame and giving it something to do. In the museum, even the rights of citizenship could be discerned as art appreciation and spiritual enrichment. To be sure, equality of access to the museum in no way gave everyone the relevant education to understand the works of art inside, let alone equal political rights and privileges; in fact, only propertied males were full citizens. But in the museum, everyone was equal in principle, and if the uneducated could not use the cultural goods the museum proffered, they could (and still can) be awed by the sheer magnitude of the treasure.

As a new kind of public ceremonial space, the Louvre not only redefined the political identity of its visitors, it also assigned new meanings to the objects it displayed and qualified, obscured, or distorted old ones. Now presented as public property, they became the means through which a new relationship between the individual as citizen and the state as benefactor could be symbolically enacted. But to accomplish their new task, they had to be presented in a new way. In a relatively short time, the Louvre's directors (drawing partly on German and Italian precedents) worked out a whole set of practices that came to characterize art museums everywhere. In short, the museum organized its collections into art-historical schools and installed them so as to make visible the development and achievement of each school. Certainly, it did not effect this change overnight. It first had to sort out the various, and in some ways, contradictory, installation models available at the time, and the different notions of artistic "schools" that each entailed.[8]

Probably the most fashionable way of hanging a collection in the later eighteenth century was what might be called the connoisseur's or gentlemanly hang. This installation model was practiced internationally and corresponded rather precisely to the art education of European aristocrats. In the eighteenth and early nineteenth centuries, there was widespread agreement among cultivated men (and those few women who could claim such knowledge) that, aside from the sculpture of classical antiquity, the masters most worth collecting were sixteenth- and seventeenth-century Italian, Flemish, Dutch, and French. Men of taste and breeding, whatever their nationality, were expected to have learned key critical terms and concepts that distinguished the particular artistic virtues of the most popular masters. Indeed, such knowledge was taken as a sign of aristocratic breeding, and in the course of the eighteenth century it became the fashion to hang collections, including royal collections, in a way that highlighted the formal qualities of the various masters – that is, in a way that displayed one's knowledge of current critical fashions. A gentlemanly hang, be it in England, Italy, or France, might group

together on one wall contrasting examples from opposing schools. For example, an Italian *Venus* or martyrdom on the right might be balanced by a Flemish *Venus* or martyrdom on the left, the better to show off their particular qualities of drawing, color, and composition; alternatively, works by various masters from the same school might be grouped together to complement each other.[9]

In the later eighteenth century, this gentlemanly type of installation was given increasing competition by newer, art-historical arrangements, versions of which were being introduced into certain private and princely collections.[10] In these new arrangements, more was made of the progress demonstrated by each school and its principal masters. By and large, this progress was measured in terms of a single, universal ideal of beauty, an ideal toward which all societies presumably evolved, but one that, according to experts, ancient sculpture and Italian High Renaissance painting most fully realized. As the administrators of the Louvre Museum put it in 1794, the new museum's goal was to show visitors "the progress of art and the degrees of perfection to which it was brought by all those peoples who have successively cultivated it."[11] And when, some years later, the noted German art expert Gustav Waagen toured English art collections, he could, in the same spirit, pronounce the National Gallery's *Resurrection of Lazarus* by Sebastiano del Piombo the star of the collection and indeed of all English collections combined, since, in his eyes, it was the one work that most embodied the genius of the Italian High Renaissance and therefore most achieved the universal ideal.[12]

These kinds of judgments concerned more than the merits of individual artists. Progress in art could be taken as an indicator of how far a people or epoch evolved toward civilization in general. That is, the art-historical approach gave works of art a new cultural-historical importance and a new cognitive value. As such, they required new, more appropriate kinds of settings. Whereas older displays, princely and gentlemanly alike, commonly subordinated individual works to larger decorative schemes, often surrounding them with luxurious furnishings and ornaments, the new approach called for settings that would not compete with the art. At the same time, new wall arrangements were evolved so that viewers could literally retrace, work by work, the historical lines of development of both individual artists and their schools. In the course of the nineteenth century, the conviction that art must be valued and ranked according to a single ideal of beauty would be gradually modified; educated opinion would appreciate an ever greater range of schools – especially fifteenth-century Italian art – each for its own unique qualities,[13] and would increasingly demand their representation in public collections.[14] In all of this, the concept of high art was being rethought. Rather than a rare attainment, it was coming to be seen as a necessary component of every society, an organic expression of one or another particular national spirit.[15] However, the language associated with the evolutionary approach and the

habit of extolling ancient sculpture and High Renaissance art above all else, would hang on for a long time. Malraux noted how long this change took in the museum market: only late in the nineteenth century would different schools be treated fully as equals, and only toward the end of the century could a Piero della Francesca be rated as equal or superior to Raphael.[16]

Historians of museums often see the new art-historical hang as the triumph of an advanced, Enlightenment thinking that sought to replace earlier systems of classification with a more rational one. To be sure, the new construct was more in keeping with Enlightenment rationality. But more significant to the concerns of this study was its ideological usefulness to emerging bourgeois states, all of which, in the course of the nineteenth century, adopted it for their public art museums. Although still pitched to an educated elite and still built on a universal and international standard, the new system, by giving special emphasis to the "genius" of national schools, could both acknowledge and promote the growth of state power and national identity.

The differences in these models of display amount to very different ritual structures. Just as the public art museum redefined the content of its displays, so it reconceptualized the identity of its visitors and their business in the museum. That is, as a new kind of dramatic field, the art museum prompted its visitors to assume a new ritual identity and perform a new ritual role. The earlier, aristocratic installation addressed the visitor as a gentleman and reinforced this identity by enabling him to engage in and reenact the kind of discerning judgments that gentlemanly culture called "good taste." By asking him to recognize – without the help of labels – the identities and distinctive artistic qualities of canonized masters – Guido Reni, Claude, Murillo, and other favorites – the visitor-cum-connoisseur could experience himself as possessing a culture that was both exclusive and international, a culture that marked its possessor as a member of the elite.[17] In contrast, the public art museum addressed its visitor as a bourgeois citizen who enters the museum in search of enlightenment and rationally understood pleasures. In the museum, this citizen finds a culture that unites him with other French citizens regardless of their individual social position. He also encounters there the state itself, embodied in the very form of the museum. Acting on behalf of the public, it stands revealed as keeper of the nation's spiritual life and guardian of the most evolved and civilized culture of which the human spirit is capable. All this it presents to every citizen, rationally organized and clearly labeled. Thus does the art museum enable the citizen–state relationship to appear as realized in all its potential.

Almost from the beginning, the Louvre's directors began organizing its galleries by national school.[18] Admittedly, some very early displays presented works of art as confiscated treasure or spoils of a victorious army (this was the era in which French armies systematically packed up art treasures from churches and palaces all over Europe and sent them to the Louvre[19]). But by its 1810 reopening as the Musée Napoléon, the museum, now under

the direction of Vivant Denon, was completely organized by school, and within the schools, works of important masters were grouped together. The conversion of the old palace into a public art museum had taken some doing architecturally, but in certain ways, the old building was well equipped for its new symbolic assignment. It was, after all, already full of sixteenth-, and seventeenth-century spaces originally designed to accommodate public ritual and ceremonial display (Figure 2.2). Its halls and galleries tended to develop along marked axes so that (especially in the rooms occupied by the early museum) visitors were naturally drawn from room to room or down long vistas. The setting was well suited to the kind of narrative iconographic program it now contained.

Thus ordered, the treasures, trophies, and icons of the past became objects of art history, embodiments of a new form of cultural-historical wealth. The museum environment was structured precisely to bring out this new meaning and suppress or downplay old ones. In this sense, the museum was a powerful transformer, able to convert signs of luxury, status, or splendor into repositories of spiritual treasure – the heritage and pride of the whole nation. Organized chronologically and in national categories along the museum's corridors, works of art now became witnesses to the presence of "genius," cultural products marking the course of civilization in nations and individuals.[20] The ritual task of the Louvre visitor was to reenact that history of genius, re-live its progress step by step and, thus enlightened, know himself as a citizen of history's most civilized and advanced nation-state.

Throughout the nineteenth century, the Louvre explained its ritual program in its ceiling decorations. An instance of this is still visible in what was originally the vestibule of the Musée Napoléon (the Rotunda of Mars), dedicated in 1810. Four medallions in the ceiling represent the principal art-historical schools, each personified by a female figure who holds a famous example of its sculpture: Egypt a cult statue, Greece the *Apollo Belvedere*, Italy Michelangelo's *Moses*, and France Puget's *Milo of Crotona*.[21] The message reads clearly: France is the fourth and final term in a narrative sequence that comprises the greatest moments of art history. Simultaneously, the history of art has become no less than the history of western civilization itself: its origins in Egypt and Greece, its reawakening in the Renaissance, and its present flowering in modern France. The same program was elaborated later in the century in mosaic decorations for the five domed spaces above the Daru Stairway (Figure 2.3) (subsequently removed).

Other ceilings further expound the symbolic meanings of the museum's program. Throughout the nineteenth century, museum authorities used the ceilings to spell them out, lecturing visitors from above. They especially hammered home the idea of the state as protector of the arts. Often resorting to traditional princely iconography, images and insignia repeatedly identified this or that government or monarch as the nation's cultural benefactor. One ceiling, for example, decorating the museum's 1812 grand stairway (the stair

Figure 2.2 The old Louvre Palace, a former royal apartment, converted to museum use in the nineteenth century (photo: author).

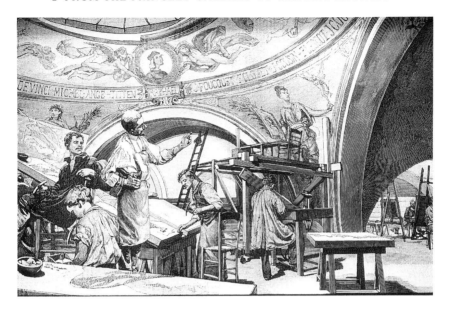

Figure 2.3 Creating a genius ceiling in the central dome of the Louvre's Daru Staircase (from *L'Illustration*, 27 August, 1887). The decorations were later removed (photo: author).

is gone but the ceiling remains), represents *France in the Guise of Minerva Protecting the Arts* (by Meynier, 1819). The Napoleonic insignia that originally surrounded it were later removed. Successive regimes, monarchical or republican, often removed the insignia of their predecessors in order to inscribe their own on the museum's walls and ceilings.

Increasingly the iconography of the museum centered on artists. For example, in the Musée Charles X (the series of rooms opened to the public in the 1820s), ceilings still celebrate great patron-princes of the past; but artists are also abundantly present. As in later decorations, sequences of their names or portraits, arranged into national schools, grace the entablatures. Indeed, ever greater expanses of overhead space would be devoted to them as the century wore on. If anything, the nineteenth century was a great age of genius iconography,[22] and nowhere are genius ceilings more ostentatious than in the Louvre (Figure 2.4). Predictably, after every coup or revolution, new governments would vote funds for at least one such ceiling, prominently inscribing its own insignia among the names or profiles of the great artists so honored. Thus in 1848, the newly constituted Second Republic renovated and decorated the Salon Carré and the nearby Hall of Seven Chimneys, devoting the first to masters of the foreign schools, and the second to French geniuses, profiles of whom were alphabetically arranged in the frieze (Figure 2.5).[23] It

Figure 2.4 Louvre Museum, the newly decorated Salle des Etats, 1886 (from *L'Illustration*, 30 October, 1886) (photo: author).

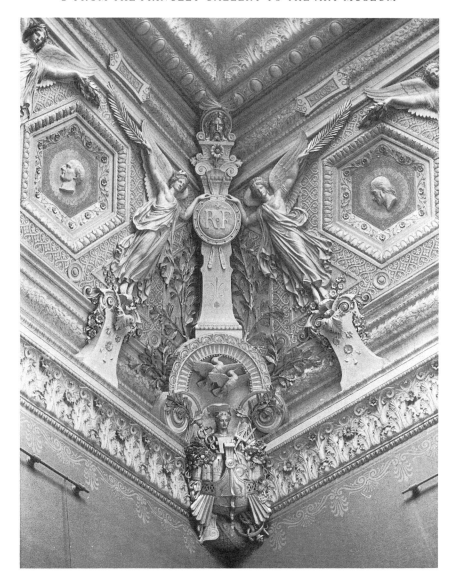

Figure 2.5 Louvre Museum, detail of a genius ceiling in the Hall of Seven Chimneys, commissioned in 1848 by the French Republic (photo: author).

is relevant to recall that from the early nineteenth century on, most artists were very aware of themselves as candidates for the category of great artist so lavishly celebrated on the ceiling and plotted their artistic strategies accordingly.

It should be obvious that the demand for great artists, once the type was developed as an historical category, was enormous – they were, after all, the means by which, on the one hand, the state could demonstrate the highest kind of civic virtue, and on the other, citizens could know themselves to be civilized. Not surprisingly, quantities of great artists were now duly discovered and, in time, furnished with properly archetypal biographies by the burgeoning discipline of art history.[24] These conditions are perpetuated today in the institution of the giant retrospective. A voracious demand for great artists, living or dead, is obligingly supplied by legions of art historians and curators trained for just this task. Inevitably some of the great artists inducted into this role fill it out with less success than others. Even so, a fair or just good great artist is still a serviceable item in today's museum business.

The importance of the Louvre Museum as a model for other national galleries and as an international training ground for the first community of professional museum men is everywhere recognized. After the example of the Louvre, there was a flurry of national gallery founding throughout Europe, whose heads of state often simply designated an existing royal or imperial collection as a public art museum. Conversions of this kind had been made before the Revolution, in Dresden and Vienna, for example, but would continue now with greater speed. Under Napoleon's occupying armies, numerous public art museums were created in, among other places, Madrid, Naples, Milan, and Amsterdam. Of course, some of the new "national galleries" were more like traditional princely reception halls than modern public spaces – more out to dazzle than enlighten – and one usually entered them as a privilege rather than by right.[25] Whatever form they took, by 1825, almost every western capital, monarchical or republican, had one.

The influence of the Louvre continued in the later nineteenth and twentieth centuries in the many public art museums founded in European provincial cities[26] and in other places under the sway of European culture. In New York, Boston, Chicago, Cleveland, and other American cities, museums were carefully laid out around the Louvre's organizing theme of the great civilizations, with Egypt, Greece, and Rome leading to a centrally placed Renaissance. When no Greek or Roman originals were on hand, as they were not in many American cities, the idea was conveyed by plaster casts of classical sculpture or Greek-looking architecture, the latter often embellished with the names or profiles of great artists from Phidias on; such facades are familiar sights everywhere (Figures 1.2 and 3.4).

As for the Louvre itself, despite a long history of expansions, reorganizations, and reinstallations, the museum maintained until very recently

its nineteenth-century bias for the great epochs of civilization. Classical and Italian Renaissance art always occupied its most monumental, centrally located spaces and made the museum's opening statements.[27] In the course of the nineteenth century, it expanded its history of civilization to include the art of ancient Egypt, the Near East, Asia, and other designated culture areas. Just as these episodes could be added, so others could be subtracted without damaging the museum's central program: in the years after World War II, Impressionist painting and far eastern art were moved out of the Louvre altogether, the one to the Jeu de Paume, the other to the Musée Guimet. In terms of the museum's traditional program, neither collection – however valued as a collection – was essential, and, as one museum official affirmed, their subtraction actually clarified the museum's primary program:

> It may be said that the Louvre collections form today a coherent whole, grouping around our western civilization all those which, directly or indirectly, had a share in its birth. . . . At the threshold of history there stand the mother civilizations: Egyptian, Sumerian, Aegean. Then, coming down through Athens, Rome, Byzantium, towards the first centuries of our Christian era, there are the full blossomings of Medieval, Renaissance and Modern art. At the Louvre, then, we are on our own home territory, the other inhabited parts of the earth being dealt with elsewhere.[28]

The museum's commitment to lead visitors through the course of western civilization continues to this day, even though a new entrance, new access routes and a major reinstallation allow visitors to map their own paths through a somewhat revised history of art. As I write this (in 1993), the museum is getting ready to unveil its latest expansion, the newly installed Richelieu Wing, in which, for the first time, northern European art will be given the kind of grand ceremonial spaces that, up until now, were usually reserved for French and Italian art. It appears that, in today's Louvre, French civilization will look more broadly European in its sources than before, more like a leading European Community state. Whatever the political implications of the new arrangement, the Louvre continues its existence as a public state ritual.

But 1993 is a long way from 1793. Of the legions of people who daily stream through the Louvre, most, whether French or foreign, are tourists. Which is to say that, as a prime tourist attraction, the museum is crucial to the city's economy. If it still constructs its visitors as enlightenment-seeking citizens, it must also cater to crowds of hungry, credit-card-bearing consumers in search of souvenirs and gifts. Besides a revised art-historical tour, therefore, the Louvre of 1993 also includes spacious new restaurants and a monumental shopping mall.[29] Such developments, however, belong to the Louvre's later years. We have still to consider more of the public art museum's significance in the nineteenth and early twentieth centuries, first in Britain and (in the following chapter) in the United States.

II

Let us turn now to the National Gallery in London. If the Louvre is the prototype of the public art museum – and that is its status in the literature[30] – how are we to understand the National Gallery? The dramatic and revolutionary origins of the French museum, including its very site in what was once the royal palace, is unparalleled in the British example, whose founding, next to the Louvre's, seems sorely lacking in political and historical fullness. The decisive events and powerful symbolic ingredients that made the French example so much the archetype of the European public art museum are simply not present.

The first missing ingredient is a significant royal art collection of the kind that seventeenth- and eighteenth-century monarchs had often assembled and which then became the core of a national gallery. Certainly, England had once known such royal treasure: Charles I's famous and much admired collection of paintings. Broken up when Charles fell, the story of this collection – its destruction as much as its creation – must figure as the beginning of the story of public art museums in England.

Charles came to the English throne in 1625, bringing with him ideas about monarchy that were shaped by continental models and continental theories of the divine right of kings. Especially impressed by the haughty formality and splendor of the Spanish court, he sought to create on English soil similar spectacles of radiant but aloof power. Accordingly, he commissioned Inigo Jones to design a properly regal palace complete with a great hall decorated by Rubens (in 1635). A show of power in the seventeenth century also demanded a magnificent picture collection; elsewhere in Europe, church and state princes – Cardinal Mazarin and the Archduke Leopold William are outstanding examples – paid fortunes for the requisite Titians, Correggios, and other favorites of the day. Charles understood fully the meaning of such ceremonial display. So did his Puritan executioners, who pointedly auctioned off a large part of the king's collection. Not only did they feel a Puritan discomfort with such sensually pleasing objects; they also wished to dismantle a quintessential sign of regal absolutism.[31] The absence of a significant royal collection in England is as much a monument, albeit a negative one, to the end of English absolutism as the Louvre Museum is to the end of French absolutism.

This is only to say that the process of British state building was English, not French, as was the development of the symbols and public spaces which culturally articulated that process. In the England after Charles I, monarchs might collect art, but political realities discouraged them from displaying it in ways that recalled too much the regal shows and absolutist ambitions of the past. In fact, after Charles and a very few other grand seventeenth-century art collectors – in particular the Earl of Arundel and the Duke of Buckingham – there would be no significant English collections for several decades.[32] It was only after the Restoration that large-scale English picture-collecting

would be resumed, most notably by the powerful aristocratic oligarchs to whom state power now passed. Meanwhile, British monarchs kept rather low public profiles as art collectors and art patrons.

Kensington Palace is a telling reminder of the modesty in which monarchy was expected to live, at least in the later seventeenth century. The residence of King William III and Queen Mary (installed on the throne in 1689), the building began as an unpretentious dwelling, certainly comfortable and dignified enough for its noble occupants – as seen in its two "long galleries" filled with art objects – but not in any way palatial. It lacked the ceremonial spaces of an empowered royalty, spaces that would appear only later under Kings George I and II.[33] William's picture gallery held a fine collection, but it remained a source of private pleasure, not regal display. In fact, various royal residences would end up with considerable holdings, but these were never institutionalized as "the British Royal Collection." Even now, they remain largely private; indeed, when displayed in the new Sainsbury Wing of the National Gallery in 1991–2, they attracted attention precisely because so much of the collection has been unfamiliar to the art-viewing public.[34]

Besides the want of a royal collection properly deployed as such, British eighteenth-century history lacks a potent political event that could have dramatically turned that collection into public property – in short, an eighteenth- or nineteenth-century type of democratic revolution. Of course, another way to get a public art museum (short of being occupied by a French army) was through the liberalizing monarchical gesture as seen on the continent, in which a royal collection was opened up as a public space in symbolic (if not direct political) recognition of the bourgeois presence. The French crown had been planning just such a move at the time of the Revolution. The Revolution took over that museum project but also redefined it, making what would have been a privileged and restricted space into something truly open and public. The revolutionary state thus appropriated the legacy of absolutist symbols and ceremonies and put them to new ideological use, making them stand for the Republic and its ideal of equality. The English ruling class, on the other hand, had rejected the use of a royal art collection as a national symbol just as deliberately as it had blocked the development of an absolutist monarchy. There was political room neither for the kind of art collection that the people could meaningfully nationalize nor for the kind of monarch who could meaningfully nationalize it himself.

By the late eighteenth century, however, the absence of a ceremonially important royal collection was more than made up for by those of the aristocracy. In fact, the British art market actually became the most active in eighteenth-century Europe as both the landed aristocracy and a newly arrived commercial class sought the distinctive signs of gentlemanly status. Whether defending older class boundaries or attempting to breach them, men of wealth deemed it socially expedient to collect and display art, especially paintings. Italian, Flemish, and other old-master works of the kind prescribed by the

current canons of good taste poured into their collections. As Iain Pears has argued, art collecting, by providing a unifying cultural field, helped the upper ranks of English society form a common class identity.

> They increasingly saw themselves as the cultural, social and political core of the nation, "citizens" in the Greek sense with the other ranks of society scarcely figuring in their understanding of the "nation."[35]

In short, here were the social elements of the "civil society" of seventeenth- and eighteenth-century political philosophy, that community of propertied citizens whose interests and education made them, in their view, most fit to rule.[36]

To modern eyes, the social and political space of an eighteenth-century English art collection falls somewhere between the public and private realms. Our notion of the "public" dates from a later time, when, almost everywhere in the West, the advent of bourgeois democracy opened up the category of citizenship to ever broader segments of the population and redefined the realm of the public as ever more accessible and inclusive. What today looks like a private, socially exclusive space could have seemed in the eighteenth century much more open. Indeed, an eighteenth-century picture collection (and an occasional sculpture collection) was contiguous with a series of like spaces (including, not incidentally, the newly founded British Museum[37]) that together mapped out the social circuit of a class. Certainly access to these collections was difficult if one did not belong to the elite.[38] But from the point of view of their owners, these spaces were accessible to everyone who counted, the

> finite group of personal friends, rivals, acquaintances and enemies who made up the comparatively small informal aristocracy of landed gentle- men, peers or commoners, in whom the chains of patronage, "friend- ship," or connection converged.[39]

Displayed in galleries or reception rooms of town or country houses, picture collections were seen by numerous visitors, who often toured the countryside expressly to visit the big landowners' showy houses and landscape gardens.[40] Art galleries were thus "public" spaces in that they could unequivocally frame the only "public" that was admissible: well-born, educated, men of taste, and, more marginally (if at all), well-born women.[41]

Art galleries signified social distinction precisely because they were seen as more than simple signs of wealth and power. Art was understood to be a source of valuable moral and spiritual experience. In this sense, it was cultural property, something to be shared by a whole community. Eighteenth-century Englishmen as well as Frenchmen had the idea that an art collection could belong to a nation, however they understood that term. The French pamphlet- eers who called for the nationalization of the royal collection and the creation of a national art museum[42] had British counterparts who criticized rich

collectors for excluding from their galleries a larger public, especially artists and writers.[43]

Joshua Reynolds, Benjamin West, and Thomas Lawrence, the first three presidents of the Royal Academy, were among those who called for the creation of a national gallery or, at the least, the opening up of private collections. Even before the creation of the Louvre, in 1777, the radical politician John Wilkes proposed that Parliament purchase the fabulous collection of Horace Walpole and make it the beginning of a national gallery. The proposal was not taken up and the collection was sold to Catherine the Great.[44] A few years later, the creation of the Louvre Museum intensified the wish for an English national collection, at least among some. Thus in 1799, the art dealer Noel Joseph Desenfans offered the state a brilliant, ready-made national collection of old masters, assembled for King Stanislas Augustus of Poland just before he abdicated. Desenfans, determined to keep the collection intact and in England, offered it to the state on the condition that a proper building be provided for it. According to the German art expert J. D. Passavant, the offer "was coolly received and ultimately rejected." Desenfans's collection was finally bequeathed to Dulwich College (see Chapter 4), and was, for another decade or so, the only public picture collection in the vicinity of London.[45]

Why was Parliament so resistant to establishing a national gallery? In the years between the founding of the Louvre in 1793 and the fall of Napoleon in 1815, almost every leading European state acquired a national art museum, if not by an act of the reigning monarch then through the efforts of French occupiers, who began museum building on the Louvre model in several places. Why did the ruling oligarchs of Great Britain resist what was so alluring in Berlin, Madrid, and Amsterdam? The answer to this question, I believe, lies in the meaning of the art gallery within the context of eighteenth-century patrician culture.

Eighteenth-century Britain was ruled by an oligarchy of great landowners who presided over a highly ranked and strictly hierarchical society. Landed property, mainly in the form of rents, was the basic source of wealth and the key to political power and social prestige. Although landowners also engaged in commercial and industrial capitalist ventures, profits were normally turned into more land or land improvement, since that form of property was considered the only gentlemanly source of wealth. Living off rents was taken to be the only appropriate way of achieving the leisure and freedom necessary to cultivate one's higher moral and intellectual capacities. Apologists for the landowners argued that ownership of land was a precondition for developing the wisdom, independence, and civic-mindedness necessary for the responsible exercise of political power. They maintained that holdings in land rooted one in the larger community and made one's private interests identical with the general interest and well-being of the whole of society. Landowners, both

old and newly arrived, thereby justified their monopoly of political rights on the basis of their land holdings.

In fact – and contrary to the claims of their apologists – the great landowners exercised power according to narrow self-interest. The business of government was largely a matter of buying and selling influence and positioning oneself for important government appointments, lucrative sinecures, and advantageous marriages for one's children. The more land one owned, the more patronage, influence, and wealth one was likely to command and the better one's chances to buy, bribe, and negotiate one's way to yet more wealth and social luster.[46] To be even a small player in this system required a great show of wealth, mediated, of course, by current codes of good taste and breeding. A properly appointed country house with a fashionably landscaped garden was a minimum requirement. If few landowners could compete with Horace Walpole's Houghton, the Duke of Marlborough's Blenheim, or the Duke of Bedford's Woburn Abbey, they could nevertheless assemble the essentials of the spectacle. As Mark Girouard has described it,

> Trophies in the hall, coats of arms over the chimney-pieces, books in the library and temples in the park could suggest that one was discriminating, intelligent, bred to rule and brave.[47]

Art collections, too, betokened gentlemanly attainments, and marked their owners as veterans of the grand tour (mandatory for any gentleman). Whether installed in purpose-built galleries or in other kinds of rooms (Figure 2.6), they provided a display of wealth and breeding that helped give point and meaning to the receptions and entertainments they adorned. Compared to today's academic discourse, the critical vocabulary one needed to master was decidedly brief and the number of canonized old masters few: the Carracci, Guido Reni, Van Dyck, and Claude were among those most admired.[48] However shallow one's understanding of them, to display them in one's house and produce before them the right clichés served as proof that one was cultivated and discerning and fit to hold power. Whatever else they might have been, art collections were prominent artifacts in a ritual that marked the boundary between polite and vulgar society, which is to say, the boundary of legitimated power.[49]

Given the structure of the British oligarchy, the notorious self-interest of its ranking magnates, and the social uses of art displays, the unwillingness to create a national gallery until 1824 is not surprising.[50] Absorbed in a closed circle of power, patronage, and display, the ruling oligarchy had no compelling reason to form a national collection. Indeed, at this historical moment – an era of democratic revolutions – it had good reason *not* to want one, since national galleries tended either to signal the advent of republicanism or to give a liberalized face to surviving monarchies attempting to renew their waning prestige.[51] The men who dominated Parliament had no reason to send either of these signals. Their existing practices of collection and display

Figure 2.6 The eighteenth-century dining room from Lansdowne House, London, as installed in the Metropolitan Museum of Art, New York (photo: author).

already marked out boundaries of viable power and reinforced the authority of state offices.[52]

Parliament's claim to represent the interests of the whole society, when in fact self-enrichment had become the central operating principle of its members, was a contradiction that became ever more glaring and ever less tolerable to growing segments of the population. Over the first few decades of the nineteenth century, groups of industrialists, merchants, professionals, disgruntled gentry locked out of power, and religious dissenters mounted well-organized attacks on both the structure and policies of the government. They not only pressed the question of what class should rule, they also challenged aristocratic culture, contested its authority, and discredited some of its more prestigious symbols. Their most scathing and effective attacks on the culture of privilege would come in the 1820s and 30s, when radicals and reformers, the Benthamites prominent among them, gave voice to widely felt resentments.[53] (The Benthamites were followers of the social reformer and utilitarian philosopher Jeremy Bentham, 1748–1832.) From those decades date proposals for public art galleries and campaigns to increase access to existing public museums and monuments. In the context of early nineteenth-century Britain, these efforts were highly political in nature and directly furthered a larger project to expand the conventional boundaries of citizenship. The cultural strategy involved opening up traditionally restricted ritual spaces and redefining their content – this as a means of advancing the claims of "the nation." The effort to define and control these spaces would build as the nineteenth century wore on.

This concern to defend and advance the rights of the political nation easily shaded into feelings of a broader nationalism, appearing elsewhere in western Europe in the early nineteenth century, as well as patriotic sentiments, which the wars with France intensified. The creation of the Louvre Museum and its spectacular expansion under Napoleon sharpened these feelings of English-French rivalry and gave them a cultural focus. The marvels of the Louvre caused acute museum envy not only among English artists and writers like Hazlitt, Lawrence, and West, but also among some of the gentleman collectors who sat in Parliament and felt the lack of a public art collection as an insult to British national pride.[54] Both during and after the wars, however, the state was diffident about projects that might have fostered national pride. As the historian Linda Colley has argued, in late eighteenth- and early nineteenth-century England, to encourage nationalism was to encourage an inclusive principle of identity that could too easily become the basis of a political demand to broaden the franchise. It is thus no surprise that the expression of nationalist feeling came from outside the circles of official power. Typically, it took the form of proposals for cultural and patriotic monuments, as well as charitable institutions and philanthropic gestures.[55]

In 1802 the wealthy and self-made John Julius Angerstein, the creator of Lloyds of London, set up a patriotic fund for dependants of British war dead

and contributed to it handsomely. He also published the names of everyone who contributed and exactly what each gave. The tactic exposed the landed aristocracy as selfish – their donations were generally meager – while publicizing commercial City men like Angerstein as patriotic, generous, and more responsive to the true needs of the nation. Angerstein clearly saw himself as the equal if not the better of any lord of the realm, and he lived accordingly. With his immense fortune and the help of artist friends like Thomas Lawrence, he amassed a princely art collection of outstanding quality, installed it in magnificently decorated rooms in his house in Pall Mall, and – in pointed contrast to many aristocratic collectors – opened his doors wide to interested artists and writers. But not all doors were open to Angerstein. As a Russian-born Jew who lacked formal education – and was reputedly illegitimate to boot – he was never allowed to shake the appellation "vulgar" and could never fully enter the highest ranks of society.

Nevertheless, after his death in 1823, Angerstein's art collection became the nucleus of the British National Gallery. With the help of Lawrence, the state was allowed to purchase the best of his collection – thirty-eight paintings – at a cost below their market value.[56] By now, sentiment in Parliament had shifted in favor of such a gallery; both Lord Liverpool, the Prime Minister, and his Home Secretary Sir Robert Peel backed the move. However, while the motion passed with relative ease, working out just where it would be and who would oversee it occasioned considerable political skirmishing. The trustees of the British Museum clearly expected to take it in hand, but had to give up that idea in the face of fierce parliamentary opposition. The problem was solved when the government was allowed to buy the remainder of the lease on Angerstein's house in Pall Mall, and the new National Gallery opened there in May, 1824. Thus, intentionally or not, Angerstein posthumously provided both the substance and site for a prestigious new symbol of the nation. There is every indication that he would have heartily approved and supported this transformation of his property. Both his son and executors thought so.[57] Indeed Angerstein's son believed that had it been proposed to his father that he contribute to a National Gallery, "he might have given a part or the whole [of his collection] for such a purpose."[58]

Which brings me back to the larger, historical issue with which I began this section. Although the story of the founding of the National Gallery lacks a clear-cut revolutionary moment, it nevertheless points to a growing acceptance of a new concept of the nation in Britain. Because the issue of nationalism looms so large in today's political news, and because the terms nation and nationalism are now so much in currency, we must take care not to read modern meanings into early nineteenth-century political discourse when it speaks of "the nation." In the eighteenth and early nineteenth century, one spoke of patriotism, not nationalism. Later ideas of the nation as a people defined and unified by unique spiritual yearnings or "racial" characteristics, are foreign to the early nineteenth-century political discourse

I am describing. Although there was great concern and interest in the uniqueness of national cultures, nations were generally understood and described in social, political, and economic terms, and the term "nation" was normally used as a universal category designating "society." The word "nation" was often used in the context of a middle-class campaign to dispute the claim of the privileged few to be the whole of the polity. In British political discourse, the nation could even be a code word for the middle class itself, one that highlighted the fact that British society consisted of more people than those presently enfranchised.[59] The founding of the National Gallery did not change the distribution of real political power – it did not give more people the vote – but it did remove a portion of prestigious symbolism from the exclusive control of the elite class and gave it to the nation as a whole. An impressive art gallery, a type of ceremonial space deeply associated with social privilege and exclusivity, became national property and was opened to all. The transference of the property as well as the shift in its symbolic meaning came about through the mediation of bourgeois wealth and enterprise and was legitimated by a state that had begun to recognize the advantages of such symbolic space.

The story, far from ending, was only at its beginning when the National Gallery opened in 1824. The struggle between the "nation" and its ruling class was still heating up politically. Years of resentment against the aristocracy, long held in by the wars, had already erupted in the five years following the Battle of Waterloo (1815). If the violence had subsided, the political pressures had not. Throughout the 1820s, a strong opposition, often Benthamite in tone and backed by a vigorous press, demanded middle-class access to political power and the creation of new cultural and educational institutions. This opposition ferociously attacked hereditary privilege, pro-testing the incompetency of the aristocratic mind to grasp the needs of the nation, including its cultural and educational needs, and the absurdity of a system that gave aristocrats the exclusive right to dominate the whole. After the passage of the Reform Bill in 1832, elections sent a number of radicals to Parliament, where, among other things, they soon took on the cause of the National Gallery.

Debate was immediately occasioned by the urgent need to find a new space for the collection, since the lease on Angerstein's old house in Pall Mall would soon end and the building was slated for demolition. In April, 1832, Sir Robert Peel proposed to the House of Commons that the problem be solved by the erection of a new building on Trafalgar Square. He had in mind a dignified, monumental structure ("ornamental" was the term he used), designed expressly for viewing pictures. The proposal passed easily, but not before it sparked a lively discussion, with many members suggesting alterna-tives to it. A few members even toyed with the possibility of a British Louvre: instead of spending public money on a new building, they argued,

why not put the collection in one of those royal buildings already maintained at public expense? Indeed, as one speaker noted, Buckingham Palace would make a splendid art gallery – it already had suitable space and, as a public art museum, it would be bigger and better than the Louvre! It was Joseph Hume who took the idea to its logical and radical conclusion. Since the nation needed a new art gallery, and since the government spent huge sums to maintain royal palaces which royalty rarely or never occupied, why not pull down a palace and build an art gallery in its place? In Hume's view, Hampton Court, Kensington Palace, or Windsor Castle would all make fine sites for a new public space.[60] Hume's proposal could hardly have been serious. But it does expose, if only for an instant, an impulse in the very heart of Parliament to dramatically displace vulnerable symbols of British royalty and claim their sites for the public.

As the new building on Trafalgar Square progressed, radical and reforming members of Parliament again concerned themselves with the National Gallery. In 1835, they created a select committee of the House of Commons and charged it to study the government's involvement with art education and its management of public collections.[61] The committee was full of well-known radicals and reformers, including William Ewart, Thomas Wyse, and John Bowring, long an editor of the influential Benthamite organ, the *Westminster Review*. The committee's immediate purpose was to discover ways to improve the taste of English artisans and designers and thereby improve the design and competitiveness of British manufactured goods. Its members, however, were equally intent on uncovering the ineptitude of the privileged gentlemen to whom the nation's cultural institutions were entrusted.

To the committee, the management of the National Gallery was a matter of significant political import. Most of its members were convinced that art galleries, museums, and art schools, if properly organized, could be instruments of social change capable of strengthening the social order. The numerous experts called in to testify to this truth repeatedly confirmed the committee's already unshakable belief that the very sight of art could improve the morals and deportment of even the lowest social ranks. Not surprisingly, the committee found the nation's improving monuments to be seriously mismanaged by their inept aristocratic overseers, who allowed entry fees and other obstacles to keep out most of the people. These issues were aired not only in the Select Committee *Report* of 1836 and its published proceedings, but also in subsequent parliamentary proceedings, in other public meetings, and in the press at large.

Reforming politicians were not only concerned with the utilitarian benefits of art. They also believed that culture and the fine arts could improve and enrich the quality of national life. To foster and promote a love of art in the nation at large was political work of the highest order. Thomas Wyse, a member of the Select Committee of 1836 and well known as an Irish reformer,

addressed these concerns at some length in his public speeches. In 1837, he spoke at a gathering called for the purpose of promoting free admission to all places in which the public could see works of artistic and historical importance. The real issue in the question of free admission, argued Wyse, was the conflict between the needs of the nation and the interests of a single class. The outcome was important because art, far from being a mere luxury, is essential for a civilized life. Art is "a language as universal as it is powerful," said Wyse; through it, artists leave "an immediate and direct transcript" of moral and intellectual experience that embodies the full nature of man. The broad benefits of art therefore belong by natural right to everyone – the nation as a whole – and not just to the privileged few.[62] As Wyse argued elsewhere, however great English commercial achievements, no nation is whole without the arts.

> Rich we may be, strong we may be; but without our share in the literary and artistic as well as scientific progress of the age, our civilization is incomplete.[63]

For Wyse, as for many other reformers of his day, progress toward this goal could be brought about only by removing from power a selfish and dull-witted aristocracy and replacing it with enlightened middle-class leadership. These ideas run through the Select Committee hearings of 1835 and its *Report* of the following year. Radical committee members pounced on anything that could demonstrate the ill effects of oligarchic rule, anything that, as one member put it, showed the "spirit of exclusion in this country," a spirit that had allowed art-collecting gentlemen to monopolize the enriching products of moral and intellectual life.[64]

It was just now that the National Gallery, having lost its house in Pall Mall, was on the point of moving into its new building on Trafalgar Square.[65] The coming move provided an excellent opportunity to ask whether or not the National Gallery could be called a truly *national* institution. Here, certainly, was an entity purporting to serve the cultural needs of the nation. But did its planners and managers understand those needs? Alas, as so many testified, prompted and prodded by Ewart and the others, the National Gallery was a sorry thing compared to the Louvre, to Berlin's Royal Gallery, and to Munich's Pinakothek, the new picture gallery built as a complement to the Glyptothek. As the eminent picture dealer Samuel Woodburn said, "from the limited number of pictures we at present possess, I can hardly call ours a national gallery."[66] But it was not merely the small size of the collection that was wrong. As the Select Committee made plain, it was not enough to take a gentleman's collection and simply open it up to the public. In order to serve the nation, a public collection had to be formed on principles different from a gentleman's collection. It had to be selected and hung in a different way. And that was the crux of the problem. So testified Edward Solly, a former timber merchant whose famous picture collection, recently sold to Berlin's

Royal gallery, had been formed around advanced art-historical principles. Solly noted that whereas other nations gave purchasing decisions to qualified experts, in England the "gentlemen of taste" who made them – creatures of fashion with no deep knowledge of art – were hardly up to the serious mental task of planning an acquisition program for a national collection worthy of the name. Solly's opinion was inadvertently backed by the testimony of William Seguier, the first keeper of the National Gallery.[67] Grilled at length, his ignorance of current museological practices was of great political value to the Committee. No, admitted Seguier, there was no plan for the historical arrangement of pictures according to schools. No, nothing was labeled (although he agreed it was a good idea), and no, he had never visited Italy, even though, as everyone now knew, Italy was the supreme source for a proper, publicly minded art collection. Nor was there any rationalized acquisitions policy, so that, as keeper, Seguier had been helpless to watch the build-up of Murillos and other things inappropriate to a national collection while nothing whatsoever by Raphael was acquired.

And what should a national collection look like? The Committee was well informed about continental museums and frequently cited the Louvre as a model of museum arrangement and management.[68] Although no one from the Louvre testified at the hearings, the Committee did have two renowned museum experts on hand. One was Baron von Klenze, director of Munich's new museum. His descriptions of its art-historical arrangements and labeling, not to mention its fire-proofing, air-heating, scientifically researched lighting and color schemes, inspired much admiration and envy. The other star witness was Dr. Gustav Friedrich Waagen, a leading art-historical authority and director of the Royal Gallery at Berlin. He told the Committee that a public collection had to be historically arranged so that visitors could follow "the spirit of the times and the genius of the artists." Only then would they experience art's harmonious influence upon the mind. Dr. Waagen also insisted that early Renaissance art was necessary to a good collection, as were representative works from even earlier times. The point to be made (and the Committee made it repeatedly) was that the traditional favorites among gentleman collectors, what still passed among them as "good taste," would no longer do. The Committee therefore recommended that the National Gallery change its course and focus its efforts on building up the collection around works from the era of Raphael and his predecessors, "such works being of purer and more elevated style than the eminent works of the Carracci."[69] A taste for Carracci was now disparaged as evidence of class misrule.

The Committee published its report in 1836, but the objectives for which it struggled were far from won. It would in fact require decades of political pressuring and Select Committee probings before the National Gallery would conform to the type developed on the continent. Although it would always

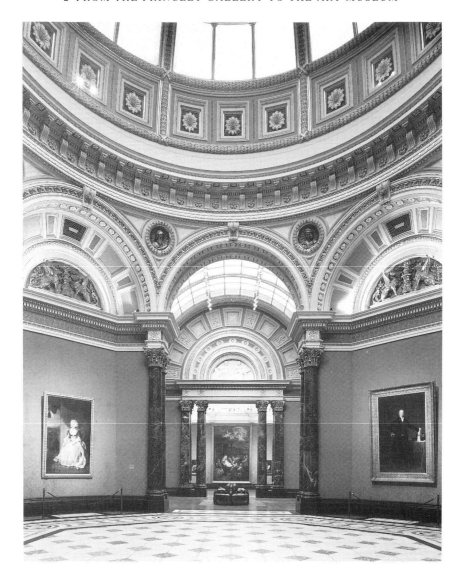

Figure 2.7 National Gallery, London, the Barry Rooms (reproduced by courtesy of the Trustees, the National Gallery, London).

be a picture gallery (and never a universal survey museum like the Louvre), it would eventually become one of Europe's outstanding public art museums, complete with elaborate genius ceilings and sumptuous galleries (Figure 2.7) in which the history of art unfolds with the greatest possible quality and abundance. It is significant, however, that it would become a fully realized civic ritual only in the third quarter of the nineteenth century, the same era that brought universal male suffrage to much, if not all, of Britain. That is to say, the National Gallery came to rival the Louvre only when political developments forced the British state to recognize the advantages of a prestigious monument that could symbolize a nation united under presumably universal values. As the historian E. P. Thompson has noted, it is a peculiarity of British history that the formation of the bourgeois state – and of its supporting culture – evolved slowly and organically out of a complex of older forms.[70] So, too, the evolution of its National Gallery. However protracted, piecemeal and partial the process, eventually, in Britain as in France, the princely gallery gave way to the public art museum.

3

PUBLIC SPACES, PRIVATE INTERESTS

Municipal art museums in New York and Chicago

We have in America made-to-order museum collections imitating similar collections in Europe. As one American city after another becomes the home of wealthy citizens, they hasten to gather valuable collections and to house them in buildings of great cost and of a style that convention demands, with the unfortunate result that each newly filled American museum has a collection of ancient, unique, and highly priced objects which is inferior to the one that last preceded it in the collecting process.

John Cotton Dana[1]

New York's Metropolitan Museum of Art was born in Paris in 1866, at a Fourth of July celebration dinner. It was proposed by John Jay, a prominent New Yorker who thought that America's first city should have a cultural monument worthy of its importance, one that (at some future date) would hopefully rival the Louvre and other great European art museums. Jay did not speak idly. On his return, he called meetings and organized committees of influential men.[2] Clearly, the time for such an institution had come. New York's men of wealth and power would bring the new museum into existence with relative ease, as would similar men create similar institutions in Boston, Chicago, Saint Louis, Philadelphia, Detroit, and other major American cities. Indeed, for several decades, something like a museum-building fever took hold of well-to-do urban Americans. As one observer remarked,

> For the people of our cities, having achieved city halls, public libraries, union stations, and hotels with hot and cold water in every room, have now determined that they want art museums, and having so determined, are getting them with remarkable speed.[3]

Although there were some older public art collections in America, the post-Civil War museums mark a new departure in American museum building.[4] Significantly, the kind of large-scale art museum that in Europe became an indispensable feature of state capitals appeared not in Washington, DC, still

a sleepy little city, but in the northern cities, where business and banking elites were concentrated enough to support such expensive and ambitious cultural enterprises.[5] The outstanding examples of these new museums are the first three, all of them founded in the 1870s: New York's Metropolitan Museum of Art (hereafter "the Met"), Boston's Museum of Fine Arts, and Chicago's Art Institute. All three grew quickly. By 1880 the Met had outgrown its original town house and moved into a free-standing building in Central Park, where it would continue to expand. Boston's Museum of Fine Arts and Chicago's Art Institute similarly outgrew smaller quarters and built impressive and spacious neo-classical structures situated in public parks. This chapter looks mostly at the Met, but also at Chicago and, occasionally, Boston.[6]

In late nineteenth-century America, when the boom in museum building began, the idea of the public art museum as a site of learning and uplifting pleasure – a palace that offers its treasures to all who enter – was enormously attractive. This museum model, consciously borrowed from Europe, conceives the public art museum as a ritual that makes visible the ideals of a republican state, frames the "public" it claims to serve, and dramatizes the unity of the nation. To be an effective civic symbol of this kind, the museum had to construct the visitor as an ideal bourgeois citizen, an individual with interests and needs very different from those of the courtier or aristocratic visitor implicit in older displays of art. As implied by the museum, this visitor was, at its most ideal, a self-improving, autonomous, politically empowered (and therefore male) individual who enters the museum in search of moral and spiritual enlightenment. As a dramatic field, the public art museum prompts visitors to enact – and thereby ritually assume – this identity.

By the late nineteenth century in both Europe and America, museum officials everywhere took it as a given that public art museums were obliged to meet the needs of this bourgeois citizen. A consensus was reached that what best met his needs (and most distinguished the citizen-oriented museum from its princely and aristocratic antecedents) was an art-historical arrangement. As we have seen in Chapter 2, this new arrangement could became politically mandatory. It stood not simply as a modern, "scientific" alternative to princely or gentlemanly collections but as an explicit rejection of the political values implicit in those older kinds of collections. So urgent was its symbolic import, that in the course of the century, even royal collections were rehung chronologically and by school. Eventually, art history would seem the most natural way to order a national gallery. On both sides of the Atlantic, a proper art museum was expected to unfold for the visitor the origins and development of the schools, highlighting whenever possible their outstanding geniuses. As we have seen, the supposition was that by walking through this history of art, visitors would live the spiritual development of civilization. In the United States as in Europe, Italian Renaissance and classical art were accorded privileged places as *the* defining moments of a universally attainable principle of civilization. Even after this evolutionist view lost ground to more

relativist concepts of the different "schools," displays of Italian Renaissance and classical art continued to be the most authoritative demonstrations that state (or city) authorities were providing their citizens with the highest of goods. These ideas were adopted more or less whole in the United States but, as we shall see, they were also mixed with other ideas.

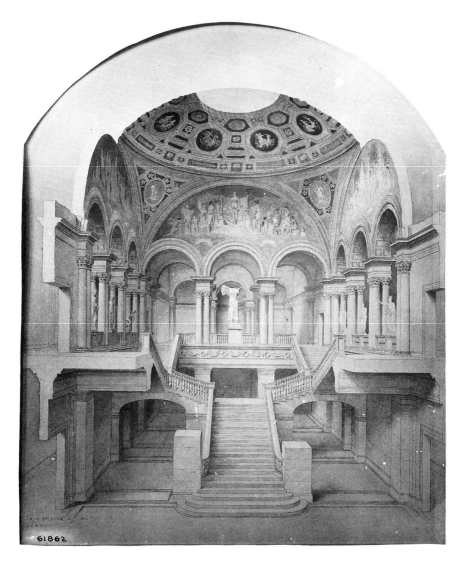

Figure 3.1 Proposed Staircase and Dome for the Art Institute of Chicago (un-executed), ink and wash drawing by Robert C. Spencer, Jr., from the office of Shepley, Rutan, and Coolidge, architects, 1894 (photo copyright 1994, The Art Institute of Chicago, all rights reserved).

An 1894 drawing (Figure 3.1) of a grand staircase, planned for Chicago's Art Institute, tells us much about the ambitions of the wealthy American businessmen who backed new art museums everywhere. In Chicago, these same men also financed the famous White City of the 1893 World's Columbian Exposition. In fact, the Art Institute building, still a shell in 1893, had housed some of the Fair's downtown offices and exhibits. Its proposed new stair was obviously a reference to the Louvre's Daru Staircase of 1876 (Figure 2.3). It borrowed from it not only its dome and the idea of multiple stair flights (albeit reduced in size and number), but also its mosaic decorations (since removed but much admired in the late nineteenth century). The dome and mosaics were finally dropped, but the reference to the Louvre hung on in the stair design and the plaster copy of the *Victory of Samothrace* that was placed on the landing (Figure 3.2). Meanwhile, the building's exterior, a nineteenth-century *beaux arts* version of an Italian Renaissance palace, quotes freely from the classical past, incorporating arcades from the Library

Figure 3.2 The Art Institute of Chicago's Grand Staircase, *c.* 1910 (photo copyright 1994, the Art Institute of Chicago, all rights reserved).

51

Figures 3.3 Art Institute, Chicago (photo: author).

Figure 3.4 Art Institute, Chicago, detail of south facade (photo: author).

Figure 3.5 Metropolitan Museum of Art, New York: the Great Hall (photo: author).

of San Marco in Venice and pastiches of the Parthenon's inner frieze (Figures 3.3 and 3.4). Clearly, Chicago's business elite wanted it known that, as one speech-maker of the time put it, art and culture had arrived to "crown [Chicago's] commercial life as was crowned the commercial life of Athens and Florence and Venice."[7]

At the same time, New York's cultural ambitions were taking even more grandiose shape in the Met's new Fifth Avenue wing, which took its inspiration from an ancient Roman bath (Figure 3. 5). Soon after, Boston's Museum of Fine Arts, having finally outgrown its building on Copely Square, moved to a dignified classical structure in Fenway Park. To fill these and other new museum buildings in other American cities, millionaire Americans embarked on extravagant shopping tours, combed Europe for art, bought in bulk, and shipped home as much of it as money could buy. They earmarked profuse quantities of it for their own mansion dwellings, but they also sent literally tons of it at a time straight into their new municipal museums.

It should be said at the outset that, whatever these American Louvres owe to European models, they did not arise from the same historical experience. As we have seen in Chapter 2, the founding and shaping of the Louvre Museum and the National Gallery in London were strongly associated with bourgeois political struggles for civic power. In their different ways, those monuments commemorate a triumph over the principle of aristocratic privilege and exclusivity. American public art museums like the Met or the Art

Institute were not founded in competition with or in opposition to important, already-established ritual art spaces. Nor can the men who founded them be considered a radical or liberal opposition. Americans might borrow the forms of European national galleries, but in the New World, those forms would take on peculiarly American meanings, even as they affirmed to an international community the identity of the United States as a full-blown bourgeois society, an equal among other great nations of the western world.

The motives of the American bankers and business tycoons who founded public art museums were both complex and contradictory, a mix of personal and public ambitions, elitist and democratic sentiments. As we shall see, that complexity is visible in the often contradictory scenarios that structure public art museums to this day. Certainly, as their founders often avowed, the new institutions were meant to make the cities of the United States more civilized, beautiful, and knowledgeable, more like the cultural capitals of Europe. When Joseph Hodges Choate, a distinguished lawyer and Met founder, declared that "knowledge of art in its higher forms of beauty would tend directly to humanize, to educate and refine a practical and laborious people,"[8] he spoke the convictions and longings of many men of his class that art and art museums would somehow transform American cities by lifting the souls of their inhabitants above the material concerns of life.

Lofty sentiments such as these were frequently and fervently voiced in these years. No doubt they were sincerely embraced by many of the men who brought the new institutions into existence, often with great labor and cost to themselves. However, as J. P. Morgan once said, "a man always has two reasons for the things he does – a good one and the real one."[9] Besides their civilizing powers, art museums and the high-cultural products they contained also conferred social distinction on those who possessed them, as Thorsten Veblen exhaustively argued in his biting and much-read book of 1899, *The Theory of the Leisure Class*.[10] Moreover, a big, showy art museum could announce to both national and international business and banking communities the arrival of a city financially and politically. The Republican bankers, merchants and lawyers who founded the first great American public art museums had certainly arrived economically – they owned or controlled vast shares of American capital. Now they were in the process of securing both their political base and their social prestige. The power of high culture to identify them as members of an elite social network with international connections was not simply a luxury; it was necessary to their political and economic objectives.

The new institutions could be useful to elite groups in yet another way. Even while they reinforced class boundaries, municipal art museums could appear as unifying and even democratizing forces in a culturally diverse society. After all, their purpose was to disseminate a single high culture to one and all. In fact, what they disseminated was western European high culture, the culture of the Protestant elites, but they identified it as the

definitive *national* culture, the highest philosophical and moral heritage of "the American people." Public art museums could thus provide elites with clear class boundaries, while simultaneously giving them an identity that was seemingly above class interests.[11]

The creation of an official, institutionalized high culture must be seen in relation to the ever-growing waves of immigrants – Irish, Jews, Italians, Poles, and other groups – that swelled American cities and more than doubled their working-class populations in the later nineteenth and early twentieth centuries.[12] Crowded into shantytowns and tenements, this diverse population was remaking American cities, changing their look and sound, transforming their politics (often electing machine bosses to office), and organizing their industrial labor forces. As historians agree, the presence of immigrants and the poor excited immense anxiety in the older population. To native-born, Anglo-Saxon Protestants, the working poor, much of it foreign, often appeared like a rising tide that threatened not only their cultural identity but also their property and political base. To them, the working poor loomed as a dangerous presence that was openly disrespectful of established authority and all too ready to instigate strikes, riots, and the like.

To be sure, there were other critics who thought that big business, with its spectacular greed and wasteful consumption, was equally if not more threatening to the social order and that heavy industry's compulsive drive toward monopoly was far more politically corrupting.[13] But for most people, it was the poor and the foreign, not a corrupt and corrupting rich, who raised fears about urban squalor, the deterioration of civic order, and the dissolution of national identity. So the *New York Times* in 1889:

> The great foreign population, largely uneducated, has so upset municipal politics that it is hard for an American of education to be firmly friendly to the civic majority. Immigration causes the gulf between two sections of the people to remain constant, and the corruption of city politics does not mend matters.[14]

The new public art museums were but one element of a larger agenda to make American cities more civilized, sanitary, moral, and peaceful. The same men who created the Met and other public art museums also created parks and libraries, symphony halls, and Grand Army Plazas.[15] Indeed, they backed almost anything that they thought would make their cities more dignified and efficient – from new sewers and schools to better-looking lamp posts. From the turn of the century through and beyond World War I, from the City Beautiful Movement through progressivism and various urban reform initiatives, wealthy, respectable businessmen steadily sought to create, shape, and control a public culture and its ceremonial spaces.[16] It should be emphasized that the men who undertook this labor were, like the influential New England intellectual Charles Eliot Norton, overwhelmingly convinced that only Anglo-Saxon, New England "stock" could properly rule the nation and define its

culture. Their many philanthropic efforts to educate and Americanize the immigrant masses were born as much of fear as of goodwill and were aimed at engendering feelings of patriotism and allegiance to established civic authority. This is not to say that the WASP elites were always necessarily insincere in their espousal of democratic ideals, but that, intentionally or not, their pursuit of those ideals in educational and philanthropic efforts were structured to advance the cause of WASP supremacy.

Much hope was placed in the power of culture to mould newcomers into citizens and unite warring classes into a single, harmonious nation. Educated Americans, like educated Europeans, incessantly evoked the improving power of art objects, whose display presumably could produce Anglo-Saxon moral and social values in beholders, strengthen their ties to the community, and even help the economy by stimulating a taste for more artfully designed and internationally competitive goods.[17] But while the transforming power of art was taken for granted as the public art museum's reason for being, in reality, poor people wishing to visit their city's museum often faced barriers. The Met charged an entry fee on most days. In addition, for the first twenty years of its existence, it was closed on Sundays, despite massive political and popular demands that it be open on this, the only day that most working people could go. Finally, the location of the Met way uptown made it difficult to get to. Similarly, Boston's Museum of Fine Art was built in what was for most people a remote park.[18]

As these instances show, decisions made by museum trustees behind closed doors often contradicted their public rhetoric about the museum's mission to serve the entire community. The official, published record almost never admits to class, ethnic, or racial biases. One of the very few instances I have found is a review by Charles Loring of the Boston Museum of Fine Arts. Discussing Harvard University's new Fogg Museum, Loring made no bones about his dislike of museums that attracted an "immigrant population" or what Loring regarded as any other vulgar, thrill-seeking crowd out to gawk at displays of treasure. He liked the Fogg's quiet, well-mannered look, which suggested to him "a very rich and exclusive metropolitan club house," with nothing spectacular about it, "nothing to lure the average man in the street off the street." (In fairness, it should be added that Loring's view of the vulgar majority included most of Harvard's students, who, along with immigrants, pleased Loring most by staying out of the museum.)[19]

More usually, public pronouncements by museum officials in New York, Chicago, and Boston consistently described the art museums of those cities as educational institutions to which everyone was welcome. Indeed, all three museums made occasional attempts to broaden their audiences. But the main task of educating and Americanizing the immigrant masses was left to other kinds of institutions such as schools and settlement houses. Whatever their stated intentions and whatever the sentiments of their benefactors, the social value of public art museums depended precisely on their exclusivity, their

56

ability to mark and maintain the gulf that, as the *Times* put it, divided "Americans of education" from foreign immigrants.[20] Their most successful efforts to increase attendance were aimed at the middle classes, the natural social and political allies of the WASP elite. Not surprisingly, in New York as in Chicago and Boston, the public art museum quickly established itself as a haven for the genteel and the educated.[21]

Yet, no matter how exclusive their practices, American public art museums would have to *appear* inclusive and democratic in order to effectively symbolize community and define national identity. To thrive as art collections, they needed money and art from the rich, but to work as ideologically effective institutions, they required the status, authority, and prestige of public spaces. However much they catered to elites, museums had to appear, at least to the middle class and their press, as credible public spaces, above politics and class interests and accessible to all.

The men who built and backed them took care to make their art museums demonstrably public. They almost always built them on public land and usually with at least some public money, a circumstance that gave substance to their claim that museums belong unequivocally to the public realm. At the same time, however, the management of museums together with the ownership of their collections usually remained firmly in the hands of autonomous, self-perpetuating boards of trustees. This mix of publicly owned space and private, restricted management successfully kept the new institutions outside the jurisdiction of often hostile city politicians (like New York's notorious Boss Tweed).[22] Above all, it created a ceremonial space in which museum culture could appear as a truly public and disinterested realm of culture. On occasion, however, insensitive or politically clumsy trustees could jeopardize even the appearance of publicness.

During the Met's early years in Central Park, many of the patrician gentlemen who dominated the museum's board could barely conceal their view that the museum was a private, not a public space. In 1881, the *New York Times* complained that the Met, although "founded ostensibly for the freest use of the public," was actually less accessible

> than similar institutions in monarchical Europe. Here, where we are forever bragging of freedom, liberty, and the education of the masses through free schools and the ballot, our institutions of higher culture are more retroactive, more "aristocratic" if you will, than those of Europe.[23]

What occasioned this assertion was the museum's refusal to open its doors on Sunday, but the larger question the Met's stubbornness raised was whether the museum belonged to the "public" or to its trustees. The *New York Times* (among other newspapers) relentlessly assailed the obdurate trustees for thinking they owned the museum. According to the *Times*, one of them flatly declared the museum "a private affair and . . . in no sense a public institution," while another asserted that where the Met is concerned "the

public has no rights."[24] The reformist, Republican *Times*, normally a class ally of the Met's trustees, was rightly alarmed that the museum was losing credibility as a public-looking institution.

The Met's younger trustees, more forward-looking and attuned to the newer ideological needs of corporate capitalism, shared the outlook of the *Times*' editors.[25] When their turn came to manage the museum, they kept its image securely and unequivocally public, tirelessly representing the museum as "essentially a public institution, a museum of the people, sustained largely by the people and administered for the people."[26] To quote one city official in 1902:

> Art no longer ministers solely to the pride and luxury of the rich, but it has become to the people their best resource, and most efficient educator. If, as we believe, it is within the real objects of government to raise the standard of its citizenship by furnishing educational advantages to the people, then no expenditure of the city could be more wise or profitable than the building of this home for the magnificent art treasures which have been collected here.[27]

The Met's long-time president Robert De Forest frequently discoursed on the museum's democratic character, even declaring that access to it was a fundamental American right:

> Every man, woman, and child . . . has an inherent right to be able to see . . . good works of art. . . . It is part of the 'pursuit of happiness' which our Declaration of Independence declared to be our American birthright.[28]

And, on another occasion, he called the Met

> essentially a people's museum. It is not a private gallery for the use of our Trustees and members. It is a public gallery for the use of all the people, high and low, and even more for the low than for the high, for the high can find artistic inspiration in their own homes. The low can find it only here.[29]

There is no reason to doubt the sincerity of the Met's trustees in their espousal of this democratic ideal. In a city so ethnically diverse and politically divided as New York, and at a time when the tensions between classes could easily turn violent, the ideals of social harmony and political equality must have had powerful appeal indeed. To these upper-class gentlemen, the museum might well have been a space that could turn those ideals into vivid and lived experience, a space that could ritually banish differences and give all and sundry equal title to the highest spiritual treasure. Undoubtedly, the utopian vision implicit in the museum ritual was deeply compelling for this era. In a popular book of 1912, Mary Antin's *The Promised Land*, a young Jewish immigrant articulates that meaning in a similar kind of liminal space:

I loved to lean against a pillar in the entrance hall, watching the people go in and out . . . and remind myself that I was there, that I had a right to be there, that I was at home there. All these eager children, all these fine-browed women, all these scholars going home to write learned books – I and they had this glorious thing in common, this noble treasure house of learning. It was wonderful to say, *This is mine*; it was thrilling to say, *This is ours*.[30]

It is perhaps significant that this passage describes Boston's magnificently decorated Public Library and not its Museum of Fine Arts. Although art museums could also have claimed to be houses of learning for all who enter, in Boston as in New York and Chicago, immigrants seeking enlightenment were more likely to enter the public library than the museum.[31] The fact was that they were not welcome in public art museums. In New York, for example, even the Met's liberal supporters were relieved that the museum's long-awaited Sunday openings did *not* attract "Essex Street Polish Jews and Thirty-ninth Street and Eleventh Avenue [Irish] hod carriers in ragged clothing and dilapidated hats."[32] As for the crowds of poor people who did appear on those first open Sundays in 1891, they quickly dwindled, and the museum went back to being an exclusive space for the "respectable classes." The educational program aimed at artisans was quietly discontinued, while lectures on such genteel subjects as lace and textiles continued.[33] The museum was learning that it could appear to be serving the public at large without greatly compromising its aura of exclusivity.

In their earliest years, big city art museums like the Met were more impressive as buildings than for the art inside them. The Chicago Art Institute made it a policy to build first and collect later on the theory that an expensive, showy building would draw the interest of wealthy collectors. The theory proved correct.[34] In Boston and New York, too, millionaires stood ready to lend or give collections of "old masters" (or what passed for them) or of "modern" French art – usually a mix of Barbizon School and Salon painting picked up on trips to Paris.[35] Besides paintings, the new museums filled up with bronzes, porcelains, tapestries, pewter, laces, and every other kind of thing deemed collectable by the wealthy. Major bequests were front page news and brought enviable celebrity and acclaim to their donors as benefactors of the public and persons of museum-quality taste.[36]

Early on, however, knowledgeable critics began complaining about the inadequacy of the museum's collections and organization and its lack of professional and aesthetic standards.[37] The main object of such complaint was the museum's director, Luigi P. di Cesnola. A former American consul to Cyprus, during his years of service, he had amassed a large collection of ancient Cypriot sculpture. The Met not only bought Cesnola's collection, it also named him president of the board and, in 1879, director.[38] Installed in

the new Central Park building, the Cypriot marbles almost immediately became the focus of controversy. Cesnola had apparently sold the Met a number of statues pieced together out of unrelated fragments. Accusations of fraud and chicanery filled the press for weeks. The scandal deepened when the Met's trustees exonerated Cesnola in what the press described as a cover-up.[39] More trouble came in 1905. Apparently, Henry Marquand, one of the museum's most illustrious benefactors,[40] had knowingly given the museum paintings falsely attributed to renowned old masters and then ordered the museum staff not to investigate them. *Nation* magazine, commenting on the episode, urged that the museum be put in the hands of professional curators who would serve the interests of the public and not those of private individuals.[41]

At issue was the credibility of the Met as a public art museum. If the Met was to be worthy of New York, it would have to conform more closely to international public art museum standards. The educated, elite gentlemen that interested themselves in such matters were perfectly familiar with what was wanted. In effect, credibility meant art history: the museum would have to acquire more and better-authenticated examples of the major European schools; it especially needed more classical and Renaissance art; and it would have to display these schools in art-historical order. Only then would visitors be engaged as enlightenment-seeking citizens of a municipality committed to providing for their moral and spiritual enrichment – in short, a city as good as any in Europe. It was especially the Met's younger trustees who understood these requirements and who would soon make them the museum's official policy.[42] It was, of course, understood that good collections of validated European paintings would take time to acquire. But thanks to modern methods of plaster casting, one could purchase entire ready-made sequences of famous monuments of western sculpture. They filled halls in almost every public art museum, including the Met's grand entry hall, and, until they fell out of favor, helped legitimate American museums.[43] Such legitimation, however, brought new difficulties.

The more art museums achieved credibility as public spaces, the more attractive they became to collectors seeking personal and family memorials. There were, of course, enlightened donors who helped museums fulfill their public missions by giving unearmarked cash or buying works needed to fill gaps in the collection's art-historical survey.[44] Others, however, took to leaving their hoards to museums on condition that they be displayed in total, in perpetuity, and in rooms reserved exclusively for them. Very quickly, such gifts turned public art museums into a series of separate, jealously guarded terrains, each one crammed with what one critic, speaking of the Met, called a "hodge-podge of bric-a-brac"[45] and another, speaking of Boston, described as a cemetery lot:

It was recognized that one room belonged to this family and another to

that. They had a prescriptive right to arrange and contribute what they would and exclude the rest, by right of birth they were experts in their corner or corridor and would hesitate to visit another lot in the cemetery unaccompanied by the representative of its tribal chief.[46]

Chicago's Art Institute was similarly divided. While the ground floor presented a unified – if plaster – history of sculpture from ancient Egypt to the present,[47] the majority of rooms upstairs held restricted collections that could not be broken up or loaned or even stored away. The socially prominent families that controlled these galleries outdid each other in fitting them out, often hiring fashionable decorators like Tiffany Studios.[48] At one point, three such sumptuously appointed galleries were controlled by Samuel Nickerson, a retired banker, who insisted that his gift of modern paintings and far eastern objects be displayed together. Mrs. Nickerson personally supervised their periodic cleaning and rearranging.[49] The Lucy Maud Buckingham Memorial Rooms, opened in 1924, similarly contradicted the museum's educational pretensions. Its two rooms were connected by an ancient Chinese doorway, which led from a collection of far eastern bronzes into a room whose architectural detailing, according to the museum's *Bulletin*, was "suggestive of the great hall of a large French medieval dwelling or *château*."[50] Meanwhile, in New York, Herbert Bishop, a Met trustee, gave the museum his jade collection on condition that it be shown in its customary setting. Accordingly, the museum built a replica of the Bishop mansion ballroom in its new East Wing and installed the jades in it.[51] The Met, complained one critic, was in danger of becoming

> not so much an institution for the instruction and the pleasure of the people as a sort of joint mausoleum to enshrine the fame of American collectors."[52]

Such ostentatious donor memorials clearly threatened the museum's credibility as a public art museum. Designed to stand out as distinctive, each gallery introduced into the museum a ritual scenario that sharply contravened the civic ritual. Having beckoned you to enter the museum on equal terms with others, having promised a program of art-historical genius – the only program proper to enlightenment-seeking citizens – and even having emblazoned that program across the museum's facade in the form of artists' names (as in Chicago), or their portraits (as in New York), the museum now casts you as a visitor come to admire the possessions of a particular family or individual important enough to claim a semi-private precinct in the midst of a public, presumably educational space. The Bishop jades, the Buckingham bronzes or the Nickerson Corot may well merit serious attention. But when exhibited together with art-historically unrelated objects for the sole reason that a particular individual owned it all, or when they are kept in a ballroom because that is where he kept them, their value as objects of aesthetic or

art-historical contemplation can be easily swallowed up by their memorial-izing function. Especially when the installation replicates or suggests the donor's private dwelling, his former possessions inevitably conjure up his spirit, conferring upon it a kind of immortality.

The more space awarded to such collections, the less convincing the museum's meaning as a public institution – and the greater the difficulty of restoring its integrity as a civic ritual. To turn things around would mean checking the ambitions of the very millionaires who most supported the museum, a task that would require extraordinary leadership. In New York, that job fell to no less a figure than J. Pierpont Morgan, president of the Met from 1904 to 1913.[53]

When, at the age of sixty-seven, he took office, Morgan's mastery of finance capitalism had long been legendary. His fame had especially soared in the 1880s when he had imposed financial order on the nation's warring railroad barons. Convincing the most powerful of them to end the practice of pirating each other's businesses, Morgan had showed them how to divide the market peacefully and rationally, thus stabilizing a key center of international investment banking and laying the groundwork for the monopolistic control of railroad rates. More recently, having put together what was the world's largest trust – the US Steel Corporation – his reputation as the mightiest of the lords of finance had reached its zenith. Morgan, who had already taught fellow capitalists the advantages of cooperation in controlling industry and commerce, would now teach many of the same men the social and ideological advantages of class solidarity in the public display of art. In short, Morgan, the master trust-builder, would now "trustify" the Met.

A member of the Met's board for some fifteen years, Morgan had been one of the museum's more forward-looking trustees. He had understood the ideological shortsightedness of allowing the museum to become too obviously a "joint mausoleum" for American millionaires. Certainly he knew the allure of a donor memorial; his own, the Morgan Library (discussed in Chapter 4), is one of New York's most imposing. But he built it on Thirty-sixth Street, next to his Madison Avenue house, not inside the Metropolitan Museum of Art, whose integrity as a public space he took steps to protect. On taking office as president, he announced a new policy: from now on, the Met's central obligation would be the display of authenticated, high-quality works of art, historically arranged by professional museum men. So declared the museum's *Annual Report* of 1905, the first one issued by the new President:

> It will be the aim of the Trustees not merely to assemble beautiful
> objects and display them harmoniously, still less to amass a collection
> of unrelated curios, but to group together the masterpieces of different
> countries and times in such relation and sequence as to illustrate the
> history of art in the broadest sense, to make plain its teaching and to
> inspire and direct its national development.[54]

Morgan also specified that art from Egypt and classical antiquity and painting and sculpture from Europe would be the base of all the other collections.

Morgan moved swiftly to reorganize the museum staff and hire professionals. Sir Casper Purdon Clarke, formerly head of the Victoria and Albert Museum, became director, and the young Roger Fry became curator of paintings. Then, mobilizing his enormous prestige, Morgan persuaded both present donors and the heirs of past ones to remove restrictions from their collections so that the museum could integrate their contents into its art-historical galleries. Finally, future donors were notified that the museum was not interested in restricted benefactions. Previously, donors earned distinction simply by giving art to the museum. Now, under Morgan's reign, one earned even greater distinction by an unrestricted bequest.[55] Thereafter, the museum would display most of its paintings art-historically, blending what restricted collections remained into the larger scheme. A few years later, Boston took steps to integrate its collections. Chicago would not do so until 1933.[56]

By 1910, a newly reinstalled Met could boast a more or less unified, knowledgeably arranged, art-historical tour (although not absolutely historical[57]), with substantial displays of Egyptian, classical, and European art, the three collections that most validated the museum as a public space and which, accordingly, were given front and center locations in the museum building. It is significant that through all the intervening years, through numerous expansions and reinstallations, the 1910 museum still stands as the art-historical nucleus around which the later museum and its many wings developed. The classical collection continues to dominate the south wing of the Fifth Avenue building, the Egyptian collection the north, and upstairs, European paintings unfold chronologically and by school with the Renaissance still holding the central axis (Figures 3.6 and 3.7).[58] Chinese, Japanese, Islamic, American, Primitive, Modern, and other new sections and wings have been fitted around this canonical core.

But not all of the Met's galleries would be brought into this educational scenario. Pulling the museum in quite another direction were donors in search of personal and family memorials. Their interest created a kind of fault line between the museum's art-historical installations and its decorative arts galleries. Like other American museums, the Met was deeply committed to the decorative arts. In nineteenth- and early twentieth-century museum culture, collections of decorative arts were taken as indisputable evidence of a museum's commitment to public education. In this, American museums looked to the precedent of the Victoria and Albert Museum in London. Everyone knew the rationale for its outstanding displays of textiles, ceramics, ironwork, glass, and the like, objects thought to improve the skills of artisans, raise the quality of manufactured goods, create higher standards of taste, and enhance modern life.[59]

Figure 3.6 A gallery of early Renaissance art in the Metropolitan Museum of Art (photo: author).

Figure 3.7 A gallery of Renaissance art in the Metropolitan Museum of Art (photo: author).

In fact, what public art museums acquired as decorative art usually turned out to be just the things that most interested millionaire collectors in search of aristocratic identities – chairs and silver made for eighteenth-century English noblemen, clocks and china made for French aristocrats, pieces of old castles, Renaissance arms and armor,[60] and anything else that could associate one with a distinctive lineage. Morgan himself gave the Met boatloads of such things. As the museum maverick John Cotton Dana put it,

> The kinds of objects, ancient, costly and imported, that the rich feel they must buy to give themselves a desired distinction, are inevitably the kinds that they, as patrons and directors of museums, cause those museums to acquire.[61]

The museum, having been thus caused to acquire such ancient, costly and imported objects, proceeded to grow pockets and wings seemingly designed to turn it into the very kind of ritual setting *against* which public art collections had first defined themselves. Let us again recall that American public art museums had not begun as oppositional spaces; the businessmen that created them did not live through the historical struggle of their counterparts in Europe. In the words of C. Wright Mills, "The American business elite entered modern history as a virtually unopposed bourgeoisie."[62] It should not be surprising, then, that in their museums they reconstructed just the kinds of socially privileged spaces that, in Europe, had been seen as the antitheses of what public art galleries should be.

So the ground floor of today's Met: away from the Greek and Egyptian galleries, behind the grand stair and under the European painting galleries, sprawls the museum's ever-expanding displays of European decorative arts. Walking through them, the visitor tours rooms from English country houses (Figure 3.8); a dining room from the London house of the Marquis of Lansdowne, designed by Robert Adam, its great table set for guests (Figure 2.6); a bedchamber from a Venetian rococo palace (Figure 3.9); and many, many French rooms, including one with a desk made for Louis XV and another with a dainty, powder-blue, eighteenth-century dog house, signed by its designer. Some of these rooms were purchased from dealers more or less whole; others were assembled by curators from various gifts and bequests. A number of them came straight from the Fifth Avenue apartments or Palm Beach estates of the Met's donors.

Whatever their origins, as installed in the Met, they present an array of socially privileged moments of the past, each one represented as a triumph of discerning taste or splendor. Labels meticulously detail the names of the noblemen who formerly owned each object or ornament. Together, these many rooms function as a kind of cultural trust. They collect and idealize ancestral identities from other times and places – past royalty, aristocracy, or (elsewhere in the museum), well-bred, Anglo-Saxon stock[63] – and ritually transfer them to the conglomerated elites of the present. Of course, some

Figure 3.8 Room from Kirtlington Park, Oxfordshire, England, *c.* 1748, as installed in the Metropolitan Museum of Art (photo: author).

Figure 3.9 Bedroom from the Palazzo Secredo, Venice, *c.* 1718, as installed in the
Metropolitan Museum of Art (photo: author).

individuals might claim more of this identity than others. The collectors Charles and Jayne Wrightsman spent millions of Texas oil dollars surrounding themselves with eighteenth-century French furniture and decorative arts. Objects that facilitated their extraordinary rise to the most glittering heights of international society now fill the galleries that prominently bear their name and permanently enshrine their success.[64] Beyond memorializing individuals, however, these rooms serve what J. P. Morgan might have called a "community of interest."[65] They not only idealize the individuals who might have once lived in them, but they also speak for a class outlook that measures the worth of individuals by the status of their ancestors. Far from being displays of dead objects, as museum displays are often thought to be, these period rooms actively recycle social identities of the past for the benefit of the living.

Public art museums normally construct visitors as citizens who theoretically enjoy equal access to the state's enlightening displays. These rooms, too, are dramatic fields that prompt us to a ritual role. Instead of staging a universe of equals, however, they cast us as outsiders, removed in both time and space from the perfectly ordered, socially ranked worlds into which we gaze. Whereas our ritual task as citizens is to possess in full whatever spiritual goods are laid before us, in these rooms, we are prompted to admire others – those whose rooms these once were. It is they, not we, who do whatever possessing is to be done here. The ropes and barriers, however necessary to protect the displays, give emphasis to the social distance between the privileged spaces into which we look and the public space in which we stand.

In recent decades, the amount of space that the Met has conceded to restricted benefactions has increased. Of these, the Lehman Pavilion is by far the grandest. It has also been the most criticized. Its donor, the banker and art collector Robert Lehman, was hardly the first millionaire who wanted his art collection to serve as a personal memorial. What is notable about his story is not the kind of art he collected – it is a typical, old-fashioned millionaire's collection – nor the quality and magnitude of his holdings.[66] What is notable is the willingness with which the Met's managers granted him an architecturally distinct wing constituting a personal memorial of immense proportions.

The new wing incited fierce opposition and raised issues that sounded very like those first debated when the Met's nineteenth-century patrician trustees ran the museum. Although Lehman money was to pay for the building, its erection in Central Park looked like (and probably was) an illegal encroachment on public land. Aside from its legality, its grandiose scale and its placement as the culminating point in the museum's east–west axis seemed to seriously compromise the public meaning of the Met as a whole. To many, the trustees seemed more solicitous of a banker's vanity than concerned about the public interest. Asked one critic: "Should the destiny of a large public organization be determined by a small group of aristocratic trustees, or should the community have a voice in the decision-making?"[67] Chapter 4 will

examine the Lehman Wing as a memorializing ritual. What needs to be said here is that, first, the new wing contained reconstructions of rooms from the Lehman family mansion (just as, decades before, the museum had replicated the Bishop ballroom to hold a millionaire's jade collection); and, second, the art press did not like them. Critics repeatedly called them tasteless, tacky, and expensively excessive. The *New York Times* critic Hilton Kramer was displeased to see so many undoubted and rare masterpieces forever encased in environments that were visually distracting and inappropriate to a public art museum. Their installation, he wrote, represents a

> surrender to a collector's fantasy, pride and will. . . . It violates the whole spirit of modern museology, which aims to separate the art object from the accidents of ownership and let it stand permanently free in its own universe of discourse.[68]

In these post-Lehman years, donor memorials have returned to the Met with a vengeance. One of them is the Jack and Belle Linsky Collection, opened in 1984.[69] Its several rooms are filled with eighteenth-century furniture (Figure 3.10) and porcelain, Renaissance oils and bronzes, and quantities of extravagantly bejewelled objects made for monarchs and millionaires of the past. It is perhaps significant that this impressive luxury was made possible by the extraordinary market success of a small item not

Figure 3.10 A room in the Metropolitan Museum of Art's Linsky Collection (photo: author).

69

displayed here: the Swingline Stapler. By all reports, both Mr. and Mrs. Linsky went to work in the Long Island City factory that manufactured this product every day of the week up until the time they sold their business. Their museum memorial, however, suggests lives of only the most regal and fairytale rococo splendor. Like the Lehman bequest, their collection is also restricted: its Flemish paintings must be kept forever near the Louis XV chairs and porcelains. Unlike the Lehman bequest, however, it raised almost no protest.[70]

The ideal of the public art museum in America was clearly irresistible, and compelled from its elite supporters a high degree of social and political cooperation. Its success, I believe, lay in its capacity to address and reconcile a variety of contradictory interests. Whatever else it has been, the American public art museum is a monument to the powerful men who not only led the development of American finance capitalism but also understood its cultural and ideological needs.

It appears that in today's Met (as well as in other public art museums in the United States), the desires of "the memorial-seeking rich" (as John Cotton Dana called them), have lately gained ground over the rights of the citizen in quest of enlightenment, the visitor who, as Kramer pointed out, seeks to experience art not as someone else's former property, but "in its own universe of discourse." It is not that Met donors of today are more ambitious, vain, or demanding than past donors. What seems to have changed is the degree of commitment on the part of museum trustees to guard the integrity of the museum as a public space. Compared to the generation of J. P. Morgan and his successor Robert De Forest, today's Met managers seem rather lax, not to say callous, about keeping up even the appearance of a democratic, public space. Apparently, the historical and ideological pressures that once made those ideals so politically urgent – and therefore so central to the museum's defining ritual – have faded. If the Met's trustees have less commitment to public service than their grandfathers, it is also true that the elitist interests that brought American public art museums into existence now go virtually unchallenged – in the realm of public culture as in the realm of political discourse.

If the enlightenment-seeking citizen has lost ground in the museum's ritual, other kinds of visitors have gained. For one thing, traditional museums now regularly include modern art wings, which bring with them a new scenario that constructs a different ideal visitor (the subject of Chapter 5). For another, museums are increasingly anxious to acknowledge the affluent consumer who enters the museum not only to engage with art, but also to enjoy a pleasant lunch and the opportunity to look over a tasteful array of merchandise – museum-validated reproductions of jewelry, china, and pewter, or tastefully printed scarves, calendars, or note cards. In the Met, a large space just off the Great Hall has recently been opened that caters to the genteel taste of this

consumer, who as marketing experts know, is likely to be over sixty years old and well-off. The museum has also increased the areas in which visitors can eat and drink and the hours in which they can do so (some of these areas are reserved for the more privileged, higher-paying categories of the museum's membership).

Elsewhere, too, the public museum's traditional educational environment has been disrupted or replaced by something more upbeat. Boston's Museum of Fine Arts offers an especially good example of a modernized museum. In the old Boston Museum, everything was organized around the central theme of civilization. Behind the classical monumental entry facade, the entire sequence of world civilizations followed one upon the other, Greece, Rome, and Egypt on one side balanced by Japan, China, and India on the other. The rest of art history came after, all in its proper order, with the Renaissance centrally placed. This arrangement is still intact today, but the recent addition of the new East Wing has seriously disrupted the order in which it unfolds. Because the new wing has in practice become the museum's main entrance, the classical galleries, the old museum's opening statement, now occupy the most remote reaches of the building – remote that is, in relation to the new entrance. The museum's opening statement now consists of a large gallery of modern art, three new restaurants, a space for special exhibitions and a large gift and book store. It has become possible to visit the museum, see a show, go shopping, and eat, and never once be reminded of the heritage of civilization.

4

SOMETHING ETERNAL
The donor memorial

"Railroads are the Rembrandts of investment."

Henry Clay Frick[1]

Just north of Los Angeles in Malibu, California, on a promontory overlooking the Pacific Ocean, a slab of granite marks the grave of J. Paul Getty, the famous oil tycoon and art collector. Nearby stands the J. Paul Getty Museum, a reconstruction of an ancient Roman villa that is filled with art. Several miles to the southeast, visitors to the Henry E. Huntington Art Gallery explore an English country house. Meanwhile, the Frick Collection in New York City is housed in an elegant French-styled villa. In contrast to these highly personal monuments is the Hirshhorn Museum in Washington, DC, a clean-lined, concrete and glass structure holding immense quantities of modern art. Other than the name "Hirshhorn" inscribed on its exterior wall, nothing about its modernist interiors or stark installations recalls particulars of the donor's dwelling.

Like state and municipal art museums, donor memorials frame the activity of looking at art in terms of a ritual scenario. However, as the above sampling suggests, unlike the museums discussed in the last chapter, they cannot be readily defined as a group by their look or collections. Their collections may be encyclopedic or specialized, and their architecture anything from historicist, like the first three examples above, to modern, like the Hirshhorn. Despite their unpredictability, many donor memorials, including most of those discussed in this chapter, are former residences; or they were designed to resemble residences, usually royal or aristocratic dwellings of the past. Thus, a visit to a donor memorial is often structured as a ritual enactment of a visit to an idealized (albeit absent or deceased) donor.[2]

In the United States, such museums were especially fashionable among gilded age millionaires, many of whom were self-made businessmen whose knowledge of high culture was limited but whose willingness to spend money was not. Once they decided to rival the palaces and country houses of European nobility, they went at it with the same single-mindedness and sometimes the same cunning with which they amassed their fortunes. They

bought the best art, retained the best architects, and employed the best art experts that money could buy.

While determined to rival the European nobility, they also kept a competitive eye on each other. Long before he built his own house, Frick had promised himself something as impressive as the Vanderbilt mansion on Fifth Avenue. Getty, in turn, was inspired by Frick (among others), and J. P. Morgan aimed to be unsurpassed in everything he acquired.[3] Their competitiveness fuelled the growth of the nation's art museums, many of which owe their origins to a single art collector. The rivalry of millionaires also supported a thriving art trade whose most brilliant figure was Joseph Duveen. He, along with Knoedler and Seligmann, supplied almost all of the great collectors of the time: Morgan, Frick, Mellon, Widener, Huntington, Altman, and Kress. Duveen knew very well that the commodities he sold had the value of prime status symbols. Accordingly, he limited his trade; he allowed only the richest, most committed millionaire collectors to buy from his best stock of old masters, whose scarcity and extravagant prices he carefully regulated.[4]

Of the collections most admired by Duveen's customers, the Wallace Collection in London was the most important.[5] Although it bore the name of Sir Richard Wallace (1818–90), most of it had been assembled by Wallace's father, Richard Seymour-Conway, the fourth Marquess of Hertford (1800–70). Hugely wealthy, the Marquess had formed part of the Parisian *haute-monde* of the Second Empire. There he had turned an already impressive family collection into one of Europe's biggest and most admired assemblages of art. Besides old master paintings, he amassed an extraordinary collection of French eighteenth-century painting, furniture, and decorative art – this at a time when the upper reaches of French society had adopted eighteenth-century styles as defining signs of aristocratic identity.[6] As the illegitimate son of the Marquess, Wallace could not inherit his father's title, but as his only offspring, he did inherit great wealth and the art collection – to which he proceeded to add. Frightened by the Paris Commune, he moved most of the collection to London and, in 1872, installed it in the recently enlarged and renovated Hertford House, a grand mansion of the eighteenth century. Some time before his death, he made known his wish to give the house and its contents to the British nation, on condition that the collection be kept intact and unmixed with any other. Eventually, his conditions were accepted, and, in 1900, Hertford House opened as a public museum.

The present mansion recreates a nineteenth-century interpretation of an eighteenth-century house designed for aristocratic display and state rituals.[7] From an impressive entry hall, one passes through a series of reception rooms (Figure 4.1) whose furnishings are carefully identified – a cupboard made for the Comte d'Artois, candelabra from Fontainbleau, a roll-top desk exactly like one made for Louis XV, commodes crafted by the same men who furnished Versailles, and everywhere, Dutch, Flemish, French, Spanish, and English masters – Rembrandt, Velasquez, Hobbema, Watteau, Greuze,

Figure 4.1 A gallery in the Wallace Collection, London. Reproduced by permission of the Trustees of the Wallace Collection (photo: collection).

Gainsborough, Meissonier. These are hung in gentlemanly fashion, roughly by school, size, and subject rather than art-historically. The grand finale is gallery nineteen, a long room of princely proportions containing at least seventy paintings by the kind of blue-chip old master that eighteenth-century gentlemen avidly sought: Titian, Rubens, Van Dyck, Claude, Salvator Rosa, Murillo, and the like. Tables and chairs, carved, inlaid, and gilt, circle the room, as if waiting to receive guests.

But, of course, in such a setting, the modern visitor, always under security surveillance, is not quite a guest. She is meant to look at, not sit on, the rare and costly chairs. In Hertford House, one visits *as if* calling on its donor and his ancestors, but hardly on equal terms. The visitor can only look at, admire, and envy such a display of wealth and (presumably) taste. Hertford House's central theme, the demonstration of aristocratic refinement, was not missed by Frick, Morgan, or the other American millionaires who saw it.

According to his biographer, Henry Clay Frick (1849–1919) decided to become a millionaire when he was still a child. As a young man, he

anticipated the needs of the rising steel industry, and, borrowing the capital (from Thomas Mellon, the banker father of Andrew), he had the coke market cornered by the time the steel business boomed. Thus did he make his first million by the time he was thirty. Soon after, he became a partner in Andrew Carnegie's giant steel company, and, eventually, its principal executive. His name became a household word in 1892 when workers at a Carnegie plant in Homestead, Pennsylvania, struck against a pay cut. To "recover" the firm's property and break the union, Frick sent in hundreds of armed Pinkerton guards. Men were killed on both sides, and Frick became infamous as the epitome of the heartless capitalist, who, even when struck with an assassin's bullet (the assassin was Alexander Berkman), coolly finished his day's routine.[8]

By 1905, Frick had freed himself from the steel business, henceforth investing his capital in other men's businesses while he pursued his new interest in art collecting. Like other millionaires of his generation, he started with French academic and Barbizon paintings, but, after moving to New York, changed course and began buying old masters. According to George Harvey, his biographer, he eventually conceived the goal of leaving "to the people of his own country" something "as complete and as nearly perfect" as the Wallace Collection, "suitably housed and amply endowed." "I want this collection to be my monument," declared Frick.[9] In 1913–14, he built one of New York City's most impressive mansions on one of its most expensive pieces of real estate, the corner of Fifth Avenue and Seventy-first Street. Although it would remain a private dwelling for two decades, its future as a memorial and a public art museum had been understood from the start. The collection was finally opened to the public in 1935, after the death of Mrs. Frick.

In its scale and detailing, the building (mainly the work of Thomas Hastings) imitates grand urban mansions of the old French aristocracy. Its interior spaces, arranged around a sky-lit atrium, unfold as a series of spacious rooms and galleries. Dispersed throughout are old master paintings, bronzes, enamels, and other rare and costly objects of the kind that American millionaires avidly sought. Works by Piero della Francesca, Laurana, Goya, Vermeer, and others are arranged according to size, theme or color in gentlemanly style. One room (Figure 4.2) is decorated entirely with panels by Fragonard, originally commissioned for Madame du Barry, mistress of Louis XV (they came to Frick via the Morgan estate). Near it is a perfectly furnished English dining room, followed by a small sitting room filled with Boucher panels and Rococo furniture. Like Hertford House, the Frick mansion culminates in a great gallery hung with the collection's showiest, most grandiose masterpieces.

The only weak painting in the collection is the large portrait of Frick which dominates the main wall of the library. In this and the living room next to it the decor strikes a note of early twentieth-century genteel informality. A

Figure 4.2 Frick Collection, New York: the Fragonard Room (photo: copyright The Frick Collection, New York).

ticking clock, lamps, and upholstered chairs surround Bellini's *Saint Francis* and portraits by Holbein and Titian. Masterpieces from the great epochs of European art are thus incorporated into a modern, prosaic, domestic setting where they appear as but some of Frick's many possessions. Indeed, the setting seems bent on absorbing them as components of a decorative scheme that, once enviable as the last word in fashion, today appears fussy, dark, and dull. (One could say that the museum's liminality wears thin at this point.) Other rooms in this Fifth Avenue palace represent the donor as a great European nobleman; but in these rooms, Mr. Frick is more historically specified as a twentieth-century industrialist rich enough to have such rare and costly objects in his day-to-day surroundings.

In 1920 when the bequest was announced, and again in 1935, when the collection was opened, the respectable press lauded Frick for his generosity and exemplary public spiritedness. "His will," said the *New York Times*, "will be a model to other rich men who, like him, regard themselves as instruments for the general good, as trustees for humanity."[10] But not everyone was willing to forget Homestead. The Marxist critic Clarence Weinstock wrote:

You may think that Frick gathered his paintings in sympathetic under-
standing, and not out of envy of Wallace in England and Morgan here.
Look twice at the junk shop which struggles through the salons and fills
the corners of the smaller cabinets. . . . So much ground is given to the
untouchable bric-a-brac that one gets cock-eyed looking at the pictures.
The most expensive paintings are roped off from the audience. . . . The
house is a bad museum; the vulgar public can't sit down, and everything
is in place according to Frick in the degree that it is irrelevant to every
living thing.[11]

Today, after years of professional curatorial effort and technological advance-
ment in security systems, the ropes have disappeared, and there is more
seating in the museum. More importantly, the memory of Homestead has
receded, and the Frick name is attached more to things of art than to coke
furnaces or striking steel workers.

The story of the Henry E. Huntington Library and Art Gallery, in San
Marino, California, parallels that of the Frick Collection in many particu-
lars.[12] Huntington (1850–1927), was the business associate and heir of his
uncle, the notoriously unscrupulous Collis P. Huntington, one of the railroad
giants of the western United States. Although long a bibliophile and eventu-
ally the founder of a major research library,[13] Henry Huntington, like Frick
before him, became a serious art collector only late in life. In 1907, he began
spending heavily on French tapestries and furniture and hired the Los Angeles
architect Myron Hunt to design a grand house for his San Marino property,
intending it to become an art museum after his death. The result is an
impressive enough English-style country house, replete with Ionic columns
and decorative urns, and containing appropriately dignified spaces to hold a
growing collection of British portraits of the Georgian period. His efforts as
a collector were aided by both Duveen and his close friend Arabella
Huntington (1850–1924), the millionaire widow of his uncle and another avid
art collector. In 1914, he moved into his new house with Arabella, now his
wife. Duveen, who had already been supplying Mrs. Huntington with her own
old masters (most of them ended up in the Metropolitan), was a frequent
guest, arriving on at least one occasion with literally a railroad car of
paintings, furniture, and decorative arts. Upon the Huntingtons' deaths, the
estate became a public institution, and its direction passed into the hands of
a board of trustees that Huntington had appointed before he died.

The present museum is well stocked with eighteenth-century furniture,
tapestries, silver, and porcelain, (some of it once owned by the fourth
Marquess of Hertford), and, everywhere, British eighteenth-century
portraits.[14] The mansion's grand gallery (Figure 4.3) is filled with the most
monumental of them – full-length images by Reynolds, Gainsborough,
Romney, Lawrence, and others of beautiful and haughty aristocrats (as
well as some of their bourgeois imitators), presented in all the dignity and

Figure 4.3 Huntington Art Gallery, San Marino, California (photo: author).

high-fashion glitter that eighteenth-century painting could muster: Reynolds' *Jane, Countess of Harrington*, Gainsborough's *Blue Boy*, Hoppner's *Isabella, Marchioness of Hertford*. These and many others form a would-be gallery of British ancestors.

The Huntington does not stop with its art collection but continues out-of-doors in a series of gardens and groves. Exploiting a unique chaparral environment, they constitute a semi-tropical Versailles that includes a large cactus garden, a Japanese garden, a palm garden, and a rain forest. The gardens nearer to the house are more European, with fountains, sculptural decorations, and plantings recalling the park vistas and rose gardens of eighteenth-century England. More than the house and its art, it is this unusual collection of gardens that have made the Huntington a popular attraction.

As a whole, the Huntington is a dramatic field highly programmed both inside and out to summon up the life-style of an exceptionally enlightened, perfectly cultivated gentleman of leisure: horiculturalist, bibliophile, art-lover. It seems to me, however, that most visitors take lightly the ritual roles prompted by the estate's setting. In the several visits I have made, the gardens and parks attract more people and elicit more delight, wonder, and comment than all the full-length portraits of posturing aristocrats. In contrast to the Frick Collection, whose lordly donor maintains a presence throughout, Huntington's visitors can breeze through or even skip the house, where the patrician host's imprint is heaviest, and go straight for the gardens where ritual duties are, at most, light and pleasurable.

No discussion of art-collecting, robber-baron mansion-builders can ignore Isabella Stewart Gardner (1840–1924), one of the earliest and most flamboyant of them. From New York, but a fixture of Boston society (she was, reputedly, never wholly accepted by Boston's ultra elite), this widow and heiress had both ambition and money enough (it came mostly from steel) to take a lead among art-museum-mansion-building millionaires. She also had the advice of Bernard Berenson, whose early career she had supported and who, in turn, educated her to what was collectable and acted as her European agent.[15] To house her growing collection, she built a Renaissance palace literally out of pieces brought back from Europe for that purpose – indeed, she stockpiled an entire warehouse of Renaissance and medieval columns, fireplaces, ceilings, ironwork, tiles, and other things to decorate Fenway Court (as she named her house) and personally directed much of its construction.[16] The result, finished in 1902, remains today a theatrical and romantic assemblage of paintings, antique furnishings, and *objets*, all built around a flower-filled, fifteenth-century-style Venetian court. While Gardner lived, a limited public was permitted to see parts of it on select days – one purchased a ticket through a special agent. After her death, it became a public institution, but Gardner's will stipulates that it must maintain furnishings and even flower arrangements exactly as she left them. In death as in life, Gardner's self-dramatizing presence is felt.

In southern California, dream capital of the world, where entire sections of the city are architectural fantasies and Disneyland has achieved the status of a postmodern masterpiece, the J. Paul Getty Museum seems downright restrained. Looking for all the world like a brand new, freshly painted ancient Roman villa, the building and its gardens bring together archaeological research and film industry know-how with supreme California panache.[17] As one might expect, the museum is bigger than its ancient model, the Villa dei Papiri (possibly the residence of Lucius Calpurnias Piso, father-in-law of Julius Caesar), while its air conditioning, elevators, and other amenities no doubt make it more convenient. Its details, however – its frescos, fountains, and mosaics, its porticos and patios – are all Herculaneum and Pompeii – albeit polished, aggrandized and color-enhanced.

Getty (1892–1976)[18] never actually saw the museum to which he left most of his vast oil fortune. When it was built (between 1970 and 1974), he had long since settled into Sutton Place, a genuine sixteenth-century English manor house, and was not inclined to travel. But he had once lived on the sixty-four acre seaside site and supervised all the details of the museum's construction from England. There is no question but that it was conceived as Getty's memorial to himself – an idealized $17 million, imperial residence in which an immortal Getty might forever receive the adulation of visitors. Indeed, Getty explicitly wanted visitors to his museum to feel that they were in the palace of a legendary figure: "I feel no qualms or reticence about likening the Getty Oil Company to an Empire – and myself to a Caesar."[19]

The two-story structure appears at the end of a long garden. Inside, opening around its atrium and an inner peristyle garden, are a series of rooms designed to display the museum's classical collection (Figure 4.4). Several of these, including a circular temple, a small basilica, and a mausoleum-like room whose walls are inlaid with richly colored marbles, evoke ancient ritual sites. In them, the museum's cult and votive statues and other assorted monuments seem suspended between a make-believe antiquity – the architectural equivalent of a costume ball – and the liminal space of a modern museum. In this fanciful setting, you not only perform a ritual; you also play a walk-on part in an old Hollywood movie – *Quo Vadis?*, *Ben Hur*, or *Spartacus*. The Getty gives its visitors a good time.

From the ground floor's Roman imperial luxury one ascends to princely magnificence above (Figure 4.5). Here European paintings and decorative arts are displayed in a series of galleries that include an immense and stately reception hall as well as rooms of eighteenth-century French furniture. As one moves from regal splendor to rococo intimacy, the ghost of Getty does

Figure 4.4 In the J. Paul Getty Museum, Malibu, California (photo: author).

Figure 4.5 Upstairs in the J. Paul Getty Museum (photo: author).

a series of virtuoso quick changes, from great prince to aristocratic dilettante. "I like a palatial atmosphere, noble rooms, long tables, old silver, fine furniture," declared Getty, who also held that a taste for art marked "the difference between being a barbarian and a full-fledged member of a cultivated society."[20]

It is perhaps unkind to recall that in real life, princely spending habits, aristocratic social graces, and *noblesse oblige* were not Getty traits. Alas, the oil emperor – who hungered for admiration, fawned on those with title or fame, and longed to be believed as a cultured and knowledgeable aristocrat[21] – was famous for his miserly ways. Forever lamenting his impoverishment (he was tax-poor, the dollar had shrunk in value, his money was tied up), he gave nothing to charity and undertook no civic cause – unlike his gilded-age precursors J. P. Morgan or Andrew Carnegie. Even after he took up collecting, he shopped for art in the same way he shopped for oil refineries – buying only at discount prices. In his writings and interviews, his art collection figures largely as a pretext for boastful anecdotes about when,

where, and how much he paid for something and how much it has since appreciated; or else which duke or prince once owned what is now his.[22] When his museum opened in 1974, experts judged much of his painting collection to be second rate, the result of his incessant bargain-hunting. As for "giving" his collection to the public – of course, he milked the public benefactor image for all it was worth; but the truth is that he first opened a wing of his Malibu house to the public only after determining how much it would save him in taxes and kept it open only the minimum days and minutes necessary to claim the tax advantage: visitors were allowed in for only a few hours on two days of the week.[23]

In the twenty years since Getty died, the collection has been both broadened and improved in quality. A professional staff has spent many millions of Getty dollars buying the kind of high-priced, mainstream, art-historically significant works that Getty himself avoided. The staff has also introduced into the galleries its own professionally motivated agenda, one that runs counter to the donor's insatiable craving for attention and his wish to be admired and idealized. Numerous guided tours, abundant labeling and at least two video-equipped information stations introduce into the museum a clear educational intent. Whether or not one uses them, these highly visible facilities acknowledge the identity of the visitor as a modern citizen come to seek enlightenment and pleasure – although the resident prince/patrician is not easy to ignore.

It took over two years of legal work before Getty's body could be buried on the grounds of his palace museum.[24] Guarded by television cameras, the actual grave site is not open to the public. Nevertheless, the very presence of Getty's remains on the grounds turns the museum into an explicit (if semi-secret) mausoleum, adding yet more flavor to what is already an interesting and vivid donor memorial.

There are recurrent themes in the stories of these men and women: late in life, after amassing their fortunes in business or banking (or after being left another's fortune), they hurriedly assemble princely art collections which will stand as memorial monuments to themselves. Sooner or later, they must decide whether to give them to a public art museum like the Metropolitan or keep them separate as distinctive individual donor memorials (there are also possibilities in-between, such as a donor memorial wing within a public museum à la Lehman). The various choices entail different advantages and risks.[25] One obvious attraction of the mansion or palace museum is the aristocratic identity it secures for its donor. However, as we have seen in the previous chapter, late nineteenth- and early twentieth-century elite culture often gave even greater honor to the Good Citizen – the public-spirited individual who sacrificed his desire for personal aggrandizement in order to enrich the holdings – and, presumably, thereby advance the educational mission – of public institutions.[26]

Of course, giving spiritual treasures to the public in any form could bring a certain kind of social-moral credit to men who might have had a special need to repair their public image or (admittedly, what is less likely) salve a bad social conscience. None of the donors discussed in this chapter owe their excessive wealth to any but the standard cut-throat, labor-exploiting practices of their day, and more than one of them was forced to defend himself before government tribunals (most notably, J. P. Morgan and Andrew Mellon). Their monuments were designed to outlive and no doubt redeem their reputations in life. They commemorate not the capitalist selves that amassed the wealth – those selves are almost always philanthropically expunged – but something rather loftier. S. N. Behrman's comment about Frick and his museum can apply to almost all of these donors:

> The article on Frick in the *Encyclopedia Britannica* runs to twenty-three lines. Ten are devoted to his career as an industrialist, and thirteen to his collecting of art. In these thirteen lines, he mingles freely with Titian and Vermeer, with El Greco and Goya, with Gainsborough and Velasquez. Steel strikes and Pinkerton guards vanish, and he basks in another, more felicitous aura.[27]

Besides these social and moral advantages, there seems to have been something more at stake, some other reason for these mansion builders to keep their collections from being absorbed into the larger, more communal collections of the municipal art museums. It appears that at some point they came to regard their collections as surrogate selves – metaphorical stand-ins – which they ardently wished be kept intact and identifiable as having once belonged to them. The fervor with which so many of them created their mansion museums strongly suggests that their obsessive collecting was not only or always merely a matter of social ambition and class pretension. They seem also to have been in search of some lasting value to which they could attach their names. Thus, when asked why he acquired art, Andrew Mellon, whose collection would form the core of the National Gallery in Washington, replied that every man "wants to connect his life with something he thinks eternal."[28]

This wish for something eternal is written into the very architecture of donor memorials, which, besides taking the form of residences, frequently recalls tombs or mausolea. Of course, art museums in general, because they are often windowless, imposing and – at least the pre-World War II ones – classical in form, are easily associated with sepulchral and religious structures. Commonly regarded as repositories of spirit, places where one may commune with artistic souls of the past, art museums already serve a purpose that is congruous with that of tombs, mausolea, and memorials to the dead. In fact, a number of art museums include actual tombs and burial chapels. The Francine and Sterling Clark Art Institute in Williamstown, Massachusetts, for example, is a classical, white marble, purpose-built art gallery

that also serves as the burial site of its donors.[29] In the University of North Carolina's William Hayes Ackland Memorial Art Center, the donor's marble image reclines atop a Renaissance-style tomb.[30] The body-count in mansion museums is probably higher than in other kinds of art museums, especially given Euro-American traditions of private mausolea and family cemeteries.[31]

The designation of an art collection as a personal or family memorial is a practice that seems peculiar to the modern era. Of course, ancient royalty and nobility regularly took beautifully wrought objects into their burial sites, and we know that the contents of an Egyptian tomb like Tutankhamen's makes a splendid museum display. But such buried treasure was not originally gathered for the eyes of the living. Rather, it was meant to provision the dead in the next world. In contrast, the modern art-gallery-as-memorial addresses the living – "the public" – on behalf of the dead (or soon-to-die). The intent is to give the dead a prolonged existence in the memory of the living.[32] Art museums of this kind are resonant with older types of western memorializing monuments, for example, Renaissance tombs or eighteenth-century mausolea. As the historian Philippe Ariès has shown, the appearance of such monuments (beginning in the later middle ages) marks what was a growing wish to remember the dead and was linked to the new importance given to family identity. In the eighteenth century, the need of the living to remember the dead and the wish of the dying to be remembered – not specifically Christian concerns – contributed to the creation of new kinds of burial sites, namely the modern cemetery and the mausoleum – both of which are more secular than church burials but still ritual in character.[33] It is at just this historical juncture that, as we have seen, eighteenth- and early nineteenth-century art lovers like Goethe and Hazlitt began to experience art galleries as sacralized spaces in which visitors could commune with the artistic spirits of the past. Given the congruity of these developments, it is not surprising that an art gallery could come to be seen as a logical or acceptable memorial or even an alternative to more conventional burial sites. In a universe where death was being secularized and art was being sacralized, what better place to seek immortality than this, a space set apart from mundane concerns for the contemplation of timeless values?

Dulwich Picture Gallery in South London brilliantly joins into a single ritual space a mausoleum and an art gallery.[34] Designed by Sir John Soane, the building holds an exemplary eighteenth-century gentlemanly collection of old master paintings representing the principal "schools": Poussin, Claude, Rubens, Van Dyck, Teniers, Murillo, Velázquez, Guercino, Guido Reni, Raphael, Leonardo, and Titian. It was originally gathered by the art dealer Noel Joseph Desenfans (1745–1807) for King Stanislas Augustus of Poland, who wished to establish a Polish National Gallery. Before the plan could be realized, political events forced Stanislas to abdicate, leaving the collection in the hands of Desenfans. At this point, Desenfans, convinced of the collection's outstanding quality, resolved to keep it intact, in England,

and open to the public. He proposed to sell it to the British state as the nucleus of a British national gallery, but without success. His death in 1807 left the resolution of the problem to his adopted son and heir, the artist and art dealer Sir Francis Bourgeois (1757–1811). It was Bourgeois who finally arranged for it to go to Dulwich College, a small charitable institution outside of London. The eminent architect Soane, a close friend of Bourgeois, took on the project without a fee and saw it through after Bourgeois's death. The finished monument, completed in 1817, is very much Soane's own statement.

In its original plan,[35] the building resembles other art galleries of the time, including the kind of "long gallery" that was a familiar feature of grand houses. Rebuilt, restored, and somewhat enlarged after its partial destruction in World War II, it has been recently reinstalled to look as much as possible as it did in 1817 (Figure 4.6). The paintings are organized by "school" and hang in symmetrical groupings that balance or contrast to works of similar size and subject. Occasional pieces of furniture help create the feel of a stately house. What makes Dulwich Picture Gallery unusual, however, is neither its layout nor the makeup and installation of its collection but the small rotunda and mausoleum placed in its central section. Within it, three sarcophagi contain the remains of the gallery's donors – Desenfans, his wife, and Bourgeois.

It is not that mausolea in themselves were unusual in the early nineteenth century. The British gentry had been building them on their estates for some time, the most famous and imitated one being the rotunda at Castle Howard, built in the 1730s.[36] It is, again, Dulwich's combination of art gallery and mausoleum, its double display of pictures and death, that makes it different. At Dulwich, the two elements have become a single totality, perhaps best understood as a mausoleum expanded into an art gallery (rather than an art gallery with a mausoleum in it). Seen from the outside (Figure 4.7), the building's main theme is unmistakably sepulchral. Its stark, unadorned, and often windowless walls consciously evoke tomb sites of ancient, more primitive times. The section that houses the mausoleum is architecturally stressed as the central volume, and its tomb function is spelled out by a generous supply of classical mortuary objects – cenotaphs, "death's doors," urns, and sarcophagi.

One element of Soane's original design that modern restorations have not brought back is the lighting, which, reportedly, was dimmer than today's museological standards would allow. Even in Soane's day, critics thought the place too dark and gloomy for a picture gallery.[37] Soane, however, deliberately constructed a shadowy interior, creating a unified, markedly liminal ambience for both tombs and pictures. For him, tombs and pictures were comparable and complementary psychological stimuli; and if he bathed them in the same dim and tinted light (Soane used colored glass in the lantern lights above), the intent was to prompt visitors to poetic musings and imaginative reveries – musings and reveries in which pictures and sarcophagi could mingle. That is, Dulwich was meant to evoke the kind of associative

Figure 4.6 Dulwich Picture Gallery, South London (photo: author).

Figure 4.7 Dulwich Picture Gallery: exterior of the mausoleum (photo: author).

responses then considered appropriate to pictures, ancient ruins, graveyards, and other such suggestive stimuli.[38] In his own house-museum memorial in Lincoln's Inn Fields, London, Soane also combined a picture gallery with quantities of sepulchral objects and relics of extinct cultures. The entire setting was meant to prompt meditations on the passage of time and the cycle of life and death.[39] And it, too, was suggestively lit by a complex system of overhead and side-lighting that cast some areas into romantic gloom while bathing others in golden highlights.

Unfortunately for Soane's sepulchral picturesque aesthetic, later visitors to Dulwich, and – to judge by their complaints – some of Soane's contemporaries, were less ready to embark on such ritual journeys of the imagination; they sought (and today still seek) more intense and better lit encounters with individual artists. Even before Soane died, the view into the mausoleum was closed off, presumably on the assumption that visiting the dead and looking at pictures should not be done in the same ritual space. For similar reasons, the lanterns in the galleries were reglazed to give the pictures more light. Eventually, the door obstructing the view into the mausoleum was reopened (in 1908) – not as a revival of Soane's associationist aesthetic but out of respect for the artistic integrity of a Soane original.

As museum architecture, the Dulwich Picture Gallery was and continues to be regarded as an outstanding precedent for gallery design – the recently completed Sainsbury Wing of the National Gallery in London is but one of many Soane-inspired examples that could be cited. However, as a type of ritual space – a fusion of art gallery and mausoleum – nothing later would be quite like it. It belongs wholly to that peculiar moment in the early nineteenth century in which notions of art galleries and picture-viewing, and developing burial and memorial practices could actually converge. There would be later tomb-like art galleries and art galleries with tombs, but nothing that combined mausoleum and art gallery so dramatically and thoroughly, or treated pictures and coffins with such equivalence.

The mausoleum of Henry and Arabella Huntington in San Marino, California, for example (Figure 4.8), completed in 1929, can be compared to Dulwich in several ways. It, too, is in close proximity to the deceased's art collection, and its neo-classical architecture is devoid of Christian symbolism. The mausoleum is an open-air, white marble rotunda. Its designer, John Russell Pope, was one of the last practitioners of Anglo-American neo-classicism. Like Pope's earlier Jefferson Memorial in Washington, the pristine forms of the mausoleum are derived from a variety of sources – circular temples (including the Pantheon), previous mausolea (including the one at Castle Howard), and eighteenth-century garden structures.[40] In its center, Henry and Arabella lay at rest within a massive double sarcophagus, semi-enclosed by four large marble slabs. On each slab, a relief allegorically represents a stage of life: infancy (a winged figure lights a lamp), youth (pastoral love), maturity (a couple with the fruits of an autumn harvest), and old age (another winged figure snuffs out a lamp). Thus does this late neo-classical temple evoke an exceedingly genteel and sentimental meditation on life, death, and the passage of time. It does so, however, well away from the main attractions of the Huntington estate – the gardens and the galleries. Hidden within a grove of orange trees, it is barely visited and is not even indicated on the map that guides visitors through the grounds. A mausoleum that doubles as a park ornament, it has more to do with the pretensions of the would-be aristocratic Huntingtons than with meditations about art.

Figure 4.8 Huntington Mausoleum (photo: author).

Dulwich Picture Gallery, too, bears more than a residual trace of class pretentiousness in that it appropriates for its middle-class donors two features of aristocratic country houses, the art gallery and the mausoleum. Its site on the grounds of Dulwich College, however, leaves it – and its entombed donors – unattached to any private estate. Their domain, if they have one, is that of poetry, art, and the imagination, a domain that, at least in the theory of Soane, transcends the claims of class.

I have moved my topic from single-donor art museums conceived as idealized aristocratic residents to those which serve as tomb sites. Other than Dulwich Picture Gallery, however, I have not found examples of art museums that integrate the ritual space of the mausoleum with that of the art gallery in any meaningful way.[41] If, on the other hand, we do not insist on the actual presence of a tomb, but instead look for settings that create a tomb-like atmosphere or that seem especially structured to prompt a remembrance of the dead, then the choices are greater. I do not wish to suggest that mausoleum-like monuments are a separate formal category of museum architecture. Rather, I am tracking a ritual emphasis. My aim is to get at the way certain donor memorials – whatever their architectural formats – build into their

rituals especially potent memorializing contents. The Isabella Stewart Gardner Museum, for example, with its prescribed flower arrangements, lit candles, and other personal reminders, inevitably structures one's visit as a call paid to the departed donor. Similarly, in the Morgan Library, which I shall treat presently, the ritual tour centers on remembering the dead.

The Robert Lehman Wing in the Metropolitan Museum of Art, designed in the 1970s, is another, mausoleum-like monument. In Chapter 3, it was discussed in the context of the public art museum's weakening commitment to its former liberal ideals. This chapter will look at it again, this time as an art museum with a strong memorializing ritual.

Lehman's original intent had been to give his large and exceptionally fine collection of mostly Renaissance art to the Met, where much of it had been hanging on loan since 1954. But in the late 1950s, he changed his mind. Only the second Jew ever to have been given a seat on the Met's WASPish board, Lehman had arrived at the position where, according to the board's own long-standing practice, one automatically succeeded to the museum's presidency. When the board denied him that post – clearly because he was a Jew – he withdrew his collection and had it installed in the town house built by Lehman Sr. on Fifty-fourth Street (Lehman had long lived elsewhere). His intention at this point was to turn the house into an independent art museum. A commercial decorating firm was engaged to give the 1905 structure a vaguely Renaissance-looking decor.

The injured Lehman was persuaded to reverse his decision a second time, but only after the Met's board conferred on him the title of Honorary President – a title specifically created to atone for the earlier slight – *and* after it agreed to the creation of a separate wing to hold his collection.[42] For a time, Lehman held out for a plan that would have literally replicated the 1905 house – an attached, mid-block, structure – as a wing of the Met. An architectural drawing was even made, showing the house rising incongruously from what was then a museum parking lot.[43] Just before he died in 1969, Lehman was persuaded to give up this idea and agree to a new purpose-built wing – which, however, would be required to replicate the seven recently decorated, semi-museumized rooms of the Fifty-fourth Street house. Thus was the Met's embarrassed anti-semitic board made to bring into the museum not merely a memorial to Lehman, but a shrine to Lehman's father in the form of the old patriarchal dwelling. The new wing, designed by Kevin Roache, John Dinkeloo, and Associates, and costing $7.1 million, opened in 1975.

The Met calls the seven Lehman-house interiors "period rooms," although it is doubtful that they represent any period other than late American Robber Baron (Figure 4.9). Situated inside what is, in effect, an earth mound, they feel like subterranean chambers. Together, they form the outer walls of a diamond-shaped structure, within which is a sunken, two-story court surrounded by a spacious ambulatory. Rising above the whole is a large glass pyramid, the most prominent of the wing's exterior features (Figure 4.10).

Figure 4.9 A "period" room in the Lehman Wing of the Metropolitan Museum of Art (photo: author).

The architecture not only suggests ancient Egyptian tombs, its centralized plan and ambulatory, together with its memorial function, also link it to various royal and imperial mausolea of the past, structures in which the dead eternally receive the living and impress upon them their greatness. At the same time, the intimate scale of the period rooms, together with their carpets, draperies, sofas, and fireplaces, evoke the domestic comforts of a home, albeit an art-collecting millionaire's home. Today the rooms are less cluttered than in 1975, but they still suggest the once-lived-in spaces of the Fifty-fourth Street house, as Lehman's bequest stipulates. Even as they suggest real living space, however, they also deny it. Dimly lit and without working doorways or windows, the atmosphere of these rooms is stage-like, unreal, and intensely liminal. On entering them one steps out of the realm of the living into a zone where time and life itself have been ritually suspended. It is not surprising that the security guards who work this part of the building joke that Lehman is buried somewhere under the floor. With or without a body, a visit to the Lehman rooms is, as a ritual, a visit to an underworld where one pays respects to the dead.

I conclude this exploration of donor memorials with a pair of monuments

Figure 4.10 The Lehman Wing's glass pyramid, Metropolitan Museum of Art
(photo: author).

created by two of the most powerful figures in the history of American
capitalism, J. P. Morgan and Andrew W. Mellon. Admittedly, the two
monuments – the Morgan Library in New York City and the National Gallery
of Art in Washington – are not comparable as cultural institutions: the
Morgan Library, is, after all, primarily a rare book collection (although its
art holdings are by no means negligible), while the National Gallery's vast
interior holds one of the world's great collections of paintings. Moreover, the
National Gallery, unlike the Morgan, does not announce itself as a donor
memorial (an issue I will discuss shortly) but rather looks like a proper,
art-historically arranged city or state museum. Yet, despite the differences
between them, each stands as a monument to a giant of finance capitalism.

The Pierpont Morgan Library (Figure 4.11) is a piece of donor memorialism
in the grand manner of Duveen's generation. Although built as a memorial,
in the first years of its life, it served as a study and library annex to the Morgan
mansion next door (now replaced by a library extension). Like everything
associated with Morgan, this most imposing and expensive display of marble
and neo-classical design (by the famous Charles McKim) was calculated to
show off the lordly Morgan as belonging to a class apart. Wrote William
Valentiner, a Metropolitan Museum curator:

It is one of the most grandiose monuments to personal taste in New

92

Figure 4.11 Pierpont Morgan Library, New York, watercolor rendering from the office of McKim, Mead, & White, architects, *c.* 1902, the Pierpont Morgan Library, New York (photo copyright The Pierpont Morgan Library. 1958. 24).

York; not even the Frick Collection can equal it in individuality and artistic value, for the manuscripts, early prints, drawings, and jewels of the Renaissance and antiquity there are collectors' items of much greater value than anything else made accessible to the public in New York at that time.[44]

Morgan clearly regarded it as his personal memorial and wanted it built to last. The most notable fact about its structure is that the marble blocks that form its supporting walls are, like ancient Greek temples, precision cut to fit together without mortar. The idea was McKim's, but it greatly appealed to Morgan, who readily paid the extra costs it entailed.[45] As one of his biographers wrote:

It would put him one up on the Medicis, the Sforzas, the builders of Mont Saint Michel and Chartres, and far beyond the local grandees with their Fifth Avenue palaces all bonded with concrete.[46]

The most interesting and ritually programmed part of the library today is the original McKim building and its three so-called "period rooms" – rooms Morgan himself furnished and used: the entry hall, the original library, built to hold Morgan's vast collection of rare books, and Morgan's study (Figure 4.12). These rooms, all extravagantly decorated with murals, mosaics, carvings, and tapestries, are fitted behind a facade that is both solemn and

Figure 4.12 The West Room of the Morgan Library (Morgan's study), photographed without the rope barrier that normally confines visitors to the center of the room (photo copyright The Pierpont Morgan Library).

elegant. The whole constitutes a kind of composite ceremonial space that reads as both a palace wing and – seen from the street – a grandiose, windowless, tomb-like memorial. In all of its decorations, one theme dominates: Morgan as guardian and high representative of civilization itself, successor to all past princes of church, state, and commerce.[47] The West Room, Morgan's famous study, holds most of the library's art collection. It is also the room that most preserves the memory of the legendary banker, a portrait of whom glares fiercely down from over a Florentine marble mantelpiece. Formerly, Morgan himself sat behind that very desk conducting his business amidst the most exquisite treasures that money could buy: works by Memling, Desiderio da Settignano, Perugino, Bellini, Tintoretto, Rossellino, and others, set off against walls of red silk damask from the palace of the Chigi family, the powerful Renaissance bankers. And everywhere, quantities of those rare and ancient bronzes, porcelains, ivories, and other *objets* of which Morgan's generation of millionaires were so fond.

The room today preserves much of its original look, so much so, in fact, that visitors can barely examine its contents. That is to say, its many small objects are dispersed around the room on open shelves and other surfaces, presumably as Morgan himself arranged them. The security problem this poses is solved by confining visitors to a roped-off area well away from any work of art. (The roping is removed in the museum's photographs of the room – other photography is not permitted.) If one leans even slightly over the ropes, a loud alarm bell sounds. Since almost all of the study's art collection consists of small objects or paintings that demand close inspection, and since everyone instinctively leans forward to get a better look at them, the alarm bell sounds every few moments. One is aware that while these objects are *shown* to the public, they are not offered to it as art. Rather, they are presented as objects-once-owned-by-Morgan, a distinction that apparently consigns them to the purgatory of never again being used as art by anyone else, at least not publicly. As we have seen in Chapter 3, in his role as trustee and president of the Metropolitan Museum of Art, Morgan made sure that the museum adhered to modern, ideologically liberal practices of installation. But here, in the heart of his personal memorial, there is barely space for the public to stand. There is room only for the memory of Morgan, who, in the guise of a Renaissance prince, not only commands the world's treasure but also monopolizes its spiritual benefits.[48]

In the sheer magnitude of its ambition, Andrew Mellon's National Gallery of Art in Washington, DC, matches, and in some ways surpasses, the Morgan Library. I introduce it here even though it is not obviously a donor memorial. It does not bear the name of its founder, and its central ritual conforms strictly to the norm of the public art museum: it constructs its visitors as enlightenment-seeking citizens, and leads them on a tour of western art history from the Renaissance to the present. As even the briefest of its guidebooks proclaims, it is, by order of Congress, property of the people of

the United States. Yet, the museum's decided civic look does not preclude it from functioning as a donor memorial. To those who know its history, the National Gallery is virtually a monument to the Mellon family.[49] Besides owing its existence to Andrew W. Mellon, it has enjoyed continued attention and gifts from his children. The question I shall pursue here is how a national gallery can also serve as a donor memorial.

Along with Andrew Carnegie, John D. Rockefeller, and J. P. Morgan, Andrew W. Mellon (1855–1937)[50] was one of the handful of men who shaped the United States economy at the turn of the century. Heir to a Pennsylvania-based family banking business, Mellon started out hugely rich and became increasingly richer. By 1920, he controlled one of the nation's two or three biggest fortunes, which included enormous holdings in aluminum, oil, railroads, and coal. It was at that point that the sixty-five-year-old financier entered public life for the first time. In 1921, just as the United States was entering a period of marked economic expansion, President Harding asked him to serve as Secretary of the Treasury. Harding's successor, Calvin Coolidge reappointed him in 1924, as did President Hoover in 1928.

Under Coolidge ("the business of government is business"), Mellon's influence reached its height – indeed, he was regarded as the central figure in the Coolidge White House and was widely credited as the architect of the decade's prosperity. The once reclusive businessman now became prominent as one of the nation's most revered public servants. In this role, he confidently assured an adoring business community that the prosperity of the 1920s would continue indefinitely – provided that new capital remained abundant and active and credit available and cheap. Already under Harding, Secretary of the Treasury Mellon had called for a sharp reduction of taxes on corporate profits and on the personal incomes of the very rich, since these were the sources of the golden stream of capital that sustained the life of the nation. At the same time, the Secretary urged the curtailment of expenditures on public works and services and even opposed payment of a bonus that the government had already promised to veterans of World War I on the grounds that such spending is a waste of potential working capital. It thus came about that, in 1924, the same year that Mellon successfully obstructed the payment of the veteran's bonus, the US Treasury issued him a personal tax refund of $404,000, while Mellon family businesses – Gulf Oil, Alcoa, Standard Steel Car – received refunds, credits, and abatements totalling almost $7.5 million.[51]

When the depression came, Mellon's reputation took a hard fall. In 1932, amid allegations of tax fraud, trustbuilding, and other illegal business practices, Mellon, now a liability to the Hoover administration, agreed to quit his office in the Treasury and be shunted off to Britain as ambassador. The 1932 election of Franklin D. Roosevelt ended for good his career as a public servant. Even before he left the Treasury, revelations in the House led one congressman to move that Mellon be impeached for "high crimes and

misdemeanors." His reputation would become more tarnished as the new Democratic government pried into his past business practices and his use of federal power during his tenure as Secretary of the Treasury.[52]

It was during his years as Secretary that Mellon became a serious art collector, filling his palatial Washington apartment with old master paintings selected for him by Knoedler and Duveen. Around the same time, possibly under the tutelage of Duveen, he conceived the idea of leaving behind a significant collection – in the hope, as he reportedly said, of linking himself with "something eternal." It is not certain when the idea of a national gallery took shape, but by 1930, he was buying old masters in bulk. In that year, he gave millions to a Soviet Union in dire need of cash in exchange for twenty-one masterpieces from the Hermitage Museum. Soon after, he paid Duveen $21 million for twenty-four more works. Later, Mellon claimed that he had the idea for a national gallery of art in the late 1920s and that he formed a charitable trust to hold his collection soon after. Part of the government's tax case against him revolved around this trust – for which no documents existed – and Mellon's later claims that it entitled him to tax deductions. Eventually, this count would be dropped.[53]

It is probable that Mellon did, in fact, conceive the idea of giving the nation a great art museum in the late 1920s. In the two years or so before the Crash, he was at the height of his popularity, basking in his reputation as one of the nation's greatest-ever Secretaries of the Treasury. As his collecting activity indicates, surely it was now that he decided to crown his civic achievement by a magnanimous gesture: the donation of a national monument that would eternally link his reputation to his years of service in the capital. The coming of the Crash, which forced him out of public office, out of public favor, and into a tax court, seems only to have slowed him somewhat. Such setbacks were hardly likely to deter the man who had sufficient will and resources to amass more corporate power than almost anyone else alive. In fact, the reversal of fortunes Mellon suffered seems to have made him all the more resolved to leave behind a monument that would recapture his lost national stature.

In 1936, in a letter to President Roosevelt, the eighty-one-year-old Mellon offered the nation his paintings as the nucleus of a national collection.[54] His offer included a building to house the collection and an endowment for its development. The museum would be governed by a self-perpetuating board of five (initially selected by Mellon) with four public servants acting as ex-officio members. Within weeks, the proposal was approved by Congress and the gallery was given a site on the Washington Mall. Mellon chose the architect, John Russell Pope, approved his design, and selected the costly white marble building material. He also named as the first director David Finley, his former legal aid.[55] The donation of three other outstanding collections of paintings, those of Joseph Widener, the Kress brothers, and, later, Chester Dale, helped make the museum a convincing national

collection. Nevertheless, the museum's most faithful supporters would continue to be Mellon family members, especially Mellon's son Paul and, even more so, his daughter Ailsa Mellon Bruce.[56]

Pope's marble building is solemn and tomb-like in the extreme, a study in neo-classicism at its coolest and most abstract (Figure 4.13). Its blank, exterior walls carry a minimum of architectural detail. Inside, acres of polished stone surfaces seem built to last for a millennium. One of Pope's Pantheon-like rotundas forms the entrance (Figure 4.14), the dark stone of its columns (from Tuscany) set off by a green and gray marble floor (from Vermont and Tennessee). Gallery walls are sparsely hung (Figures 1.4 and 4.15). The museum follows to the utmost the precepts of the "aesthetic hang," according to which the more space you spend on an object, the more significant it is and the more intense the attention it can command. The galleries' decors are in keeping with the rest of the structure. Simplified moldings and panels suggest rather than imitate the palatial halls or religious chapels for which many of the works on display were originally made. In this highly liminal setting, the specificity and noise of historical time and space are kept at a distance. Even the building's classicism is not really classical but rather neo-classical: the classical remembered, streamlined, distilled into perfectly impersonal geometry. "Beaux-Arts in the purity of death," wrote one critic.[57] Another remarked on the air of authority the building emits:

Figure 4.13 National Gallery, Washington, DC (photo: author).

Figure 4.14 National Gallery, Washington, DC: the Rotunda (photo: author).

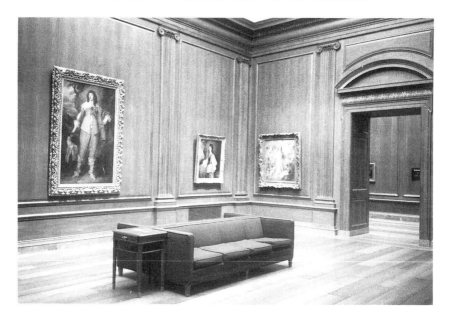

Figure 4.15 A room in the National Gallery, Washington, DC (photo: author).

Across the wide spaces which separate art and reality, a sacred forest invites at every step the astonishment of the visitor, seducing him with expense and weight, crushing him under its firm assertion of authority.[58]

How then, does the National Gallery memorialize its founder and still take the form of a civic ritual? In what way does Mellon figure in the museum ritual? Certainly, he is not present in the same way Frick or Huntington are in their museum memorials, as hosts of aristocratic residences. Nothing about the National Gallery so much as hints at a residential setting, and Mellon even declined to give it his name. On the face of it, the museum ritual prompts one to pay respects not to the patrician figure of Mellon, but to the American people – or rather to the state which represents them and holds the collection in their name. The building's only autograph is the bald eagle, insignia of the Federation; it appears in the Rotunda, the museum's grand opening space, inscribed several times on the entablature.

Yet, invisible as he may be in any specific historical guise, it was, after all, Mellon who created and shaped this solemn and dignified place. His presence in this state ritual is implicit; he is there as the presiding officer of the state, whose authority he embodies and mediates. The former Secretary of the Treasury takes his place in these halls not as a would-be aristocratic host but as an ideal Federal Citizen, an identity whose claim he could base on his long years of service in the cabinets of three presidents. This civic and federal

Mellon is quite removed from Mellon the businessman whose interests were rooted in cities well to the north of Washington – and whose phenomenal wealth and power made him a sinister figure in the minds of many of his fellow citizens. On the contrary, it is Mellon as Man of State who stands behind the gallery's impersonal authority, an authority powerfully conveyed not only by the building's calculated classicism but also by the orthodoxy of its collection and the extremism of its aesthetic hang.

Mellon's lofty Man of State presents a sharp contrast to the Morgan who is memorialized in the Morgan Library. As gilded-age bankers, both men required grandiose, *beaux arts* piles in the McKim tradition, but the Mellon monument, while it robes itself in the authority of that tradition, also speaks to a newer sensibility. The difference shows up clearly in the historical allusions each building makes. The Morgan Library is a Renaissance palace, complete with Palladian entrance loggia and Vatican-inspired frescoes. Its opulent decorations evoke Morgan as an egotistical banker-prince who ritually brandishes his wealth. The cleaner, more updated neo-classicism of the National Gallery answers to a later moment, one that required something less personal, more redolent of civic and state authority.

The National Gallery also acknowledges a larger national and international community. The Morgan Library was built as an extension of the Morgan mansion and primarily addressed the elite of the financial community. The National Gallery rose up in sight of the Capitol, on the Washington Mall itself, the most national of sites and the nation's premier ceremonial space. In the 1920s, as Secretary of the Treasury, Mellon had overseen massive building projects in the capital and had been deeply involved in the redesign and landscaping of the Mall itself.[59] Now, in the 1930s, his own monument was purposefully designed to harmonize with the new federal Washington that he had helped shape. His refusal to attach his name to the museum that he gave the nation has been frequently commended as an act of self-effacing modesty and a strategy wisely designed to attract other donors. It is an act, however, that also obscures the deep contradiction on which the National Gallery is built: that one man, single-handedly, was able to dictate, pay for, and carry out the creation of so potent a symbol of the nation's spiritual and material wealth.

5

THE MODERN ART MUSEUM
It's a man's world

Mrs. Guggenheim said Barr had suggested she squint at it [Picasso's *Demoiselles d'Avignon*] in order to get the pattern without the subject. She said she had been squinting ever since [but] does not like [it].[1]

Finally we come to the rituals of modern museums and modern wings.[2] Before we can enter any of these, however, something must be said about the history of modern art and artists.

The "history of modern art," as it is generally understood in our society, is a highly selective history. To be more exact, it is a cultural construct that is collectively produced and perpetuated by all those professionals who work in art schools, universities, museums, publishing houses, and any other place where modern art is taught, exhibited, or interpreted. The first thing that needs to be said here is that this world of art professionals is enormously fragmented and often fails to arrive at any simple or clear consensus about the history of modern art. Especially in the higher, more difficult reaches of critical and art-historical discourse – in university classrooms, academic conferences, and journal articles – conflicting concepts of the field openly dispute one another. Not only are there disagreements about where the boundaries of the field lie and what comprises its most important incidents; there are also competing ideas about what its basic intellectual tools should be and what fundamental questions it should be addressing.

Twenty-five or thirty years ago, this was not the case. It is, of course, still possible to speak of an established, or perhaps one should say, until recently established, art history with its own cluster of central truths. For, despite all the critical uproar, almost everywhere in the Anglo-American university world, a fair number of professors and lecturers still teach the familiar narratives of unfolding genius and formal development. These narratives continue to feature the usual Great Artists, and their work continues to be set against an historical background kept vague and far away enough so as not to interfere with the autonomy and universality of art, but near enough to supply occasional iconographic themes (when needed). Then again, however entrenched this art history still is in some institutions, in others it is

mercilessly assailed and undermined by the "new art history" – or rather the new art histories, since there are actually several (some are rather old), based variously in French post-structuralism, language and literary theories, the tradition of Marxist cultural analysis, and psychoanalytic theory.

Which leads me to this: despite their success in academia and high criticism, these new art histories have won very little ground in public art museums. That is, they have won very little ground that is visible. This resistance is not surprising. Like science and history museums, public art museums are mediating institutions, situated between academic and critical communities on one side, and, on the other, trustees, the museum-going public, and, on occasion, state officials, all of whom expect museums to confirm their own beliefs about art. Most art museums are caught in the middle. Their curatorial staffs may share many of the views of their academic colleagues; but, the government-supported and/or tax-free public institutions in which they work are under pressure to present forms of knowledge that have recognizable meaning and value for a broader community. They are expected to augment and reinforce the community's collective knowledge about itself and its place in the world, and to preserve the memory of its most important and generally accepted values and beliefs. Therefore, especially where permanent collections of art are concerned, museums tend to reaffirm familiar, widely held notions about art and art history. In all but a few public art museums today, that translates into conservative art-historical narratives.

For many decades, now, in both American and European art museums, the central narrative of twentieth-century art – let us call it the narrative of modernism[3] – has been remarkably fixed. One of its first effective advocates was Alfred Barr, the founding curator of the Museum of Modern Art (MoMA), who adopted it (beginning in 1929) as his organizing narrative.[4] Barr did not invent single-handedly what would become the MoMA's central art-historical narrative; but under his direction, the MoMA would develop it more than any other institution and promote it through a vigorous program of acquisitions, exhibitions, and publications. Eventually, the history of modern art as told in the MoMA would come to stand for the definitive story of "mainstream modernism."[5] As the core narrative of the western world's premier collection of modern art for over half a century, it constituted the most authoritative history of modern art for generations of professional as well as non-professional people. To this day, modern museums (and modern wings in older museums) continue to retell its central gospel, as do almost all history of art textbooks. William Rubin, the MoMA's director of painting and sculpture for many years, remarked,

> Modern art education during and just after World War II was, in the first instance, very much a question of this museum and its publications. . . . I find my own views about the collection and about the exhibiting of it are very much like Alfred's. That's partly because I was brought up on Alfred's museum and on the collection as he built it.[6]

As director, Rubin maintained Barr's basic narrative structure, but more rigidly and dogmatically than Barr – as critics complained.[7] Thus, the writer and editor Thomas Hess:

> The basic structure . . . seems to be that familiar formalist one which moves with a deathly sort of inevitability from the 1940s to the '60s, from Pollock to Morris Louis, the "style" purifying itself of "irrelevancies" like a snake shucking its skin. This is the current art-historical stereotype which gets repeated and repeated with all the inane self-confidence of a freshman art-survey demonstration of how Giotto tried to figure out perspective, but Piero della Francesca really got it right.[8]

As I complete this book, the MoMA has just unveiled a new installation, the work of the present curator Kirk Varnadoe. While it modifies slightly some of the strict linearity and compartmentalization of past installations, it leaves intact the basic outlines of the MoMA's traditional history of modern art. In what follows, I draw on the new as well as older MoMA installations, but also on other art museums, including (to name only a few), the Los Angeles County Museum of Art, the East Wing of the National Gallery of Art in Washington, DC, the Tate Gallery in London, the Philadelphia Museum of Art, the Boston Museum of Fine Arts, the modern wing of the Metropolitan Museum in New York, and the Musée de l'Art Moderne in Paris.

As it is most often told in art museums, classrooms, and textbooks, the history of modern art unfolds as a succession of formally distinct styles (or, in more sophisticated accounts, as a series of art-historical moments that open up new formal possibilities). Usually it is Cézanne who takes the most significant first step toward modernism – in the MoMA's installation, this happens almost literally: Cézanne's *Walking Man* greets the visitor at the very threshold of the permanent collection, as he has in MoMA installations for the last two decades (Figure 5.1). Appropriately enough, considering his importance as the bringer of modern art, Cézanne's advent is dramatically foretold by a large bronze figure of *Saint John the Baptist* (Rodin's), who points to him from just outside the entrance. Following Cézanne and other post-Impressionists, Fauvism makes an appearance. But in the MoMA, as in many other museums, it is Cubism that most heralds the future. In the MoMA's version, it commands the narrow passage through which visitors make the first turn in the prescribed route (the layout of the galleries allows visitors few options). After Cubism, the history of modern art burgeons – practically all of the famous twentieth-century avant-garde movements from Futurism up to Surrealism will take from it their basic direction and structure. A non-Cubist, "Expressionist" subplot, in which Matisse is the central figure (announced by Van Gogh, Gauguin, and Fauvism), is also present but subordinated to the Cézanne-to-Cubism story.

Figure 5.1 Museum of Modern Art, New York: entrance to the permanent collection (photo: author).

Dada and Surrealism open the next major chapter in this history of art (I am still relying on the MoMA's program, but the same story is told almost everywhere in the West). They push modern art's earlier conquests of the subjective self to new depths and in new directions. Miró is usually the most important figure here, but Duchamp and Ernst also loom large. The next big moment after Surrealism comes in Post-World War II New York with the development of Abstract Expression. In the MoMA, European figures like Dubuffet, Masson, and Bacon are assimilated to it. Earlier American artists like Stuart Davis and Hopper, who can not be so easily fitted in, are hung in corners or alcoves out of the way of the "main stream"; likewise the Mexican artists Rivera and Orozco, who have often ended up out in the hall. Minimal and Pop Art follow Abstract Expressionism as its major after-shocks. Then, comes an assortment of works drawn from major market trends of the 1970s and 1980s.

MoMA's presentation of this history – at least through Abstract Expressionism, Minimal, and Pop – is extraordinary in both quality and quantity; few other museums can offer, as it does, so many chapel-like rooms exclusively

devoted to *the* major art-historical figures – Picasso, Matisse, Miró, Pollock. Even so, rival collections – in London, Los Angeles, Washington, New York, and other big cities – mount good replicas of the MoMA's orthodox plot (Figure 5.2). Of course, there are variations. In most places, special import-ance is attached to home-grown artists – Braque in the Centre Pompidou, Mondrian in Amsterdam, and so on. In MoMA's present installation, the simultaneity of developments of art-historical styles is more acknowledged than heretofore; for example, Kandinsky is introduced earlier, next to and no longer after, some of the later Cubists. The European avant-garde thus looks less like a strict succession of separate, nation-based styles, although the familiar art-historical style categories still structure the story.

Galleries devoted to post-World War II American art are especially predictable. Individual Abstract Expressionists such as Clifford Still or Mark Rothko are often given galleries of their own, as in the Met, San Francisco's Museum of Modern Art, or the Tate Gallery in London (Figure 5.3). Although few museums have both space and collection enough for such individual artist chapels, almost every major museum in America and many abroad devote one or more galleries to the New York School collectively (Figure 1.5). Whether in New York, Los Angeles, or Houston, Texas, large-scale works by Pollock, Newman, Gottlieb, de Kooning, Klein, and the rest fill monu-mental galleries that read as climactic moments in the museum's modern-art narrative. Indeed, in the 1950s and 1960s, these artists produced large

Figure 5.2 Modern art in the Los Angeles County Museum of Art (photo: author).

106

Figure 5.3 A room of Rothko paintings in the Tate Gallery, London (photo: author).

quantities of their most characteristic, signature works precisely to feed a rapidly expanding, seemingly insatiable art-museum market.

My point is not that museum directors and curators lack the interest or imagination to do anything different (although that may be true), but rather that they are constrained to program their galleries within a cultural construct – one that is never fully of their making but for which they will be held responsible by their superiors in the museum, by the views of other art-world professionals and by the variously informed, often conservative publics they serve, publics whose expectations are barely touched by the new or revisionist art-historical thinking. Which brings me, once again, to the central idea of this book, that art museums are a species of ritual space.

It is not, I believe, farfetched to think of the situation of a museum curator as analogous to that of a medieval church official responsible for planning the iconographic program of a cathedral. As scholars have long observed, the images and themes that recur in the sculptural decorations of medieval cathedrals are almost always based on certain authoritative literary sources – Old and New Testament texts, Apocryphal books, narratives of saints, and the like. Moreover, the theological significance of these subjects (the story of Jonah, the Annunciation, the Last Judgment) was considerably elaborated by an interpretive discourse that determined even such details as the size and placement of individual iconographic elements in relation to each other and to the whole.[9] So, too, in museums, an organizing art-historical narrative

draws authority from a system of beliefs that is codified by and elaborated in a surrounding discourse. We have already seen such coherence in the nineteenth-century public art museums studied in Chapter 2.

What, then, is the ritual scenario of a gallery of modern art? Let us start with the museum's central narrative, according to which modern art unfolds as a series of moments, each involving a new and unique artistic achievement and each growing out of (or negating) something before it. As constructed in both museums and art-historical texts, modern art history – that is, the modern art history that counts – moves always forward. Its progress, relentless and irreversible, is propelled by the efforts of artists who, individually or in teams, work through issues or overcome impasses posed by earlier modern artists. Picasso's Cubist works build upon and transcend the art of Cézanne. Pollock's "breakthrough" compositions transcend the resolutions of Cubism. The most celebrated artists are those who are thought to have left the field most changed from the way they found it, pushed it the farthest in a new direction and redefined most radically the terms of entry for future individuals.

Central to all of this history of individual achievement, then, is an idea of progress. But progress toward what? In the nineteenth century, progress in art was progress toward an ideal that, brilliantly realized in the past, could now measure the achievements of the present. In the twentieth century (that is, in most twentieth-century art history), progress in modern art, especially the art of the first two-thirds of the century, is gauged by the degree to which art achieved greater abstraction – the distance it travelled in emancipating itself from the imperative to represent convincingly or coherently a natural, presumably objective world. Modern art's most important figures rejected the commitment to illusionism that was for so long central to western painting and sculpture. The mandate of modern art is thus represented as a mandate to turn away from the objective world – to devalue its significance or deny its coherence – and concern oneself with some aspect of subjective experience, including the artist's struggle to renounce the exterior world. It is to this end that modern artists have thrown out, piece by piece, all the accumulated knowledge that constituted traditional artistic skills. And it is for this reason that, as the century wore on, they become progressively less interested in and able to create convincing illusions of space, volume, light, shadow, and the rest. These were replaced with newly invented visual languages and creative techniques (free association, color experiments, the use of chance, and so on) that enabled artists to evoke new universes of modern thought and feeling.

There is a little-remarked aspect of this history – or rather of the many histories of individual artists that make it up – and that is a recurrent narrative pattern that identifies artistic invention with *moral* achievement. According to this pattern, the more artists free themselves from representing recognizable objects in space, the more exemplary they become as moral beings and the more pious and *spiritually* meaningful their artistic efforts. The pursuit

of abstraction (or the distance achieved from traditional pictorial constructions) thus becomes the supreme sign of an artist's liberation from the mundane and commonplace. Given the symbolic import of abstraction, it is not surprising that the literature of art history has been obsessed with chronicling the formal development of abstract artists. Indeed, much of the most admired art-historical enquiry has consisted in meticulously sifting the slightest minutia of an artist's production in order to grasp the uniqueness and originality of his contribution to modern art's progress toward abstraction. Countless books, articles, and catalogues depict artists who renounce representation as heroes engaging in moral struggle, accepting pain or sacrifice rather than compromise their artistic credos. The disruption of space, the denial of volume, the overthrow of traditional compositional schemes, the discovery of painting as an autonomous surface, the emancipation of color, line or texture, the occasional transgressions and reaffirmations of the boundaries of art (as in the adaptation of junk or non-high art materials), and so on through the liberation of painting from frame and stretcher and thence from the wall itself – all of these formal advances translate into moments of moral as well as artistic ordeal.

To be sure, this conflation of the moral and the aesthetic is rarely an articulated theme in the critical literature. On the contrary, the dominant tradition, beginning with the work of Roger Fry and his contemporaries and continuing through the 1960s, expressly treats the two as mutually exclusive categories of judgment. Where the aesthetic reigns, the moral is presumably immobilized. In practice, however, the moral seems not so much vanquished as hidden inside the aesthetic, which, in the name of purity or some other artistic value, appropriates its function as an imperative. A text by the critic Michael Fried, written in 1965, offers a rare statement of this aesthetic-as-moral principle. Fried first insists that the artistic judgments that make a work significant as modern art take place outside the moral-practical realm. (In this, Fried is following Clement Greenberg, the art critic who articulated most fully and authoritatively the formalist dogma that dominated high-art criticism of the 1950s and 1960s.)[10] Having thus evicted the moral from the realm of art, Fried proceeds to reimport it, arguing that the modern artist's pursuit of abstract form is *like* moral experience, that it *feels* moral and has "the denseness, structure and complexity of moral experience."[11] Fried's text is an excellent example of modern criticism as a kind of crypto-moral sermon and rightly earned him recognition as an important young critic, deeply committed to the cause of art.

The modern artist, then, as a consequence of his moral-aesthetic struggle, renounces representation of the visible world in order to connect with an inspiring realm of purity and truth that lies beyond it (or, in a more liberal variant, in order to advance toward a utopian future). In Cubism, this realm is identified as the process of thought itself. Mondrian and Kandinsky, each in different ways, discover abstract, universal forces and make their works

visible analogues of them. Similarly, Delaunay discovers cosmic energy and powers his painting with it. Miró explores a limitless and potent psychic field, while the Abstract Expressionists travel to even less nameable reaches of the unknown. All of these artistic breakthroughs (and others – Futurism, Suprematism, the Blue Rider) are, at one and the same time, moments of spiritual transcendence and moral example.[12]

In the liminal space of the museum, the visitor is prompted to re-live these many, successive moments of heroic renunciation. Just as images of saints were, by example, supposed to trigger in the initiated a quest for spiritual transcendence, so in the museum, art objects focus and organize the viewer's attention, activating by their very form an inner spiritual or imaginative act. The museum setting, immaculately white and stripped of all distracting ornament, promotes this intense concentration. All depends, of course, on whether or not visitors have learned to use these works knowledgeably as ritual artifacts, whether or not they can identify with the artist's spiritual-formal struggles through the work, its surfaces, composition, symbols, and other manifestations of artistic choice. The art objects thus provide both the content and structure of the ritual performance. Through them, viewers enact a drama of enlightenment in which spiritual freedom is won by repeatedly overcoming and moving beyond the visible, material world. In the art museum, even reproductions of beer or soup cans achieve this meaning as do other works that depend heavily on non-art objects for their form or materials. What matters is their power to demonstrate the art-ness of art and to transcend the meaning of those other beer and soup cans that are *not* in the art museum. Artists may or may not intend such meanings for their work; I speak here not of their intentions, but of the uses their works serve in art-museum installations.

These heroic-artistic acts, however, are not given equal value by the history of art. In this, saints have had an advantage. They acted in a universe whose forces of good and evil were constant. Modern artists must live in and transcend an always changing world – a world that (in art-historical thinking) is coterminous with the history of art itself. In that world, the attainments of yesterday – what previously made the heavenly gates of critical acclaim open – become derivative today and not worth even the price of the paint. The challenge before the artist is not to repeat but to advance a spiritual history, to overcome its present obstacles and plot its future course – and, often, as a by-product, throw new light on the achievements of past artists. In the narrative, certain moments are more climactic than others, more fraught with difficulty and danger; or they require greater leaps into the future. Cézanne, Cubism, and Surrealism are such moments. So is American Abstract Expressionism. Indeed, its very scale, which so overwhelms its predecessors, demands monumental space. In almost any museum displaying it, the passage into galleries of Abstract Expressionism is a movement into something visibly and dramatically different from what came before. Here is the work

of bigger-than-life heroes, who, by their own lights, went beyond the limits of art itself. They made the final breakthrough into the realm of absolute spirit, manifested as absolute formal and non-representational purity. Their achievements continue to set standards of scale and ambition for aspirants to the gigantic spaces of modern museum galleries.

And yet, there is something odd about all this progress toward ever greater abstraction, all this reaching into ever more transcendent realms of mind and spirit, all this inventing of new ways to demonstrate the category of art. Consider again the MoMA's galleries. The place is thick with images and representations. And most of them are of women (Figures 5.4 and 5.5). These women, however, are almost never portraits of specific individuals. The largest number are simply female bodies, or parts of bodies, with no identity beyond their female anatomy – those ever-present "women" or "seated women" or "reclining nudes"; Matisse and Picasso alone fill literally acres of the world's gallery space with them. There are also quantities of tarts, prostitutes, artists' models, and low-life entertainers. These, too, are un-specified individually, identifiable only as occupants of the lower rungs of the social ladder. In short, the women of modern art, regardless of who their real-life models were, have little identity other than their sexuality and availability, and, often, their low social status.

Figure 5.4 Inside the Museum of Modern Art: images of women by Picasso (photo: author).

Figure 5.5 Inside the Museum of Modern Art: with Kirchner's streetwalkers (photo: author).

In these images, too, the MoMA's collection is outstanding. Because of the museum's history as an early champion of abstract and formalist values, the sheer *amount* of female imagery in the collection and its prominent place in the installation is staggering. Picasso's *Demoiselles d'Avignon*, Léger's *Grand Déjeuner*, the street walkers in Kirchner's *The Street* (in Figure 5.5), Duchamp's *Bride*, Severini's *Bal Tabarin* dancer, de Kooning's *Woman I*, and many other works are often monumental in scale and conspicuously placed – just as the critical and art-historical literature features them as seminal works. To be sure, modern artists often make "big" philosophical or artistic statements via the nude. If the MoMA exaggerates this tradition or states it with excessive zeal (and I'm not sure it does), it is nevertheless an exaggeration of something pervasive in modern art production and its supporting critical discourse. (Other museums are not very different.) In fact, the MoMA's most recent installation seems to assign these images slightly fewer front-and-center places than previous installations; but so many big, famous "key" works are difficult to downplay. In any case, unless and until the museum adopts an entirely different organizing program, such an exercise would hardly have a point.

Until the last two decades, art history has shown little interest in accounting for this intense preoccupation with sexually available female bodies. While it has never hesitated to extol the artistic prowess of their inventors, it has

not raised larger questions about their meaning in the context of the history of art. Why, then, are images of nudes and whores an accompaniment to modern art's heroic renunciation of representation; why are they accorded such prestige and authority; and how do they relate to the high moral import of modern art? To focus these questions, let us examine some female images in the ritual space of the art museum.

It may be the case that more women than men enter modern art museums, become members, buy gifts in the gift shops, eat in the restaurants, and ultimately pay the museums' operating costs. As a high-culture ritual, however, a museum of modern art, like a universal survey museum, is normally scripted for male subjects – even New York's MoMA, which was founded by women.[13] Certainly, no public art museum admits to privileging anyone among its visitors. Nevertheless, not only is the museum's immediate space gendered, but so also is the larger universe implicit in its program. Both are a man's world. This job of gendering falls largely to the museum's many images of female bodies. Silently and surreptitiously, they specify the museum's ritual as a male spiritual quest, just as they mark the project of modern art in general as a male endeavor, built on male fears, fantasies, and aspirations. Seen in this light, the visitor's quest for the spiritual and his obsession with the female body – rather than appearing unrelated or contradictory – can be understood as parts of a larger, integrated whole. (Later, I shall try to relate that whole to the historically evolved world outside the museum.)

How often images of women in modern art speak of male fears! Many of the works I just named feature distorted or dangerous-looking creatures, potentially overpowering, devouring, or castrating. Indeed, the MoMA's collection is truly resplendent in monstrous, threatening females: Picasso's *Demoiselles* and *Seated Bather*, the latter a giant praying mantis (visible in Figure 5.4), the frozen, metallic odalisques in Léger's *Grand Déjeuner*, the several early female figures by Giacometti, Lipschitz's *Woman* and numerous Abstract Expressionist images, including Baziotes' *Dwarf* – a mean-looking creature with saw teeth and a prominent, visible uterus – to name only some. One could easily expand this category of monster to include works by Kirchner, Rouault, and others who depicted decadent, corrupt – and therefore *morally* monstrous – women.

What, then, can such images contribute to modern art's mission of progressive abstraction and purification? Each of these works testifies in its way to a pervasive fear of and ambivalence about woman. It is possible, too, that they arouse and objectify more widely felt anxieties about unknown and uncontrollable forces, including fears about the body – its life, its overpowering desires, the decay of its flesh and its death – that are often projected onto women and their presumably mysterious biology.[14] However one reads their meaning, in the museum, it is they who give motive to the central moral of modern art.[15] What I am suggesting is that modern art's quest for abstract,

transcendent realms of freedom is the top side of a deeply felt compulsion to flee "woman" and all that she is made to represent – the entire realm of spiritless matter and biological need. I noted above modernist art's pronounced iconography of transcendence – its celebration of such "higher" realms as air, light, mind, spirit, and the cosmos. All of these exist above, beyond, and in opposition to a presumably female and material earth. Cubism, Futurism, The Blue Rider, De Stijl, Surrealism, Abstract Expressionism – all seek out some non-material and autonomous energy in the self or the universe. (Léger's ideal of a rational, mechanical order can also be understood as opposed to – and a defense against – an unruly feminine nature that needs control.) The themes of so much modern art, together with its renunciation of representation and its retreat from the material world – seem at least in part based on an impulse, frequently expressed in modern (as well as primitive) culture, to escape – not the mother in any literal sense, but a psychic image of woman and her earthly domain that seems rooted in infant or childish notions of the mother. Philip Slater noted an "unusual emphasis on mobility and flight as attributes of the hero who struggles against the menacing mother."[16] In museum rituals, recurrent images of monstrous and menacing women add urgency to such flights to "higher" realms. Hence also the presence of their obverse side, the powerless or vanquished woman. Whether man-killer or murder victim – whether Picasso's deadly *Seated Bather* or Giacometti's bronze *Woman with Her Throat Cut* (she is actually a murdered monster) – women literally punctuate and structure the ritual way. Confrontation with and escape from them gives the ritual its dynamic center. The women give meaning, motive, and content to the visitor's ordeal and its spiritual resolution.[17]

I am not suggesting that women are somehow more at home with their biology than are men, or that they might seek freedom from the realm of necessity less than men. I am speaking of constructs whose gendered identities have been culturally assigned. Anthropologist Murial Dimen has noted that myths like the *Odyssey* (of which modern versions abound) are directed toward men and function as "passages to adulthood [that] celebrate independence, singularity, and the discovery and creation of subjectivity." In contrast, myths directed toward women are often about staying at home, waiting and being there for others.[18] It seems to me that the ritual scenarios of modern art museums have precisely the structure of such male-oriented myths. The fact that women may enact ritual scenarios like the one in the MoMA does not alter the gender of the museum's ritual subject or the nature of the universe in which he moves. It is another matter when it comes to the sex of the artists on display. Since the ritual's exemplary heroes are generically male, the presence of more than a token number of women artists can threaten the ritual's integrity. An occasional woman can be absorbed, but too many can dilute the urgency and dynamics of the ordeal, which depends on and exploits male-identified desires and fears. Accordingly, in

conservative, high-modernist galleries, where the ritual atmosphere is most intense (once again, the MoMA is the outstanding example), the number of women artists is kept well below the point where they might effectively de-gender the ritual's masculinity.

Of course, images of men also occur in the museum's program. But unlike those of women, the males are given personal, social, and cultural identities. Even when they represent an anonymous, generic male, they are active beings who creatively shape their world, ponder its meanings and transcend its mundane constraints. In the present MoMA, male figures actually monitor the movement of visitors along the ritual route: Rodin's gesturing *Saint John the Baptist Preaching* (1878–89, Figure 5.1), and Giocometti's *Man Pointing* (1947) show them the way. Elsewhere in the collection, men make music and art, work, build cities, conquer the air through flight, think, and compete in sports (as in works by Cézanne, Rodin, Picasso, Léger, La Fresnaye, and Boccioni). When male sexuality is broached, it is often presented as the experience of highly self-conscious, psychologically complex beings whose sexual feelings are leavened with poetic pain, poignant frustration, heroic fear, protective irony, or the drive to make art (I am thinking of many well-known works in the collection by Picasso, de Chirico, Duchamp, Balthus, Delvaux, and others).

Let us examine how two of art history's most important female images masculinize museum space. The images I will discuss, both key objects in the MoMA, are Picasso's *Demoiselles d'Avignon* and de Kooning's *Woman I*.

Picasso's *Demoiselles d'Avignon*, 1906–7 (Figure 5.6) was conceived as an extraordinarily ambitious statement – it aspires to revelation – about the meaning of Woman. In it, all women belong to a universal category of being existing across time and place. Picasso used ancient and tribal art to reveal her universal mystery: Egyptian and Iberian sculpture on the left and African art on the right. The figure on the lower right looks as if it was directly inspired by some primitive or archaic Gorgon-like deity. Picasso would have known such figures from his visits to the ethnographic art collections in the Trocadero in Paris. A study for the work (Figure 5.7) closely follows the type's symmetrical, self-displaying pose. Significantly, Picasso wanted her to be prominent – she is the nearest and largest of all the figures. At this stage, Picasso also planned to include a male figure on the left and, in the axial center of the composition, a sailor – an image of horniness incarnate. The self-displaying woman was to have faced him, her display of genitals turned away from the viewer.

In the finished work, the male presence has been removed from the image and relocated in the viewing space before it. What began as a depicted male-female confrontation thus turned into a confrontation between viewer and image. The relocation has pulled the lower right-hand figure completely

Figure 5.6 Pablo Picasso, *Les Demoiselles d'Avignon* (oil on canvas, 96⅜" × 92½"), 1906–7, Museum of Modern Art, Lillie P. Bliss Bequest (photo: museum).

around so that her stare and her sexually inciting act – an explicit invitation to penile penetration and the mainstay of pornographic imagery – are now directed outward. Other figures also directly address the viewer as a male brothel patron. Indeed, everything in the work insists on a classic men-only situation. To say it more bluntly – but in language more in the spirit of the work – the image is designed to threaten, tease, invite, and play with the viewer's cock. Thus did Picasso monumentalize as the ultimate truth of art a phallic moment *par excellence*. As restructured, the work forcefully asserts to both men and women the privileged status of male viewers – the only acknowledged invitees to this most revelatory moment. In so doing, it consigns women to a place where they may watch but not enter the central arena of public high culture – at least not as visible, self-aware subjects. The

116

Figure 5.7 Picasso, *Study for "Les Demoiselles d'Avignon"* (charcoal and pastel, 18½" × 24⅝"), 1907. Basel, Oeffentliche Kunstsammlung, Kupferstichkabinett (photo: Kunstsammlung).

alternative role – that of the whore – was and still is for most women untenable.[19]

Finally, the mystery that Picasso unveils about women is also an historical lesson. In the finished work, the women have become stylistically differentiated so that one looks not only at present-tense whores but also back down into the ancient and primitive past, with the art of "darkest Africa" and works representing the beginnings of western culture (Egyptian and Iberian idols) placed on a single spectrum. Thus does Picasso use art history to argue his thesis: that the awesome goddess, the terrible witch, and the lewd whore are all but facets of the same eternal creature, in turn threatening and seductive, imposing and self-abasing, dominating and powerless. In this context, the use of African art constitutes not an homage to "the primitive" but a means of framing woman as "other," one whose savage, animalistic inner self stands opposed to the civilized, reflective male's.

De Kooning's *Woman I* is the descendent of Picasso's *Demoiselles*. For many years, it hung at the threshold to the gallery containing the New York School's biggest "breakthroughs" into pure abstraction: Pollock's flings into artistic and psychic freedom, Rothko's sojourns in the luminous depths

of a universal self, Newman's heroic confrontations with the sublime, Still's lonely journeys into the back beyond of culture and consciousness, Reinhardt's solemn and sardonic negations of all that is not Art. And always seated at the doorway to these moments of ultimate freedom and purity, and literally helping to frame them was *Woman I* (Figure 5.8). So necessary was her presence just there, that when she had to go on loan, *Woman II* came out of storage to take her place. With good reason. De Kooning's *Women*, like Picasso's *Demoiselles*, are exceptionally potent ritual artifacts. They, too, masculinize museum space with great efficiency. (In the present installation, *Woman I* has been moved into the very center of the gallery in which the New York School's largest and most serene abstract works hang. Although her placement there is dramatic, it also disrupts the room's transcendent quietude.[20])

The woman figure had emerged gradually in de Kooning's work in the course of the 1940s. By 1951–2, it fully revealed itself in *Woman I* as a big, bad mama – vulgar, sexual, and dangerous (Figure 5.9). De Kooning imagines her facing us with iconic frontality, large, bulging eyes, an open, toothy mouth, and massive breasts. The suggestive pose is just a knee movement away from open-thighed display of the vagina, the self-exposing gesture of mainstream pornography. These features are not unique in the history of art.

Figure 5.8 Willem de Kooning, *Woman I*, 1952, as installed in the Museum of Modern Art in 1988 (photo: author).

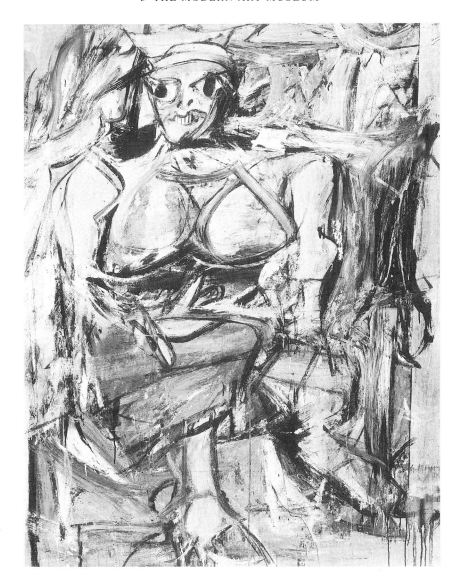

Figure 5.9 De Kooning, *Woman I* (oil on canvas, 76" × 58") 1952, New York, the
Museum of Modern Art (photo: museum).

They appear in ancient and primitive contexts as well as modern pornography
and graffiti. Together, they constitute a well-known figure type.[21] The Gorgon
of ancient Greek art (Figure 5.10) is an instance of that type and bears a
striking resemblance to de Kooning's *Woman I*. Like *Woman I*, she both
suggests and avoids the explicit act of sexual self-display; at other times, she

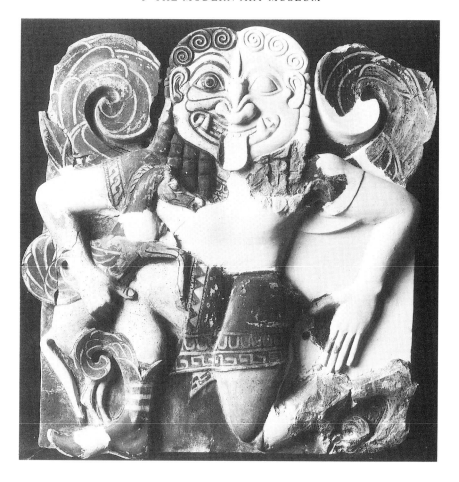

Figure 5.10 Gorgon, clay relief, 6th century BC. Syracuse, National Museum (photo: courtesy of the Photographic Archives of the Superintendent of Cultural and Environmental Affairs of Syracuse).

spreads her thighs wide open (Figure 5.11). Often flanked by animals, she appears in many cultures, archaic and tribal, and is sometimes identified as a fertility or mother goddess.[22]

As a type, with or without animals, the configuration clearly carries complex and probably contradictory symbolic possibilities. Specified as the Gorgon witch, the image emphasizes the terrible and demonic aspects of the mother goddess – her lust for blood and her deadly gaze. Especially today, when the myths and rituals that may have once suggested other meanings have been lost – and when modern psychoanalytic ideas are likely to color any interpretation – the figure appears intended to conjure up infantile feelings of powerlessness before the mother and the dread of castration: in

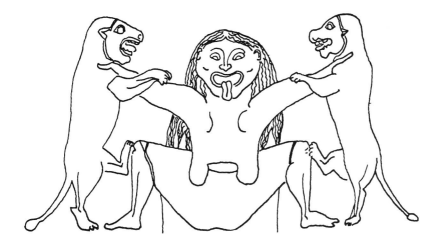

Figure 5.11 Etruscan Gorgon (drawing after a 6th-century BC bronze carriage-front). Museum Antiker Kleinkunst, Munich.

the open jaw can be read the *vagina dentata* – the idea of a dangerous, devouring vagina, too horrible to depict, and hence transposed to the toothy mouth. Feelings of inadequacy and vulnerability before mature women are common (if not always salient) phenomena in male psychic development. Myths like the story of Perseus and visual images like the Gorgon can play a role in mediating that ·development by extending and recreating on the cultural plane its core psychic experience and accompanying defenses.[23] Publicly objectified and communally shared in imagery, myth, and ritual, these individual fears and desires may achieve the status of authoritative truth. In this sense, the presence of Gorgons on Greek temples – important houses of cult worship – is paralleled by *Woman I*'s presence in a high-cultural house of the modern world.

The head of de Kooning's *Woman 1* is so like the archaic Gorgon that the reference could well be intentional, especially since the artist and his friends put great store in ancient myths and primitive images and likened themselves to archaic and tribal shamans. The critic Thomas Hess evokes these ideas in an essay about de Kooning's "women." According to Hess, de Kooning painting a "woman" was an artistic ordeal comparable to Perseus slaying the Gorgon, for to accomplish his end, de Kooning had to grasp an elusive, dangerous truth "by the throat" without looking at it directly.

> And truth can be touched only by complications, ambiguities and paradox, so, like the hero who looked for Medusa in the mirroring shield, he must study her flat, reflected image every inch of the way.[24]

But then again, the image type is so ubiquitous, we needn't try to assign de

121

Kooning's *Woman I* to any particular source in ancient or primitive art. *Woman I* can call up the Medusa as easily as the other way around. Whatever he knew or sensed about the Gorgon's meanings, and however much or little he took from it, the image type is decidedly present in his work. Suffice it to say that de Kooning was aware, indeed, explicitly claimed, that his "women" could be assimilated to the long history of goddess imagery.[25] By placing such figures at the center of his most ambitious artistic efforts, he secured for his work an aura of ancient mystery and authority.

Woman I is not only monumental and iconic. In high-heeled shoes and brassiere, she is also lewd, her pose indecently teasing. De Kooning acknowledged her oscillating character, claiming for her a likeness not only to serious art – ancient icons and high-art nudes – but also to pinups and girlie pictures of the vulgar present. He saw her as simultaneously frightening and ludicrous.[26] The ambiguity of the figure, its power to resemble an awesome mother goddess as well as a modern burlesque queen, provides a superbly designed cultural, psychological, and artistic artifact with which to enact the mythic ordeal of the modern artist-hero – the hero whose spiritual adventures become the stuff of ritual in the public space of the museum. It is the *Woman*, powerful and threatening, who must be confronted and transcended on the way to enlightenment (or, in the present MoMA, in the very midst of it). At the same time, her vulgarity, her "girlie" side – de Kooning called it her "silliness" – renders her harmless (and contemptible) and denies the terror and dread of her Medusa features. The ambiguity of the image thus gives the artist (and the viewer who has learned to identify with him) both the experience of danger and a feeling of overcoming (or perhaps simply denying) it. Meanwhile, the suggestion of pornographic self-display – it will be more explicit in his later works – specifically addresses itself to the male viewer. With it, de Kooning exercises his patriarchal privilege of celebrating male sexual fantasy as public high culture.

Thomas Hess understood exactly the way in which de Kooning's "women" enabled one to both experience the dangerous realm of woman-matter-nature and symbolically escape it into male-culture-enlightenment. The following passage is a kind of brief user's manual for any of de Kooning's "women" (and his other, more abstract paintings as well, since they, too, usually began as female figures). It also articulates the core of the ritual ordeal I have been describing. Hess begins with characterizing de Kooning's materials. They are clearly female, engulfing, and slimy, and must be controlled by the skilled, instrument-wielding hands of a male:

> There are the materials themselves, fluid, viscous, wet or moist, slippery, fleshy and organic in feel; spreading, thickening or thinning under the artist's hands. Could they be compared to the primal ooze, the soft underlying mud, from which all life has sprung? To nature?

Now comes the artist, brandishing his phallus-tool, to pierce, cut, and penetrate the female flesh:

122

And the instruments of the artist are, by contrast, sharp, like the needlepoint of a pencil; or slicing, like the whiplash motion of the long brush.

And finally, the symbolic act of the mind that the viewer witnesses and re-lives:

> Could not the artist at work, forcing his materials to take shape and become form [be a] paradigm? The artist becomes the tragicomic hero who must go to war against the elements of nature in the hope of making contact with them.[27]

De Kooning is hardly alone in embodying the artist-hero who takes on the fearsome and alluring woman. The type is common enough in high culture. To cite a striking example: an interesting drawing/photomontage by the California artist Robert Heinecken, *Invitation to Metamorphosis* (Figure 5.12), similarly explores the ambiguities of a Gorgon-girlie image. Here the effect of ambiguity is achieved by the use of masks and by combining and superimposing separate negatives. Heinecken's version of the self-displaying woman is a composite consisting of a conventional pornographic nude and a Hollywood movie-type monster. As a well-equipped Gorgon, her attributes include an open, toothy mouth, carnivorous animal jaws, huge bulging eyes, large breasts, exposed female genitals, and one nasty-looking claw. Her body is simultaneously naked and draped, enticing and repulsive, and the second head, to the left of the Gorgon head – the one with the seductive smile – also wears a mask. Like the de Kooning, Heinecken's *Invitation* sets up a psychologically unstable atmosphere fraught with deception, allure, danger, and wit. The image's various components continually disappear into and reappear out of each other. Behaving something like de Kooning's layered paint surfaces, they invite ever-shifting, multiple readings. In both works, what is covered becomes exposed, what is opaque becomes transparent, and what is revealed conceals something else. Both works fuse the terrible killer-witch with the willing and exhibitionist whore. Both fear and seek danger in desire, and both kid the danger.

In all of these works, a confrontation is staged between a Perseus-like artist-hero and a lewd, uncivil, and uncontrollable female. And in every case, the danger is forced back behind the divide of art. Like Picasso in the *Demoiselles*, de Kooning summons support from the most ancient artistic cultures. But he also draws on modern pornography. Indeed, it is de Kooning's achievement to have opened museum culture to the potential powers of pornography. By way of exploring how the pornographic element works in the museum context, let us look first at how it works outside the museum.

A few years ago, an advertisement for *Penthouse* magazine appeared on New York City bus shelters – the one in my photograph is located on 57th Street (Figure 5.13). New York City bus shelters are often decorated with

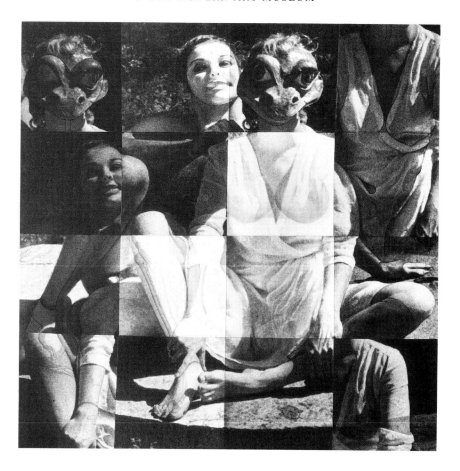

Figure 5.12 Robert Heinecken, *Invitation to Metamorphosis* (emulsion on canvas and pastel chalk, 42" × 42"), 1975 (photo: artist).

near-naked women and sometimes men advertising everything from underwear to real estate. But this was an ad for pornographic images as such, that is, images designed not to sell perfume or bathing suits, but to stimulate erotic desire, primarily in men. Given its provocative intent, the image generates very different and – I think for almost everyone – more charged meanings than the ads for underwear. At least one passer-by had already recorded in red spray-paint a terse, but coherent response: "For Pigs."

Having a camera with me, I decided to take a shot of it. But as I set about focusing, I began to feel uncomfortable and self-conscious. As I realized only later, I was experiencing some prohibition in my own conditioning, activated not simply by the nature of the ad, but by the act of photographing such an ad in public. Even though the anonymous inscription had made it socially

124

Figure 5.13 Bus shelter on 57th Street, New York City, 1988, with advertisement for *Penthouse* magazine (photo: author).

safer to photograph – it placed it in a conscious and critical discourse about gender – to photograph it was still to appropriate openly a kind of image that middle-class morality says I'm not supposed to look at or have. But before I could sort that out, a group of boys jumped into the frame. Plainly, they intended to intervene. Did I know what I was doing?, one asked me with an air I can only call stern, while another admonished me that I was photographing a *Penthouse* ad – as if I would not knowingly do such a thing.

Apparently, the same culture that had conditioned me to feel uneasy about what I was doing also made *them* uneasy about it. Boys this age know very well what's in *Penthouse*. Knowing what's in *Penthouse* is knowing something meant for men to know; therefore, knowing *Penthouse* is a way of knowing oneself to be a man, or at least a man-to-be, at precisely an age when one needs all the help one can get. I think these boys were trying to protect the capacity of the ad to empower them as men by preventing me from appropriating an image of it. For them, as for many men, the chief (if not the only) value of pornography is this power to confirm gender identity and, with that, gender superiority. Pornography affirms their manliness to themselves and to others and proclaims the greater social power of men.[28] Like some ancient and primitive objects forbidden to the female gaze, the ability of pornography to give its users a feeling of superior male status depends on its being owned or controlled by men and forbidden to, shunned by, or hidden

125

from women. In other words, in certain situations a female gaze can *pollute* pornography.[29] These boys, already imprinted with the rudimentary gender codes of the culture, knew an infringement when they saw one. (Perhaps they suspected me of defacing the ad.) Their harassment of me constituted an attempt at gender policing, something adult men routinely do to women on city streets.

Not so long ago, such magazines were sold only in sleazy porn shops. Today ads for them can decorate mid-town thoroughfares. Of course, the ad as well as the magazine cover, cannot itself be pornography and still be legal (in practice, that tends to mean it can't show genitals), but to work as advertising, it must *suggest* pornography. For different reasons, works of art like de Kooning's *Woman I* or Heinecken's *Invitation* also refer to without actually being pornography – they depend upon the viewer "getting" the reference without being mistakable for pornography. Given those requirements, it is not surprising that these artists' visual strategies have parallels in the ad (Figure 5.14). Indeed, *Woman I* shares a number of features with it. Both present frontal, iconic, monumental figures that fill and even overflow their picture surfaces, dwarfing viewers and focusing attention on head, breasts, and torso. Both figures appear powerful and powerless at the same time, with massive bodies made to rest on weakly rendered, tentatively placed legs, while arms are cropped, undersized or feeble.[30] And with both, the viewer is positioned to see it all should the thighs open. And of course, on *Penthouse* pages, thighs do little else but open. However, de Kooning's hot mama has a very different purpose and cultural status from a *Penthouse* "pet."

De Kooning's *Woman I* conveys much more complex and emotionally ambivalent meanings. The work acknowledges more openly the fear of and flight from as well as a quest for the woman. Moreover de Kooning's *Woman I* is always upstaged by the artist's self-display as an artist. The manifest purpose of a *Penthouse* photo is, presumably, to arouse desire. If the de Kooning awakens desire in relation to the female body it does so in order to deflate or conquer its power of attraction and escape its danger. The viewer is invited to relive a struggle in which the realm of art provides escape from the female's degraded allure. As mediated by art criticism, de Kooning's work speaks ultimately not of male fear but of the triumph of art and a self-creating spirit. In the critical and art-historical literature, the "women" themselves are treated as catalysts or structural supports for the work's more significant meanings: the artist's heroic self-searching, his existentialist courage, his pursuit of new pictorial structures or some other artistic or transcendent end – in short, the mythic stuff of art-museum ritual.[31]

I wish to be especially clear at this point that I have no quarrel either with the production or the public display of these or other works like them. My concern rather is with the ritual scenarios of art museums and the way they do and do not address women and other visitors. If I am protesting anything

Figure 5.14 Advertisement for *Penthouse*, April, 1988, using a photograph by Bob Guccione. Courtesy of *Penthouse* magazine.

in museums, it is not the presence of *Woman I* or the *Demoiselles* but the exclusion of so much *else* from museum space. What I would like to see is a truly revisionist museum, with different, more complex and possibly even multiple scenarios that could build on a broader range of human experience – sexual, racial, and cultural – than the present pathetically narrow program that structures most modern art museums today. Indeed, such a program might well promote a deeper understanding even of the museum's modernist old masters by recognizing their flights and fears as historically specific responses to a changing world.[32] A more open museum culture could illuminate rather than perpetuate the profound and on-going crisis of masculinity that marks so much museum art.

I have been arguing, from the example of the MoMA and other collections, that the history of modern art is a built structure that privileges men in ways that are both obvious and subtle. Certainly more women artists could be integrated into museum programs even as things now stand – figures like Joan Mitchell, Louise Nevelson, Agnes Martin, or Eva Hesse have already been fitted into the story of progressive abstraction without disrupting it. But the problem involves more than numbers and is not merely a question of adding women to the familiar narrative. What has kept women artists out of art history is not merely biased curators (who, in any case, are not more biased than anyone else). It is no small thing for women artists to face an overwhelmingly authoritative tradition that has made it highly problematic for them to occupy public art space *as women*. For many, the entire art world – its art schools, critics, dealers, and especially its summit museum spaces – has seemed organized to maintain a universe precisely structured to negate the very existence of all but white males (and a few token "exceptions").

And yet, for the last twenty-five years or so, as repercussions of the civil rights and women's movements – and, more recently, the lesbian and gay movement – have reached the art world, museum space has begun to open up. Women artists are often still confined to marginal spaces or temporary exhibitions, but it is no longer possible to ignore their presence in the art world. While older artists such as Marisol, Louise Bourgeois, and Alice Neel have become more visible, younger artists such as Barbara Kruger, Cindy Sherman, and Kiki Smith – to name only a few, have begun to de-masculinize the museum and rescript its ritual, bringing with them new concerns and, often, a critical outlook that can not easily be assimilated to the museum's normal ritual ordeal.

The modern art museum's program not only assumes a male ritual subject; like the nineteenth-century museum, it constructs a larger universe and places that subject within it. Let us again consider the citizen-visitor of the nineteenth-century public art museum and the ideal world in which he moves. A rational, enlightened male, his universe is made up of two complementary

spheres: the public and the private, the community and the family. Between them, he realizes his potential in every significant way: biologically, morally, politically, and culturally. The ritual of the public art museum affirms the structure of this world and gives particular substance to the citizen's public self, defining it in relation to a politically constituted community with shared values and a common historical past. It also celebrates and idealizes (from a male perspective) the pleasures and beauty of domestic and private experience. Within this structure, freedom (as opposed to leisure) is something exercised largely (if not entirely) in the civic realm and is contingent on the realization of the state and the political autonomy of the individual.[33]

In the course of the twentieth century, this bourgeois ideal of a social-moral universe has steadily lost its power to convince, even in the most official of public spaces. Although traces of it survive, the old dichotomy of public and private has become obscured and overlaid by a new configuration that has reworked some of its central elements. The private sphere of home and family has especially assumed new significance. Once opposed to a public sphere, it is now positioned antithetically to the world of work. And freedom, which in the nineteenth century still presupposed a public arena, has moved almost totally to the private sphere. The opposition between freedom and necessity is still there, but it has been redefined. Whereas once home and work comprised the realm of necessity (where laws of nature prevail and biological and material needs are met), in the modern world, the home, or more broadly, *privacy*, has become the realm of freedom, now understood as the chief site of leisure. Its opposite is the workplace, where one does not as one pleases, but as one must.

Nowhere is this universe more insistently evoked or graphically represented than in advertising.[34] In newspapers and magazines, on television and billboards, indoors and out, even in the sky, advertising fills every possible space, threatening to collapse all space – public and private, urban and rural – into one homogenous commercial zone. Advertising gives us the universe – and ourselves – as transformed by the profit-seeking gaze of capital. Aside from the specific products it promotes, the persistent, underlying message of advertising is the ideal of consumerism itself, the promise that individual happiness is best sought in the consumption of mass-produced goods and services. According to the imagery of ads, the most common site of this happiness and freedom is the private space of the home, where, presumably, one is empowered to shape one's life (often by altering one's body). But other times and places – vacation time, travel, the lunch break – are equally targeted. Indeed, as advertising depicts it, society (in so far as one can know it) is no more than the sum total of individual buyers in search of beauty, comfort, and status through the consumption of commodities, and freedom is no more than the right to prefer one brand over another. As a TV ad once put it,

> Soon America will have a *real* choice: the new taste of Coke or the original taste of Coca-Cola classic.

In such a world, where each seeks only personal gratification through consumption, it is barely possible to speak meaningfully of such ideas as the public or the common good, let alone of the possibility of collective action.[35] Advertising, "the official art of modern capitalist society," as Raymond Williams called it,[36] helps naturalize this world by representing and celebrating individual powerlessness as true individual freedom.

There is, I think, a remarkable fit between the world as constructed by advertising and the world as constructed in modern art museums. Like advertising, modern art museums (as distinct from modern *art*) rarely if at all acknowledge a moral-political self. Moreover, their programs aggressively devalue the objective world as a stage for significant or gratifying human effort. Even when "political" art is exhibited, the framing ambience of the museum insists on its meaning as "art," often with such emphasis that other meanings fade. To be sure, certain artists – Hans Haacke, Barbara Kruger, Leon Golub, or Adrian Piper, to name only a few – have developed ways of disrupting the museum's de-politicizing ambience (if only momentarily) and more or less force from viewers political and moral attention – but their work is more often seen in temporary exhibitions than in permanent collections. Surrounded by ample amounts of (usually) white museum space, and set within the museum's carefully ordered program, most work is made to play its part within the whole, even though, in another program it might appear differently. What modern museum culture excels at is the construction of a ritual self that finds meaning and identity not in relation to history, community, or questions of morality but by renouncing such concerns and seeking after something or some place beyond – inner reaches of the irrational or mystical mind, fantasies of the primitive, or some other, "natural," ahistorical realm that can be entered only individually. The microcosm of the art museum, like that of advertising, best accommodates an isolated self.

It is in this sense that art museums dedicated to twentieth-century art most accord with advertising. Certainly museum art and advertising share many features (most notably, an obsession with female bodies), and the two often appropriate each other's themes and forms. But it is not in their iconography or form that they reach their most significant agreement. In fact, museum art keeps a marked distance from advertising. Even when it appropriates advertising imagery, as in the work of Andy Warhol or Robert Rauschenberg, the museum or art-gallery context (not to mention differences in scale and media) surrounds it with tacit quotation marks. So, too, the strategies of later work that contests high art's boundary-lines only to reaffirm them. It is, rather, on the deeper level of ideology that the culture of consumerism and museum culture come together to form a single world: both accommodate only isolated individuals for whom life's greatest values and pleasures exist in a private or subjective realm seemingly outside of the politically organized world.[37]

Abstract Expressionism pushed this outlook to an unprecedented extreme in art-world culture and has, in a sense, kept it there ever since. That is, the

standards it set – of scale, intensity, and inwardness – still determine much modern art, and by extension, the liminal ambience of permanent museum collections. According to its artists and supporters, authentic art *had* to renounce politics (along with all other aspects of the external world). As the critic Harold Rosenberg declared in a 1952 essay, the Abstract Expressionist artist was not trying to change the world, but rather "he wanted his canvas to be a world." The new art "was a movement to leave behind the self that wished to choose his future."[38] Likewise, Barnett Newman (to cite only one more of many statements of this kind) advocated getting rid of historical memory:

> We are freeing ourselves of the impediments of memory, association, nostalgia, legend, myth, or what have you, that have been the devices of western European painting. . . . The image we produce is the self-evident one of revelation . . . that can be understood by anyone who will look at it without the nostalgic glasses of history.[39]

However, as critics and art historians have long argued, such attitudes, for all their rejection of historical memory, fairly reek of the times. We enter here the era of post-World War II America, an era when the imperatives of the Cold War and the dogma of aesthetic autonomy would coalesce in the liberal policies of American cultural institutions.[40] We should also bear in mind that, however important the politics of the period, Abstract Expressionism conquered the museum and art-critical world just as the advertising industry, propelled by expanding post-World War II markets, experienced a period of phenomenal expansion.[41] Undoubtedly, the artists, along with the social world they moved in, saw their work as the polar opposite of everything advertisements stood for: their voyages of the spirit took one away from, not down into, the trough of materialism. And yet, in their invitations to other- and inner-worldly experience, and in their ardent rejection of community, history, and – what goes with the latter – the autonomous and rational self that was the legacy of the enlightenment, their work has definite parallels in advertising. The "admen" of the 1950s worked hard to implant in Americans a new kind of self, one with greater consumer needs and less ability to defer gratification than earlier models. To that end, as Steven Fox has shown, bolder, more visually compelling images (with fewer words to read) were introduced, and motivational researchers were employed to discover the inner mechanisms of the consumerist psyche.

> Instead of treating consumers as rational beings who knew what they wanted and why they wanted it, motivation research delved into subconscious, nonrational levels of motivation to suggest – beforehand – where ads should be aimed.[42]

The museum's ritual program and mass advertising imply each other. Together, they construct a new individualist self, one which exists at the center of a boundless, a-social universe that is both spiritual and material. In

the cult of high art, this self strives for spiritual, implicitly male, purity by transcending the limited and finite material world. In the thrall of advertising, it seeks the (often erotic) pleasures of the material world, which is also without limit and, one might add, infinitely buyable. Each sphere lurks in the other as an implication, a cause, an enticement, and a negation. In the nineteenth century, educated opinion hoped that there would not be a conflict between museum beauty and the culture of commodities; it tried to bring the two together in a new type of museum – the Victoria and Albert was the prototype – invented for that purpose. In the twentieth century, the two cultures coexist as in a love–hate relationship. Advertising and all it stands for contributes to the formation of a spirit-starved self that is driven to escape a world increasingly suffocated by the needs of corporate power and increasingly choked by its products. In the museum's liminal space, the modern soul can know itself as above, outside of, and even against the values that shape its existence.

CONCLUSION

I have argued, among other things, that art museums are elements in a larger social and cultural world. Whatever their potential to enlighten and illuminate, they work within politically and socially structured limits. Should we conclude, then, that the art museum's freedom can be only an illusion that ultimately reconciles us to our own powerlessness? Given the ideological power and prestige of art museums, it is not realistic to think that museum rituals – especially the most prestigious and authoritative ones – can be moved very far from their present functions. But that does not mean that the symbolic uses of museum spaces – let alone other kinds of art spaces – are static or without value, even as they now exist, or that they are impenetrable to new ideas. Even the Museum of Modern Art occasionally addresses us (albeit, usually on a temporary basis) as inhabitants of a wider – and historically more specific – world.[1] Institutions elsewhere have taken bolder steps. In Chicago's Art Institute, the conventional narrative of modern art has been completely opened up to new content. There the present installation of twentieth-century art allows modern artists to appear as a highly diverse collection of men and women who have given form to a wide range of concerns. The work of African-American and women artists is much in evidence, and separate galleries look freshly at specific themes – the varieties of love or of political life in the modern world. Indeed, the installation creates a new context for understanding even the more familiar work of the vanguard, whose concerns now appear to touch a much broader spectrum of experience. Clearly, old assumptions about the primacy of western civilization and white male subjecthood are no longer taken for granted, among either museum professionals or their educated audiences.

Exhibitions in art museums do not of themselves change the world. Nor should they have to. But, as a form of public space, they constitute an arena in which a community may test, examine, and imaginatively live both older truths and possibilities for new ones. It is often said that without a sense of the past, we cannot envisage a future. The reverse is also true: without a vision of the future, we cannot construct and access a usable past. Art museums are at the center of this process in which past and future intersect. Above all,

they are spaces in which communities can work out the values that identify them as communities. Whatever their limitations, however large or small, and however peripheral they often seem, art museum space is space worth fighting for.

NOTES

INTRODUCTION

1 *The Museum Age*, trans. J. van Nuis Cahill, New York, Universe Books, 1967.

2 See, for examples, the numerous writings of J. Paul Getty (listed in the Bibliography), or Thomas Hoving's "The Chase, The Capture," in Hoving (ed.), *The Chase, The Capture: Collecting at the Metropolitan*, New York, Metropolitan Museum of Art, 1975, pp. 1–106.

3 The two best and most comprehensive histories of museums are still those of Germain Bazin, op. cit.; and Niels von Holst, *Creators, Collectors, and Connoisseurs*, trans. B. Battershaw, New York, G. P. Putnam's Sons, 1967.

4 As Benedict Anderson has argued, nation-states have often adopted similar forms, similar institutional strategies, and similar cultural expressions (*Imagined Communities: Reflections on the Origin and Spread of Nationalism*, London: Verso, 1991).

5 See James Clifford, "On Collecting Art and Culture," in *The Predicament of Culture: Twentieth-Century Ethnography, Literature, and Art*, Cambridge, Mass., and London, Harvard University Press, 1988, pp. 215–51.

6 For overviews of this debate, see Terry Zeller, "The Historical and Philosophical Foundations of Art Museum Education in America," in N. B. and S. Mayer, (eds.), *Museum Education: History, Theory, and Practice*, Reston, Va: National Art Education Association, 1989, pp. 10–89; Michael S. Shapiro, "The Public and the Museum," in M. S. Shapiro and L. W. Kemp (eds.), *Museums: A Reference Guide*, New York, Greenwood Press, 1990, pp. 231–61; and Edith A. Tonelli, "The Art Museum," in ibid., pp. 31–58. All of these articles contain excellent bibliographies.

7 The greatest master of anti-aesthetic, anti-ritual, pro-educational polemic was John Cotton Dana, creator of the unconventional Newark Museum of Art in Newark, New Jersey. His writings include *The Gloom of the Museum* and *The New Museum*, both published in 1917 by Elm Tree Press in Woodstock, Vermont. For another, later, and also brilliant, anti-ritual outpouring, see César Graña, "The Private Lives of Public Museums," *Trans-Action*, 1967, vol. 4, no. 5, pp. 20–5.

8 I should especially like to mention the work of Alma S. Wittlin, whose book, *The Museum: Its History and Its Tasks in Education* (London, Routledge & Kegan Paul, 1949), is an impressive piece of museum history as well as a highly reasoned argument for museum reform.

9 Pierre Bourdieu and Alain Darbel, *L'Amour de l'art: Les Musées d'art européens et leur public*, Paris, Editions de minuit, 1969, p. 165 and throughout. Bourdieu continued to argue the social meanings of aesthetic judgement, contending that

the idea of the aesthetic as a separate realm marks a social as well as a philosophical boundary (*Distinction: A Social Critique of the Judgement of Taste* (1979), trans. R. Nice, London and New York, Routledge & Kegan Paul, 1984).

10 On the art/artifact dichotomy, see, Raymond Williams, *Keywords: A Vocabulary of Culture and Society*, New York, Oxford University Press, 1976 (the entries for "Art," "Civilization," and "Culture"); *ART/artifact: African Art in Anthropology Collections*, New York, The Center for African Art and Prestel Verlag, 1988, the catalogue to a remarkable exhibition, curated by Susan Vogel, which recreated different kinds of exhibition environments; and Clifford, op. cit. (for a structuralist analysis of the dichotomy).

11 Reading Catherine Bell's *Ritual Theory, Ritual Practice*, New York and Oxford, Oxford University Press, 1992, pp. 47–54, helped me formulate this paragraph. Bell's essay, which addresses certain of the deep assumptions on which much anthropological writing has proceeded, came into my hands just as I was concluding my own project, and I was unable to avail myself more fully of its insights.

1 THE ART MUSEUM AS RITUAL

1 Mary Douglas, *Purity and Danger*, London, Boston, and Henley, Routledge & Kegan Paul, 1966, p. 68.

 On the subject of ritual in modern life, see Abner Cohen, *Two-Dimensional Man: An Essay on the Anthropology of Power and Symbolism in Complex Society*, Berkeley, Cal., University of California Press, 1974; Steven Lukes, "Political Ritual and Social Integration," in *Essays in Social Theory*, New York and London, Columbia University Press, 1977, pp. 52–73. Sally F. Moore and Barbara Myerhoff, "Secular Ritual: Forms and Meanings," in Moore and Myerhoff (eds.), *Secular Ritual*, Assen/Amsterdam, Van Gorcum, 1977, pp. 3–24; Victor Turner, "Frame, Flow, and Reflection: Ritual and Drama as Public Liminality," in *Performance in Postmodern Culture*, Michel Benamou and Charles Caramello (eds.), Center for Twentieth Century Studies, University of Wisconsin–Milwaukee, 1977, pp. 33–55; and Turner, "Variations on a Theme of Liminality," in Moore and Myerhoff, op. cit., pp. 36–52. See also Masao Yamaguchi, "The Poetics of Exhibition in Japanese Culture," in I. Karp and S. Levine (eds.), *Exhibiting Cultures: The Poetics and Politics of Museum Display*, Washington and London, Smithsonian Institution, 1991, pp. 57–67. Yamaguchi discusses secular rituals and ritual sites in both Japanese and western culture, including modern exhibition space. The reference to our culture being anti-ritual comes from Mary Douglas, *Natural Symbols* (1973), New York, Pantheon Books, 1982, pp. 1–4, in a discussion of modern negative views of ritualism as the performance of empty gestures.

2 This is not to imply the kind of culturally or ideologically unified society that, according to many anthropological accounts, gives rituals a socially integrative function. This integrative function is much disputed, especially in modern society (see, for example, works cited in the preceding notes by Cohen, Lukes, and Moore and Myerhoff, and Edmond Leach, "Ritual," *International Encyclopedia of the Social Sciences*, vol. 13, David Sills (ed.), Macmillan Co. and The Free Press, 1968, pp. 521–6.

3 As Mary Douglas and Baron Isherwood have written, "the more costly the ritual trappings, the stronger we can assume the intention to fix the meanings to be" (*The World of Goods: Towards an Anthropology of Consumption* (1979), New York and London, W. W. Norton, 1982, p. 65).

4 See Nikolaus Pevsner, *A History of Building Types*, Princeton, NJ, Princeton University Press, 1976, pp. 118 ff.; Niels von Holst, *Creators, Collectors and Connoisseurs*, trans. B. Battershaw, New York, G. P. Putnam's Sons, 1967, pp. 228 ff.; Germain Bazin, *The Museum Age*, trans. J. van Nuis Cahill, New York, Universe Books, 1967, pp. 197–202; and William L. MacDonald, *The Parthenon: Design, Meaning, and Progeny*, Cambridge, Mass., Harvard University Press, 1976, pp. 125–32.

5 The phallic form of the *Balzac* often stands at or near the entrances to American museums, for example, the Los Angeles County Museum of Art or the Norton Simon Museum; or it presides over museum sculpture gardens, for example, the Museum of Modern Art in New York or the Hirshhorn Museum in Washington, DC.

6 William Ewart, MP, in *Report from the Select Committee on the National Gallery*, in House of Commons, *Reports*, vol. xxxv, 1853, p. 505.

7 *Purity and Danger*, op. cit. (note 1), p. 63.

8 Arnold van Gennep, *The Rites of Passage* (1908), trans. M. B. Vizedom and G. L. Caffee, Chicago, University of Chicago Press, 1960.

9 Turner, "Frame, Flow, and Reflection," op. cit. (note 1), p. 33. See also Turner's *Dramas, Fields, and Metaphors: Symbolic Action in Human Society*, Ithaca and London: Cornell University Press, 1974, especially pp. 13–15 and 231–2.

10 See Mary Jo Deegan, *American Ritual Dramas: Social Rules and Cultural Meanings*, New York, Westport, Conn., and London, Greenwood Press, 1988, pp. 7–12, for a thoughtful discussion of Turner's ideas and the limits of their applicability to modern art. For an opposing view of rituals and of the difference between traditional rituals and the modern experience of art, see Margaret Mead, "Art and Reality From the Standpoint of Cultural Anthropology, *College Art Journal*, 1943, vol. 2, no. 4, pp. 119–21. Mead argues that modern visitors in an art gallery can never achieve what primitive rituals provide, "the symbolic expression of the meaning of life."

11 Bazin, *The Museum Age*, op. cit. (note 4), p. 7.

12 Goran Schildt, "The Idea of the Museum," in L. Aagaard-Mogensen (ed.), *The Idea of the Museum: Philosophical, Artistic, and Political Questions*, Problems in Contemporary Philosophy, vol. 6, Lewiston, NY, and Quenstron, Ontario, Edwin Mellen Press, 1988, p. 89.

13 I would argue that this is the case even when they watch "performance artists" at work.

14 Philip Rhys Adams, "Towards a Strategy of Presentation," *Museum*, 1954, vol. 7, no. 1, p. 4.

15 For an unusual attempt to understand what museum visitors make of their experience, see Mary Beard, "Souvenirs of Culture: Deciphering (in) the Museum," *Art History*, 1992, vol. 15, pp. 505–32. Beard examines the purchase and use of postcards as evidence of how visitors interpret the museum ritual.

16 Kenneth Clark, "The Ideal Museum," *ArtNews*, January, 1954, vol. 52, p. 29.

17 Kant, *Critique of Judgment* (1790), trans. by J. H. Bernard, New York, Hafner Publishing, 1951.

18 Two classics in this area are: M. H. Abrams, *The Mirror and the Lamp*, New York, W. W. Norton, 1958, and Walter Jackson Bate, *From Classic to Romantic: Premises of Taste in Eighteenth-Century England*, New York, Harper & Bros., 1946. For a substantive summary of these developments, see Monroe C. Beardsley, *Aesthetics from Classical Greece to the Present: A Short History*, University, Alabama, University of Alabama Press, 1975, chs. 8 and 9.

19 For the Dresden Gallery, see von Holst, op.cit (note 4), pp. 121–3.

20 From Goethe's *Dichtung und Wahrheit*, quoted in Bazin, op. cit. (note 4), p. 160.

21 Von Holst, op. cit (note 4), p. 216.
22 William Hazlitt, "The Elgin Marbles" (1816), in P. P. Howe (ed.), *The Complete Works*, New York, AMS Press, 1967, vol. 18, p. 101. Thanks to Andrew Hemingway for the reference.
23 William Hazlitt, *Sketches of the Principal Picture-Galleries in England*, London, Taylor & Hessey, 1824, pp. 2–6.
24 See Goethe, cited in Elizabeth Gilmore Holt, *The Triumph of Art for the Public*, Garden City, New York, Anchor Press/Doubleday, 1979, p. 76. The Frenchman Quatremère de Quincy also saw art museums as destroyers of the historical meanings that gave value to art. See Daniel Sherman, "Quatremère/Benjamin/ Marx: Museums, Aura, and Commodity Fetishism," in D. Sherman and I. Rogoff (eds.), *Museum Culture: Histories, Discourses, Spectacles*, Media and Society, vol. 6, Minneapolis and London, University of Minnesota Press, 1994, pp. 123–43. Thanks to the author for an advance copy of his paper.
25 See especially Paul Dimaggio, "Cultural Entrepreneurship in Nineteenth-Century Boston: The Creation of an Organized Base for High Culture in America," *Media, Culture and Society*, 1982, vol. 4, pp. 33–50 and 303–22; and Walter Muir Whitehill, *Museum of Fine Arts, Boston: A Centennial History*, 2 vols., Cambridge, Mass., Harvard University Press, 1970.

In this chapter, I have quoted more from advocates of the aesthetic than the educational museum, because, by and large, they have valued and articulated more the liminal quality of museum space, while advocates of the educational museum tend to be suspicious of that quality and associate it with social elitism (see, for example, Dimaggio, op. cit.). But, the educational museum is no less a ceremonial structure than the aesthetic museum, as the following two chapters will show.
26 Benjamin Ives Gilman, *Museum Ideals of Purpose and Method*, Cambridge, Boston Museum of Fine Arts, 1918, p. 56.
27 Ibid., p. 108.
28 Leach, "Two Essays Concerning the Symbolic Representation of Time," in *Rethinking Anthropology*, London, University of London, Athlone Press, and New York, Humanities Press, Inc., 1961, pp. 124–36. Thanks to Michael Ames for the reference.
29 Recently, the art critic Donald Kuspit suggested that a quest for immortality is central to the meaning of art museums. The sacralized space of the art museum, he argues, by promoting an intense and intimate identification of visitor and artist, imparts to the visitor a feeling of contact with something immortal and, consequently, a sense of renewal. For Kuspit, the success of this transaction depends on whether or not the viewer's narcissistic needs are addressed by the art she or he is viewing ("The Magic Kingdom of the Museum," *Artforum*, April, 1992, pp. 58–63). Werner Muensterberger, in *Collecting: An Unruly Passion: Psychological Perspectives*, Princeton, NJ, Princeton University Press, 1994, brings to the subject of collecting the experience of a practicing psychoanalyst and explores in depth a variety of narcissistic motives for collecting, including a longing for immortality.
30 See, for example, Charles G. Loring, a Gilman follower, noting a current trend for "small rooms where the attention may be focused on two or three master-pieces" (in "A Trend in Museum Design," *Architectural Forum*, December 1927, vol. 47, p. 579).
31 César Graña, "The Private Lives of Public Museums," *Trans-Action*, 1967, vol.4, no. 5, pp. 20–5.
32 Alpers, "The Museum as a Way of Seeing," in Karp and Levine, op. cit. (note 1), p. 27.
33 Bazin, op. cit. (note 4), p. 265.

2 FROM THE PRINCELY GALLERY TO THE PUBLIC ART MUSEUM

1 Much of what follows draws from Carol Duncan and Alan Wallach, "The Universal Survey Museum," *Art History*, December, 1980, vol. 3, pp. 447–69.

2 For example, in 1975, Imelda Marcos, wife of the Philippine dictator, put together a museum of modern art in a matter of weeks. The rush was occasioned by the meeting in Manila of the International Monetary Fund. The new Metropolitan Museum of Manila, specializing in American and European art, was clearly meant to impress the conference's many illustrious visitors, who included some of the world's most powerful bankers. Not surprisingly, the new museum reenacted on a cultural level the same relations that bound the Philippines to the United States economically and militarily. It opened with dozens of loans from the Brooklyn Museum, the Los Angeles County Museum of Art and the private collections of Armand Hammer and Nathan Cummings. Given Washington's massive contribution to the Philippine military, it is fair to assume that the museum building itself, a hastily converted unused army building, was virtually an American donation. (See "How to Put Together a Museum in 29 Days," *ArtNews*, December, 1976, pp. 19–22.)

The Shah of Iran also needed western-style museums to complete the facade of modernity he constructed for western eyes. The Museum of Contemporary Art in Teheran opened in 1977 shortly before the regime's fall. Costing over $7 million, the multi-leveled modernist structure was filled with mostly American post-World War II art – reputedly $30 million worth – and staffed by mostly American or American-trained museum personnel. According to Robert Hobbs, who was the museum's chief curator, the royal family viewed the museum and its collection as simply one of many instruments of political propaganda. See Sarah McFadden, "Teheran Report," and Robert Hobbs, "Museum Under Siege," *Art in America*, October, 1981, pp. 9–16 and 17–25.

3 For ancient ceremonial display, see Joseph Alsop, *The Rare Art Traditions*, New York, Harper & Row, 1982, p. 197 (on temple treasures); Ranuccio B. Bandinelli, *Rome: The Center of Power, 500 BC to AD 200*, trans. P. Green, New York, Braziller, 1970, pp. 38, 43, 110 (on museum-like displays in temples, houses, and palaces); Donald Strong, *Roman Art*, Baltimore, Penguin Books, 1976, pp. 31–40 (for the ritual display of art in Roman houses, temples, and baths); Germain Bazin, *The Museum Age*, trans. J. van Nuis Cahill, New York, Universe Books, 1967, ch. 1 (on the ancient world); and Francis Haskell, *Patrons and Painters: Art and Society in Baroque Italy*, New York and London, Harper & Row, 1971, ch. 3 and *passim* (for displays in Italian Baroque churches and seventeenth-century palaces).

4 The princely gallery I am discussing is less the "cabinet of curiosities," which mixed together found objects, like shells and minerals, with man-made things, and more the large, ceremonial reception hall, like the Louvre's Apollo Gallery. For a discussion of the differences, see Bazin, op. cit. (note 3), pp. 129–36; and Giuseppe Olmi, "Science-Honour-Metaphor: Italian Cabinets of the Sixteenth and Seventeenth Centuries," in O. Impey and A. MacGregor (eds.), *The Origins of Museums: The Cabinet of Curiosities in Sixteenth and Seventeenth Century Europe*, Oxford, Clarendon Press, 1985, pp. 10–11.

This is not to rule out the importance of seventeenth- and eighteenth-century palace rooms designated as "cabinets" in which precious objects were displayed to privileged visitors. On the ritual uses of such rooms, as well as the development of larger picture galleries, see especially, Mark Girouard, *Life in the English Country House: A Social and Architectural History*, New Haven and London, Yale University Press, 1978, p. 128 ff.; 173 ff.; and *passim*.

5 For princely galleries see Germain Bazin, op. cit. (note 3), pp. 129–39; Niels von Holst, *Creators, Collectors and Connoisseurs*, trans. B. Battershaw, London, G. P. Putnam's Sons, 1967, pp. 95–139 and *passim*; Thomas da Costa Kaufmann, "Remarks on the Collections of Rudolf II: The Kunstkammer as a Form of Representation," *Art Journal*, 1978, vol. 38, pp. 22–8; Hugh Trevor-Roper, *Princes and Artists: Patronage and Ideology at Four Habsburg Courts 1517–1633*, London, Thames & Hudson, 1976; Janice Tomlinson, "A Report from Anton Raphael Mengs on the Spanish Royal Collection in 1777," *Burlington Magazine*, February, 1993 (my thanks to the author for an advance copy of this article); Alma Wittlin, "Exhibits: Interpretive, Under-Interpretive, Misinterpretive," in E. Larrabee (ed.), *Museums and Education*, Washington, DC, Smithsonian Institution Conference on Museums and Education, 1968, p. 98; Rudolf Distelberger, "The Hapsburg Collections in Vienna during the Seventeenth Century," in Impey and MacGregor, op. cit. (note 4), pp. 44–6.

6 More exactly, it established an art museum in a section of the old Louvre palace. In the two hundred years since the museum opened, the building itself has been greatly expanded, especially in the 1850s, when Louis-Napoléon added a series of new pavilions. Until recently, the museum shared the building with government offices, the last of which moved out in 1993, finally leaving the entire building to the museum.

7 For Louvre Museum history, see Christiane Aulanier, *Histoire du Palais et du Musée du Louvre*, Paris, Editions des Musées Nationaux, 9 vols., 1947–64; André Blum, *Le Louvre: Du Palais au Musée*, Geneva, Paris, and London, 1946; Cecil Gould, *Trophy of Conquest: The Musée Napoléon and the Creation of the Louvre*, London, Faber & Faber, 1965; Andrew McClellan, *Inventing the Louvre: Art, Politics, and the Origins of the Modern Museum in Eighteenth-century Paris*, Cambridge, Cambridge University Press, 1994; and *La Commission du Muséum et la Création du Musée du Louvre* (1792–3), documents collected and annotated by A. Tuetey and J. Guiffrey, *Archives de l'art français*, 1909, vol. 3.

8 McClellan, op. cit. (previous note), gives a full account of the ideas that guided the installation of the very early Louvre Museum and of the difference between it and earlier installation models.

9 For some detailed descriptions of gentlemanly hangs, see ibid., pp. 30–9. Iain Pears' *The Discovery of Painting: The Growth of Interest in the Arts in England, 1680–1768*, New Haven and London, Yale University Press, 1988, details the workings of eighteenth-century connoisseurship and art collecting in England.

10 For example, in the Uffizi in Florence, the Museum at Naples and in Vienna in the Schloss Belvedere, the latter installed chronologically and by school by Christian von Mechel (von Holst, op. cit. (note 5), pp. 206–8; and Bazin, op. cit. (note 3), pp. 159–63). See André Malraux's *Museum without Walls* (trans. S. Gilbert and F. Price, Garden City, NY, Doubleday & Co., 1967), for an extensive treatment of the museum as an art-historical construct.

11 Quoted in Yveline Cantarel-Besson (ed.), *La Naissance du Musée du Louvre*, vol. 1, Paris, Ministry of Culture, Editions de la Réunion des Musées Nationaux, 1981, p. xxv.

12 Gustav Friedrich Waagen, *Treasures of Art in Great Britain (1838)*, trans. Lady Eastlake, London, 1854–7, vol. 1, p. 320.

13 See, for example, the lectures delivered to the Royal Academy by the painter Charles Robert Leslie, *Handbook for Young Painters* (1854), London, 1887. Leslie rejects the idea that all art is to be measured according to a single, objective ideal; Rembrandt, Watteau, and Hogarth are as good as Raphael and should be judged each in his own terms (p. 56).

14 For a good example of this, see William Dyce, *The National Gallery, Its Formation and Management, Considered in a Letter to Prince Albert*, London, 1853.

15 Raymond Williams, in *Culture and Society, 1780–1950*, New York, Harper & Row, 1966, part I; and *Keywords*, New York, Oxford University Press, 1976, pp. 48–50 and 76–82, treats the changing meaning of such key critical terms as "art" and "culture."

16 Malraux, op. cit. (note 10), gives an overview of this development in art-historical thinking.

17 See Pears, op. cit. (note 9), for an excellent treatment of this.

18 For Louvre installations, see McClellan, op. cit. (note 7); Edward Alexander, *Museum Masters: Their Museums and their Influence*, Nashville, American Association for State and Local History, 1983, ch. 4; and Aulanier, op. cit. (note 7), vol. 1, pp. 12–31.

19 For accounts of this looting, see McClellan, op. cit. (note 7), or Gould, op. cit. (note 7).

20 Genius is another of those terms that, by the early nineteenth century, already had a complex history and would continue to evolve. See Williams, *Culture and Society*, pp. xiv and 30–48, or Malraux, op. cit. (note 10), pp. 26–7 and *passim*, for some of the changing and complex meanings of the term. At this point, genius was most likely to be associated with the capacity to realize a lasting ideal of beauty. But, new definitions were also in use or in formation – for example, the notion that genius does not imitate (and cannot be imitated), but rather expresses the unique spirit of its time and place (seen, for example, in statements by Fuseli, Runge, and Goya).

21 Aulanier, op. cit. (note 7), vol. 5, p. 76. The stucco figures date from the seventeenth century; the paintings in the ovals and medallions are nineteenth century.

22 See Francis Haskell, *Rediscoveries in Art: Some Aspects of Taste, Fashion and Collecting in England and France*, Ithaca, Cornell University Press, 1976, pp. 8–19.

23 Aulanier, vol. 2, pp. 63–6; and vol. 7, pp. 96–8.

24 See Nicolas Green, "Dealing in Temperaments: Economic Transformation of the Artistic Field in France during the Second Half of the Nineteenth Century," *Art History*, vol. 10, March, 1987, pp. 59–78, for an early phase of the literature of art-historical genius.

25 See von Holst, op. cit. (note 5), pp. 169–71; 204–5; 228–9; and Bazin, op. cit. (note 3), p. 214. The ornately decorated Hermitage Museum in St. Petersburg was probably the most princely of these nineteenth-century creations in both its traditional installations and its visiting policy. Until 1866, full dress was required of all its visitors. Entrance to the Altes Museum in Berlin, the national gallery of the Prussian state, was also restricted, although in form, it was a model of the new art-historical gallery. Designed by the architect Karl Friedrich Schinkel and installed by the art historian Gustav Waagen, its installations were carefully rationalized. See Steven Moyano, "Quality vs. History: Schinkel's Altes Museum and Prussian Arts Policy," *Art Bulletin*, 1990, vol. 72, pp. 585–608.

26 See Daniel J. Sherman, *Worthy Monuments: Art Museums and the Politics of Culture in Nineteenth-Century France*, Cambridge, Mass., and London, Harvard University Press, 1989.

27 See Duncan and Wallach, op. cit. (note 1), for a tour of the Louvre as it existed in 1978.

28 Director of the Museums of France Georges Salles, in "The Museums of France," *Museum*, 1948–9, vols. 1–2, p. 92.

29 For the new Louvre, see Emile Biasini, Jean Lebrat, Dominique Bezombes, and Jean-Michel Vincent, *Le Grand Louvre: A Museum Transfigured, 1981–1993*, Milan and Paris, Electra France, 1989.

30 See, for example, Nathanial Burt, *Palaces for the People: A Social History of the American Art Museum*, Boston and Toronto, Little Brown, 1977, p. 23; Alma Wittlin, *The Museum: Its History and Its Tasks in Education*, London, Routledge & Kegan Paul, 1949, pp. 132–4; and Francis H. Taylor, *Babel's Tower: The Dilemma of the Modern Museum*, New York, Columbia University Press, 1945, p. 17. I cite here only three of the many writers who have understood public art museums in terms of the Louvre.

31 Peter W. Thomas, "Charles I of England: A Tragedy of Absolutism," in *The Courts of Europe: Politics, Patronage and Royalty, 1400–1800*, A. G. Dickens (ed.), London, Thames & Hudson, 1977, pp. 191–201; Francis Haskell, *Patrons and Painters: Art and Society in Baroque Italy*, New York and London, Harper & Row, 1971, p. 175; and Pears, op. cit. (note 9), pp. 134–6. For the contents of Charles I's holdings, see Ronald Lightbown, "Charles I and the Tradition of European Princely Collecting," and Francis Haskell, "Charles I's Collection of Pictures," in Arthur MacGregor (ed.), *The Late King's Goods, Collections, Possessions and Patronage of Charles I in the Light of the Commonwealth Sale Inventories*, London and Oxford, Alistair McAlpine in association with Oxford University Press, 1989, pp. 53–72 and 203–31.

32 Pears, op. cit (note 9), pp. 106 and 133–6; and Janet Minihan, *The Nationalization of Culture*, New York, New York University Press, 1977, p. 10.

33 George I and George II added lavishly decorated state rooms and a grand stair. See John Haynes, *Kensington Palace*, London, Department of the Environment, Royal Parks and Palaces, 1985, pp. 1–8.

34 As Tim Hilton wrote of this exhibition in the *Guardian* (2 October, 1991), p. 36, "something seems not to be right" when people must pay £4 to view works that "seem to be national rather than private treasures," and "seem so obviously to belong . . . in the permanent and free collections of the National Gallery upstairs." As Hilton noted, the Queen's Gallery, a small, recently established exhibition space next to Buckingham Palace, has made selected portions of this collection available to the public; it does not, however, change the status of the collection as private property.

35 Pears, op. cit. (note 9), p. 3.

36 See J. G. A. Pocock, *Politics, Language and Time: Essays on Political Thought and History*, London, Methuen, 1972, especially Ch. 3, "Civic Humanism and its Role in Anglo-American Thought."

37 The British Museum, founded in 1753 by Sir Hans Sloane, President of the Royal Society, is sometimes described as the nation's first public museum (see, for example, Marjorie Caygill, *The Story of the British Museum*, London, British Museum Publications, 1981, p. 4). However, it began its life as a highly restricted gentlemanly space and was democratized only gradually in the course of the nineteenth century. The state did not appropriate public funds for its purchase, but rather allowed a lottery to be held for that purpose. Nor was it conceived as an art collection. Although today it contains several aesthetically installed galleries of objects now classified as "art," (including the famed Elgin Marbles), it originated as an Enlightenment cabinet of curiosities – the museological category from which both science and history museums descend. See Caygill, ibid., and David M. Wilson, *The British Museum: Purpose and Politics*, London, British Museum Publications, 1989.

38 Pears, op. cit. (note 9), pp. 176–8; and Peter Fullerton, "Patronage and Pedagogy:

The British Institution in the Early Nineteenth Century," *Art History*, 1982, vol. 5, no. 1, p. 60.

39 Harold James Perkin, *The Origins of Modern English Society, 1780–1880*, London, Routledge & Kegan Paul, 1969, p. 51.

40 Girouard, op. cit. (note 4), p. 191.

41 Pears, op. cit. (note 9), p. 3, among others, has noted that the entire discourse on painting was explicitly addressed to gentlemen, not ladies.

42 For example, Lafont de Saint-Yenne, *Réflexions sur quelques causes de l'état présent de la peinture en France*, The Hague, 1747, in *Collection Deloynes*, Bibliothèque Nationale, Paris, vol. 2, pp. 69–83.

43 See, for example, William Hazlitt in 1824, complaining (not for the first time) about collections closed to the public: "Do [their noble owners] think that the admiration bestowed on fine pictures or rare sculpture lessens their value, or divides the property, as well as the pleasure with the possessor?" (in *Sketches of the Principal Picture-Galleries in England*, London, Taylor & Hessey, 1924, p. 128).

44 William T. Whitley, *Artists and Their Friends in England, 1700–1799* (1928), New York and London, Benjamin Blom, 1968, vol. 1, pp. 325–7; Minihan, op. cit. (note 32), p. 19; and Fullerton, op. cit. (note 38), p. 59.

45 J. D. Passavant, *Tour of a German Artist in England*, London, 1836, vol. 1, p. 61; and Giles Waterfield, Introduction to *Collection For a King: Old Master Paintings from the Dulwich Picture Gallery* (exh. cat.), Washington, DC, and Los Angeles, National Gallery of Art and Los Angeles County Museum of Art, 1985, p. 17.

46 For the social and political workings of eighteenth-century society, I consulted Asa Briggs, *The Making of Modern England, 1783–1867: The Age of Improvement*, New York, Harper & Row, 1965; Perkin, op. cit. (note 39); Philip Corrigan and Derek Sayer, *The Great Arch: English State Formation as Cultural Revolution*, Oxford and New York, Basil Blackwell, 1985; Edward P. Thompson, "The Peculiarities of the English," in *The Poverty of Theory and Other Essays*, New York and London, Monthly Review Press, 1978, pp. 245–301; and Raymond Williams, *The Country and the City*, New York, Oxford University Press, 1973.

47 Girouard, op. cit. (note 4), p. 3. See also Charles Saumarez Smith, *The Building of Castle Howard*, London and Boston, Faber & Faber, 1990.

48 John Rigby Hale, *England and the Italian Renaissance: The Growth of Interest in Its History and Art*, London, Arrow Books, 1963, pp. 68–82.

49 Pears. op. cit. (note 9), explores this meaning of eighteenth-century collections in depth, especially in chs. 1 and 2. See also Corrigan and Sayer, op. cit. (note 46), ch. 5.

50 For Parliament's neglect of the National Gallery after 1824, see Minihan, op. cit. (note 32), pp. 19–25.

51 For a good example of the latter see Steven Moyano's study of the founding of the Altes Museum in Berlin, op. cit. (note 25).

52 In any case, there was nothing in the eighteenth-century British concept of the state that would call for spending public money on art galleries (see John S. Harris, *Government Patronage of the Arts in Great Britain*, Chicago and London, University of Chicago Press, 1970, pp. 13–14). By all accounts, the rich landowners who controlled the government had neither reason nor rationale to spend government funds for any purpose other than their own protection and self-enrichment.

53 George L. Nesbitt, *Benthamite Reviewing: The First Twelve Years of the Westminster Review, 1824–1836*, New York, Columbia University Press, 1934; Briggs, op. cit. (note 46), chs. 4 and 5; and Perkin, op. cit. (note 39), pp. 287–91, 302.

54 See Minihan, op. cit. (note 32), pp. 13 and 22; and William Hazlitt, "The Elgin Marbles," from the *Examiner*, (1816), in P. P. Howe (ed.) *The Complete Works of William Hazlitt*, New York, AMS Press, 1967, vol. 18, pp. 100–3.

55 Linda Colley, "Whose Nation? Class and National Consciousness in Britain, 1750–1830," *Past and Present*, November, 1986, vol. 113, pp. 97–117.

56 The Prince of Orange had been willing to pay more, and the fear of losing the collection to a foreigner was a factor in prompting Parliament's approval of the purchase. At the same time, Sir George Beaumont, a prominent amateur and patron of the arts, made known his intention to give the nation paintings from his collection, on condition that the state provide suitable housing for them. Beaumont's offer, combined with the prestige of the Angerstein Collection, tilted the balance in favor of a national collection. For a blow-by-blow account of the legal and legislative history of the founding of the National Gallery, see Gregory Martin, "The National Gallery in London," *Connoisseur*, April, 1974, vol. 185, pp. 280–7; May, 1974, vol. 186, pp. 24–31; and June, 1974, vol. 187, pp. 124–8. See also William T. Whitley, *Art in England, 1821–1837*, Cambridge, Cambridge University Press, 1930, pp. 64–74. For Angerstein, see Christopher Lloyd, "John Julius Angerstein, 1732–1823," *History Today*, June, 1966, vol. 16, pp. 373–9.

57 As the latter wrote to a representative of the government: "Well knowing the great satisfaction it would have given our late Friend that the Collection should form part of a National Gallery, we shall feel much gratified by His Majesty's Government becoming the purchasers of the whole for such a purpose" (Lloyd, op. cit. (note 57), p. 66).

58 Ibid., p. 68.

59 See Benedict Anderson, *Imagined Communities: Reflections on the Origin and Spread of Nationalism*, London and New York, Verso, 1991, p. 4; and Eric J. Hobsbawm, *Nations and Nationalism*, Cambridge and New York, Cambridge University Press, 1990, ch. 1, especially p. 18. My thanks to Josephine Gear for helping me clarify the use of the term in British political discourse.

60 *Parliamentary Debates (Commons)*, 13 April, 1832, New Ser., vol. 12, pp. 467–70; and 23 July, 1832, New Ser., vol. 14, pp. 643–5.

61 The committee was to discover "the best means of extending a knowledge of the Arts and of the Principles of Design among the People . . . (and) also to inquire into the Constitution, Management, and Effects of Institutions connected with the Arts" (*Report from the Select Committee on Arts, and Their Connection with Manufacturers*, in House of Commons, *Reports*, 1836, vol. IX.1, p. iii.

62 In George Foggo, *Report of the Proceedings at a Public Meeting Held at the Freemason's Hall on the 29th of May, 1837*, London, 1837, pp. 20–3. Some of the other speakers on this occasion were the MPs Joseph Hume, John Bowring, and John Angerstein, son of John Julius.

63 In a speech delivered at the Freemason's Tavern on 17 December, 1842, reproduced in John Pye, *Patronage of British Art*, London, 1845, pp. 176–85.

64 William Ewart, in House of Commons, op. cit. (note 61), p. 108.

65 Paid for by the government, the building would have to be shared with the Royal Academy, a situation, in the opinion of the Committee, that amounted to government support for a body that was the very soul of oligarchic patronage and actually retarded the cultivation of the arts in England. Much of its proceedings were devoted to an investigation of the R.A.

66 Ibid., p. 138.

67 Seguier was a successful art expert and restorer who had guided several high-ranking gentlemen in the formation of conventional aristocratic collections. Both George IV and Sir Robert Peel had availed themselves of his services (*Dictionary of National Biography*).

68 House of Commons, op. cit. (note 61), p. 137.
69 Ibid., p. x.
70 Thompson, op. cit, (note 46), *passim*.

3 PUBLIC SPACES, PRIVATE INTERESTS

1 John Cotton Dana, "The Museum as an Art Patron," *Creative Art*, March, 1919, vol. 4, no. 3, p. xxiv.
2 For details of the Metropolitan Museum's history, see Winifred E. Howe, *A History of the Metropolitan Museum of Art*, New York, Metropolitan Museum of Art, 1912, vol. I, pp. 95–111; and Leo Lerman, *The Museum: One Hundred Years and The Metropolitan Museum of Art*, New York, Viking Press, 1969, commissioned by the museum as part of its centennial celebration (on the founding of the Met, see especially pp. 11–15). For a more critical account of the museum's history, see Calvin Tomkins, *Merchants and Masterpieces: The Story of the Metropolitan Museum of Art*, New York, Dutton, 1973.
3 William M. Ivins, "Of Museums," *The Arts*, January, 1923, p. 31.
4 For a different view, see Neil Harris, "The Gilded Age Revisited: Boston and the Museum Movement," *American Quarterly*, 1962, vol. 14, pp. 545–66; and E. P. Alexander, *Museum Masters: Their Museums and Their Influence*, Nashville, Tenn., American Association for State and Local History, 1983, ch. 3. These historians discuss later nineteenth-century American museums as a development that grows out of earlier nineteenth-century American establishments like Peale's Museum. In my view, museums like the Metropolitan and Chicago's Art Institute were a new starting point and were directly and self-consciously informed by European precedents.
5 This is not to say that big museums appeared only in European state capitals. Daniel Sherman's study of provincial French museums presents many parallels to the founding and development of art museums in the United States. See *Worthy Monuments: Art Museums and the Politics of Culture in Nineteenth-Century France*, Cambridge, Mass., and London, Harvard University Press, 1989.
6 It concentrates least of all on Boston's Museum of Fine Arts, which has, however, been the subject of the excellent study by Paul Dimaggio, "Cultural Entrepreneurship in Nineteenth-Century Boston," *Media, Culture and Society*, 1982, vol. 4, pp. 33–50 and 303–22. Dimaggio argues that the museum marked out a ritual space that helped give structure and authority to Boston's social elite. The present study differs from Dimaggio's work primarily in that it looks more closely at the content of museum rituals.
7 *Exercises at the Dedication of the Ferguson Fountain of the Great Lakes*, 9 September, 1913, Chicago, Trustees of the Art Institute of Chicago, p. 30. The speaker quoted here is Loredo Taft, sculptor of the work being dedicated.
8 From a speech by Choate in 1880 on the occasion of the opening of a new wing of the Met, reprinted in the Museum's (henceforth, MMA) *Bulletin*, 1917, vol. 12, pp. 126–9.
9 Quoted in Matthew Josephson, *The Robber Barons: The Great American Capitalists, 1861–1901* (1934), New York, Harcourt, Brace & World, 1962, p. 294.
10 New York, Mentor Books, 1953.
11 As historians have pointed out, there was no single elite in New York in the late nineteenth and early twentieth centuries. Nor was there a single set of elite values. Not all segments of New York's elites would have placed the same social value on art museums. For differences among New York's elites, see David Hammack,

Power and Society: Greater New York at the Turn of the Century, New York, Russell Sage Foundation, 1982, pp. 65–79.

12 For the historical context of this chapter, and for the cultural response of reforming elites to immigrants, as summarized in this and following paragraphs, I am much indebted to the following historians: Geoffrey Blodgett, "Frederick Law Olmsted: Landscape Architecture as Conservative Reform," *Journal of American History*, 1976, vol. 67, pp. 869–89; John Bodner, "Culture without Power: A Review of John Higham's *Strangers in the Land*," *Journal of American Ethnic History*, Fall 1990/Winter 1991, pp. 80–6; Paul Boyer, *Urban Masses and Moral Order in America, 1820–1920*, Cambridge, Mass., and London, Harvard University Press, 1978; John M. Dobson, *Politics in the Gilded Age: A New Perspective on Reform*, New York, Washington, London, Praeger, 1972; Michael J. Ettema, in J. Blatti (ed.), *Past Meets Present: Essays about Historic Interpretation and Public Audiences*, Washington, DC, and London, Smithsonian Institution Press, 1987, pp. 62–85; Daniel M. Fox, *Engines of Culture: Philanthropy and Art Museums*, State Historical Society of Wisconsin for the Department of History, University of Wisconsin, 1963; George M. Frederickson, *The Inner Civil War: Northern Intellectuals and the Crisis of the Union*, New York, Harper & Row, 1968; Helen Lefkowitz Horowitz, *Culture and The City: Cultural Philanthropy in Chicago from the 1880s to 1917* (1976), Chicago and London, University of Chicago Press, 1989; Howard Mumford Jones, *The Age of Energy: Varieties of American Experience, 1865–1915*, New York, Viking Press, 1971; T. J. Jackson Lears, *No Place of Grace: Antimodernism and the Transformation of American Culture, 1880–1920*, New York, Pantheon Books, 1981; Henry F. May, *The End of American Innocence: A Study of the First Years of Our Own Time, 1912–1917*, Chicago, Quadrangle Books, 1964; David Noble, *The Progressive Mind, 1890–1917*, Chicago, Rand McNally, 1970; John G. Sproat, *"The Best Men": Liberal Reformers in the Gilded Age*, New York, Oxford University Press, 1978; John Tomsich, *A Genteel Endeavor: American Culture and Politics in the Gilded Age*, Stanford, California, Stanford University Press, 1971; Kermit Vanderbilt, *Charles Eliot Norton: Apostle of Culture in a Democracy*, Cambridge, Mass., Harvard University Press, 1959; Robert Wiebe, *The Search for Order, 1877–1920*, New York, Hill & Wang, 1967.

13 For a good example of this sentiment in art criticism, see F. W. Ruckstuhl, "Municipal Sculpture from the American Point of View," *Craftsman*, 1904, vol. 7, pp. 239–62.

14 *New York Times*, 6 January, 1889, 4: 4.

15 See, for example, Roy Rosensweig and Elizabeth Blackmar, *The Park and the People: A History of Central Park*, Ithaca and London, Cornell University Press, 1992.

16 This and following paragraphs draw heavily from the work of many historians. For the City Beautiful Movement and related efforts to use art and architecture as a force of moral improvement, I found the following especially valuable: Michelle H. Bogart, *Public Sculpture and the Civic Ideal in New York City, 1890–1930*, Chicago, University of Chicago Press, 1989; Boyer, op. cit. (note 12); Horowitz, op. cit. (note 12); Francesco Dal Co, "From Parks to the Region: Progressive Ideology and the Reform of the American City," in G. Ciucci, *et al.*, *The American City: From the Civil War to the New Deal*, Cambridge, Mass., Massachusetts Institute of Technology Press, 1979, pp. 143–297; Harvey A. Kantor, "The City Beautiful in New York," *New York Historical Society Quarterly*, 1973, vol. 67, pp. 148–71; Mario Manieri-Elia, "Toward an 'Imperial City': Daniel Burnham and the City Beautiful Movement," in Ciucci, *et al.*, op.

cit., pp. 1–142; Jon A. Peterson, "The City Beautiful Movement: Forgotten Origins and Lost Meanings," *Journal of Urban History*, 1976, vol. 2, pp. 415–34; Robert W. Rydell, *All the World's a Fair: Visions of Empire at American International Expositions, 1876–1916*, Chicago and London, University of Chicago Press, 1984; Alan Trachtenberg, *The Incorporation of America: Culture and Society in the Gilded Age*, New York, Hill & Wang, 1982; Richard Guy Wilson, "The Great Civilization," in Brooklyn Museum, *The American Renaissance, 1876–1917* (exh. cat.), New York, Pantheon Books, 1979, pp. 11–70.

Among the late nineteenth- and early twentieth-century publications I consulted for this same theme of the improving power of art and the City Beautiful Movement were: numerous articles in the *Craftsman* and in *Municipal Affairs*, two short-lived, turn-of-the-century organs for the City Beautiful Movement, the latter a publication of the New York Reform Club; Edwin H. Blashfield, *Mural Painting in America*, New York, Charles Scribner's Sons, 1913; Charles H. Caffin, "Municipal Art," *Harper's Monthly*, April, 1900, reprinted in H. W. Morgan (ed.), *Victorian Culture in America, 1865–1914*, Itasca, Ill., F. E. Peacock, 1973, pp. 53–62; Charles M. Robinson, *Modern Civic Art; or The City Made Beautiful*, New York, G. P. Putnam's Sons, 1904; Charles H. Wacker, "The Plan of Chicago – Its Purpose and Development," in *Art and Archaeology*, September–October, 1921, vol. 12, pp. 101–10.

17 Ettema, op. cit. (note 12), p. 67, discusses what the nineteenth century supposed to be the improving power of objects displayed in history museums. Bogart, op. cit. (note 16), explores in depth these same issues in relation to public sculpture in New York, as does Timothy Garvey in *Public Sculptor: Loredo Taft and the Beautification of Chicago*, Urbana and Chicago, University of Illinois Press, 1988.

The same project of homogenizing immigrants by means of art and culture was undertaken in London. See Juliet Steyn, "The Complexities of Assimilation in the 1906 Whitechapel Gallery Exhibition 'Jewish Art and Antiquities,'" *Oxford Art Journal*, vol. 13, no. 2, 1990, pp. 44–50; and Seth Koven, "The Whitechapel Picture Exhibitions and the Politics of Seeing," in D. Sherman and I. Rogoff (eds.), *Museum Culture: Histories, Discourses, Spectacles*, Media & Society 6, Minneapolis, University of Minnesota Press, 1994, pp. 22–48.

18 On the controversy about Sunday openings at the Met, see Tomkins, op. cit. (note 2), pp. 76–8, and below. For Boston, see Dimaggio, op. cit. (note 6), p. 314.

19 Charles G. Loring, "A Trend in Museum Design," *Architectural Forum*, December, 1927, vol. 47, p. 579.

20 The outstanding exception to these public art museums was the Newark Museum of Art, whose director, John Cotton Dana, was determined to make it relevant to Newark's immigrant populations. Dana's museum, however, unlike the museums I am discussing here, was not committed to the display of the history of high art. The model from which it developed was the Victoria and Albert. See the Bibliography for some of Dana's writings.

21 For their clientele, see Dimaggio, op. cit. (note 6), pp. 314–18, and Horowitz, op. cit. (note 12), pp. 104 and 117. For some insights on museum education, see Vera L. Zolberg, "Tensions of Mission in American Museum Education," in P. J. Dimaggio (ed.), *Non-Profit Enterprise in the Arts: Studies in Mission and Constraint*, New York and Oxford, Oxford University Press, 1986, pp. 184–98.

22 The arrangement in New York is spelled out in the Met's charter and its subsequent amendments. It is frequently described and praised in the museum's publications and in the Republican press. See, for example, a *New York Times* editorial of 30 April, 1880, p. 2: 3; and a later one, of 22 December, 1891, p. 4: 4, which declares the Met to be "the civic possession of which we have most reason to be proud"

and finds the idea of a city-controlled museum – "a Tammany art museum" – horrifying. The editors wanted the city to pay the museum's maintenance costs without having any say in its management. Not everyone at City Hall was agreeable to this arrangement (see also 4 November, 1892, pp. 10: 2 and 4: 4).

23 *New York Times*, 10 July, 1881, p. 6: 4.

24 *New York Times*, 9 February, 1886, p. 8: 4 and 21 January, 1887, p. 2: 4. Along these same lines, Tomkins, op. cit. (note 2), p. 77, cites Met trustee William Cowper Prime, a prominent lawyer and editor, who, in a letter of 1885, complained about people who "think the Museum is a public institution, in the management of which the public has a voice. . . . They must be forced to think of it as a private institution. . . . They must be compelled to see that we own and support the Museum and give it in pure charity for public education." For other *New York Times* articles and editorials on Sunday openings, see, 17 January, 1886, p. 4: 4 and the newspaper's index.

25 The *Times* openly urged the Met to select younger, less old-fashioned men for its Board, for example, on 17 February, 1889, p. 4: 4 and 25 February, 1889, p. 4: 4. For the *Times* as an organ of late nineteenth-century Republican reformism, see Dobson, op. cit. (note 12), pp. 111–12.

26 From an obituary for Joseph Hodges Choate, a long-time trustee of the Met, reprinted in the MMA *Annual Report*, 1917, pp. 4–6.

27 From a speech delivered in 1902 at the opening ceremonies for a new wing of the Met. The speaker was William R. Wilcox, President of the Parks Department, and as such closely associated with the Met's trustees. Cited in MMA *Annual Report*, 1902, p. 20.

28 R. De Forest, MMA *Bulletin*, 1919, vol. 14, p. 102.

29 R. De Forest, "The 50th Anniversary of the Museum," ibid., 1920, vol. 15, p. 124.

30 Mary Antin, *The Promised Land* (1912), Boston, Houghton Mifflin, 1969, p. 342.

31 See Horowitz, op. cit. (note 12), pp. 117–25.

32 *New York Times*, 1 June, 1891, p. 1: 3. From a report on the crowds at the Met's first Sunday opening. The point made is that the trustees had been wrong to fear that Sunday openings would bring forth great numbers of Jews and Irish. The report treats the absence of Jews and Irish as one of the successes of the new policy.

33 Howe, op. cit. (note 2), vol. I, pp. 244–50. See also MMA *Annual Report* and *Bulletin* for educational offerings.

34 Chicago AI *Annual Report*, 1 June, 1899, pp. 54–5.

35 The Catherine Lorillard Wolfe Collection, given to the Met in 1887, was one of the most admired. Its 143 paintings included Pierre Auguste Cot's *The Storm* and many other French Salon paintings. The bequest stipulated that the collection be exhibited in its own fireproof gallery. A fund of $200,000 was left for its care and for future purchases, which had to be modern oils. See the *New York Times*, 8 April, 1887, p. 1: 5; and 9 April, 1887, pp. 1: 1 and 4: 4.

36 See, for example, the *New York Times*, 4 May, 1887, p. 4: 4 and 18 June, 1887, p. 4: 4 praising donors like Catherine Lorillard Wolfe (see previous note), the Vanderbilts, and Junius Morgan. And again, 21 January, 1889, p. 4: 4, about the gift of Henry Marquand, who is praised as a model citizen.

37 See for example the *New York Times*, 10 July, 1881, p. 6: 4: "The Metropolitan Museum is allowed to remain in the hands of a few self-sufficient and in many ways ignorant managers."

38 Tomkins, op. cit. (note 2), pp. 49–59, 67–8.

39 See the *New York Times*, 6 January, 1881, p. 6: 6; 18 January, 1881, p. 4: 6; 10 April, 1881, p. 1: 7; 11 May, 1881, p. 4: 2; and 18 May, 1882, p. 4: 4.

40 See above, Note 34.

41 "The Metropolitan Museum," *The Nation*, 1905, vol. 80, pp. 17–18.

42 As one of them said, the Museum needed "a thorough acquaintance with the great institutions of Europe and their management, the command of expert knowledge and judgment and capable Curators in every department." The speaker was Frederick W. Rhinelander, the Met's president for a brief time just before Morgan's term (MMA *Annual Report*, 1903, p. 21). See also calls for a more coherent art-historical arrangement in the *New York Times* (in its Saturday Review section), 7 and 21 July, 1900, p. 494: 4; and 22 December, 1902, p. 6: 6.

43 For casts in the Met, see Howe, op. cit. (note 2), vol. I, pp. 210–11 and 252. The Met acquired most of its casts of sculpture and architectural monuments between 1889 and 1895.

44 As when the Sprague family gave Chicago's Art Institute $50,000 toward the purchase of El Greco's *Assumption of the Virgin* in memory of a recently deceased relative (AI *Bulletin*, 1915, vol. 9, p. 34).

45 *New York Times*, 22 December, 1902, p. 6: 6.

46 Matthew S. Prichard, in a letter from around 1910 describing the museum a few years earlier. Quoted in Walter M. Whitehill, *Museum of Fine Arts, Boston: A Centennial History*, 1970, Cambridge, Mass., The Belknap Press of Harvard University Press, pp. 212–13.

47 Chicago AI *Annual Report*, 1894, pp. 24–7; and 1904, p. 26.

48 See especially the AI *Annual Report* of 1894, p. 14, for the gallery of the Henry Field Collection, which contained forty-one mostly Barbizon School paintings. Almost every *Annual Report* and many of the museum's *Bulletins* had news of one or another family or memorial gallery.

49 Chicago AI *Annual Report*, 1901, pp. 11–12; and *Bulletin*, July, 1912, p. 3; April, 1912, p. 11; and October, 1914, p. 19.

50 "The visitor," continued the *Bulletin*, "may easily project himself thereby into the atmosphere of a seigniorial hall of Gothic France" (Chicago AI *Bulletin*, 1924, vol. 18, pp. 58, 86–7). The rooms no longer exist. The Art Institute's other memorial period rooms have also disappeared, dismantled a number of years ago to make way for new construction.

51 Howe, op. cit. (note 2), vol. I, p. 273. Similarly, in the Philadelphia Museum of Art, one can look into what was once the grand salon of Mrs. Eleanore Elkins Rice, complete with all of its furnishings. The room, constructed for her Fifth Avenue, New York City, house in 1923, copied French eighteenth-century models to provide a proper setting for her collection of antique furniture.

52 The *New York Times*, 9 May, 1925, as cited in the *Literary Digest*. Such bequests had been criticized long before, however.

53 For Morgan, I consulted Frederick Lewis Allen, *The Great Pierpont Morgan* (1949), New York, Harper & Row, 1965; Josephson, op. cit. (note 9), pp. 295–313 (for Morgan's role in the railroad wars); and Herbert L. Satterlee, *J. Pierpont Morgan: An Intimate Portrait*, New York, Macmillan, 1939.

54 MMA *Annual Report* of 1905, p. 11.

55 MMA *Bulletin*, 1907, vol. 2, p. 98.

 In 1917, Robert De Forest, president of the Met between 1913 and 1931, used the occasion of another exemplary bequest, that of Isaac D. Fletcher, to spell out in detail ways to reconcile the wishes of memorial-seeking donors on the one hand and collection-building trustees on the other (R. De Forest, "The Notable Bequest of Isaac D. Fletcher," ibid., 1917, vol. 12, pp. 216–18). Museum officials, argued De Forest, must satisfy to some degree the "desire of donors for some lasting recognition" without derailing the museum's educational mission. Fletcher originally wished his collection to be kept together permanently and separately

but in the end allowed the museum to select only those objects which, as De Forest put it, would be consistent with its responsibility to educate the public by means of an art-historical arrangement. Instead of an exclusive memorial, Fletcher will be remembered on labels and in catalogue entries. Of course, he could have emulated Frick and made his New York house a museum-memorial, "but at the sacrifice of a greater public benefit." Such a course would have deprived the objects in his collection of their art-historical meanings, presenting them as tasteful furnishings rather than works of art. A realist, De Forest admits that exceptions must sometimes be made. The museum accepted the Benjamin Altman collection with restrictions because of its outstanding quality, but correctly refused the bequest of Senator Clark on the same terms.

Another exemplary will was that of Mrs. Morris K. Jesup. It allowed the Met to pick what it wanted from among seventy-one works and even to sell or trade works (ibid., 1915, vol. 10, p. 64).

56 See Whitehill, op cit. (note 46), pp. 212–13, and the Chicago AI *Annual Reports* and *Bulletin* of 1933 and 1934.

57 In conformity with a European fashion, seen in the Louvre and Uffizi, outstanding masterpieces from several eras were gathered together into a single room for aesthetic contemplation, while the remainder of the collection was exhibited chronologically and by school. The Met's *Annual Report* of 1905 (pp. 13–15) cites Dr. Wilhelm Bode's new installation of the Kaiser Friedrich Museum in Berlin as a model installation that balances the "aesthetic" and the "scientific." The task of installing the painting collection actually fell to Roger Fry, whose thoughts on the matter were published in the MMA *Bulletin*, 1906, vol. 1, pp. 58–60. For Bode's approach to installation, see Thomas W. Gaehtgens, "The Berlin Museum after Reunification," *Burlington Magazine*, January, 1994, vol. 106, pp. 14–20.

58 MMA *Bulletin*, 1910, vol. 5, pp. 35–7; and 1911, vol. 6, pp. 3–6, 45 and 199, for detailed descriptions of the arrangement.

59 The rationale, a product of the industrial revolution, was fully articulated in 1836, in the *Report from the Select Committee on Arts, and Their Connection with Manufactures* (House of Commons, *Reports*, vol. IX.l), frequently cited in Ch. 2. Indeed, the goals of the Victoria and Albert Museum (originally called the South Kensington Museum) were taken directly from the 1836 Report. Much admired in the United States, they were copied by almost every American public art museum. Hence, the early Met's annual exhibitions of batiks, stained glass, and other hand-crafted objects that could claim to be inspired by the museum's decorative arts collections (see, for example, the MMA *Bulletin*, 1920, vol. 15, p. 90).

Advocates of decorative arts displays in public art museums also argued that their inclusion helped democratize the museum, since they gave uneducated persons something they could appreciate more easily than the presumably more demanding higher arts (see, for example, M. G. van Rensselaer, "The Art Museum and the Public," MMA *Bulletin*, 1917, vol. 12, pp. 57–64).

60 As Tomkins points out, the Met collects and presents arms and armor as a fine art largely because Morgan and other trustees liked it. Boston had refused to collect it on the grounds that it is not high art (op. cit. (note 2), p. 153).

61 *The Gloom of the Museum*, Woodstock, Vermont, Elm Tree Press, 1917, pp. 5–8. Dana was a great admirer of Thorsten Veblen's *Theory of the Leisure Class*.

62 *The Power Elite*, New York, Oxford University Press, 1959, p. 12.

63 I refer to numerous rooms in the American Wing. An especially good example is the ballroom from the Van Rensselaer Manor House in Albany, New York. Installed in 1955, it is a relic of the Dutch settler stock that made up part of New York's old, pre-Civil War elite.

64 For the Wrightsman's social careers and the role of their collection in it, see Khoi Nguyen, "Gilt Complex," *Connoisseur*, September 1991, pp. 75–7; 116–17. According to Nguyen, Jayne Wrightsman began life as a sales clerk in a department store and mastered the art of collecting French furniture as a social strategy.

65 Morgan used the phrase to show the railway barons the advantages of cooperation (Josephson, op. cit. (note 9), p. 307).

66 The collection was begun by Philip Lehman, Robert's father and also an investment banker. The collection has 3,000 works of which 300 are European paintings and 1,000 drawings. For background, see, Thomas Hoving, *The Second Century: The Comprehensive Architectural Plan for the Metropolitan Museum of Art*, New York, Metropolitan Museum of Art, 1971.

67 Joseph J. Akston, in an editorial in *Arts Magazine*, March, 1971. City Councilman Carter Burden was an especially articulate opponent of the Met's policies (see his "The Met's Master Plan: Anything But a Cheap Affair," *The Art Gallery*, May, 1971, pp. 22–4).

68 The *New York Times*, 14 May, 1975, pp. 47 and 90; and 25 May, pp. VI 12–20 and 14. See also Gerrit Henry, "The Lehman Wing," *ArtNews*, September, 1975, vol. 74, pp. 35–9; and John Russell, "Desegegrating the Lehman Gift," the *New York Times*, 15 April, 1979. p. D25.

69 Moira Hodgson, "Art: A Taste for Treasures," *Harper's Bazaar*, June, 1984, pp. 117, 150–2, 180–1; and Stanley Abercrombie, "Museum Calibre (The Linsky Collection)," *Interior Design*, July, 1985, vol. 56, pp. 212–21.

70 Only John Russell, in the *New York Times*, complained that objects in the collection were forever cut off from their art-historical context, where they would be the most educational ("Linsky Collection Opens at Met," 22 June, 1984, p. C22).

4 SOMETHING ETERNAL

1 In George Harvey, *Henry Clay Frick, The Man*, New York, Scribner's Sons, 1928, p. 276.

2 In deciding which donor memorials to include in this chapter, I selected examples that are universally thought to contain quality art collections. This ruled out some of the more spectacular mansions built by American millionaires – most notably, William Randolph Hearst's famed Saint Simeon, whose once impressive art collection was eventually sold (see W. A. Swanberg, *Citizen Hearst: A Biography of William Randolph Hearst*, New York, Macmillan, 1986, pp. 574; 577; 593–4). Similarly, the houses of artists, which, with a few exceptions like the Musée Rodin, usually lack strong collections of the former occupant's work.

3 The press enjoyed the spectacle of the big collectors competing against each other. See, for example, "Mr. Frick as a Patron of Culture," *Literary Digest*, vol. 63, 10 December, 1919, pp. 29–30.

4 S. N. Behrman, *Duveen*, New York, Random House, 1955, pp. 102–3; 116; 118; and *passim*.

5 For the Wallace Collection, I consulted the collection's *General Guide*, published in 1989 by the Trustees of the Wallace Collection; Peter Hughes, *The Founders of the Wallace Collection*, London, Trustees of the Wallace Collection, Manchester Square, 1981; *Wallace Collection Catalogues: Pictures and Drawings*, 16th edn, London, Trustees of the Wallace Collection, 1968; and Pierre Cabanne, *The Great Collectors*, London, Cassell, 1963. John Walker, in *Self-Portrait with Donors*, Boston and Toronto, Little, Brown, 1974, p. xiii, talks about the importance of the Wallace Collection as a model for American millionaires.

6 See my *The Pursuit of Pleasure: The Rococo Revival in French Romantic Art*, New York and London, Garland Publishing, 1976, pp. 55–84.

7 The present installation dates from 1982.

8 For Frick's life, see Harvey, op. cit. (note 1), his principle biographer.

9 Harvey, op. cit., pp. 332 and 336. See also Edgar Munhall's text in, *Masterpieces of the Frick*, New York, Frick Collection, 1970, pp. 3–118. Frick was able to furnish his house with quantities of furniture and objects once owned by Wallace. See Germain Seligmann, *Merchants of Art: 1880–1960: Eighty Years of Professional Collecting*, New York, Appleton-Century-Crofts, 1961, pp. 92 ff.

10 "The Frick Collection of Art Becomes the Public's Property," in *Current Opinion*, January, 1920, vol. 68, pp. 100–2.

11 Clarence Weinstock, "The Frick Formula," *Art Front*, 3 February, 1936, vol. 2, no. 3. Another critic, E. M. Benson, in "The Nature of a Gift – The Frick Collection," *American Magazine of Art*, February, 1936, vol. 29, p. 101, also complained that the Bellini *Saint Francis* and the Holbeins and Titians "are roped off from the public in what was once the Frick living room and is now a model for interior decoration with a Park Avenue trade." Thanks to Andrew Hemingway for these references.

12 See *The Founding of the Henry E. Huntington Library and Art Gallery: Four Essays*, San Marino, California, Huntington Library, 1969.

13 The Henry E. Huntington Library, housed in an impressive neo-classical building on the estate, specializes in Anglo-American materials. For most of its users, it functions today more as a professional research institution than as a display of gentlemanly culture, and therefore will not be considered here.

14 Curators have continued to add to the collection. There is also an Arabella Huntington Memorial Collection, displayed separately in its own galleries inside the library building. Put together by Huntington in memory of his deceased wife, it contains the kinds of things she collected – Renaissance painting, French decorative arts – rather than (with a few exceptions) works that she actually owned.

15 Meryle Secrest, *Being Bernard Berenson: A Biography*, Harmondsworth and New York, Penguin Books, 1980, pp. 59–60; 142.

16 Morris Carter, *Isabella Stewart Gardner and Fenway Court*, Boston and New York, Houghton Mifflin Co., 1925, pp. 169–90; and John Walker, op. cit. (note 5), pp. 68–91.

17 For the Getty Museum, see the J. Paul Getty Museum, *Handbook of the Collections*, Malibu, Cal., 1986 and *Guide to the Villa and Its Gardens*, Malibu, Cal., 1988; Joseph Morgenstern, "Getty's Little Palace in Malibu," *ArtNews*, March, 1977, pp. 72–5; and Robert Lenzner, *The Great Getty: The Life and Loves of J. Paul Getty – Richest Man in the World*, New York, Crown Publishers, 1985, pp. 191–5.

 For an analysis of the original villa's decorations (elements of which are reproduced in Malibu) and the iconographic program they constitute, see P. Gregory Warden and David Gilman Romano, "The Course of Glory: Greek Art in a Roman Context at the Villa of the Papyri at Herculaneum," *Art History*, 1994, vol. 17, pp. 228–54.

18 For Getty's life, I consulted Lenzner, op. cit. (note 17), and the following works by Getty (or ghost-written for him): *As I See It: The Autobiography of J. Paul Getty* (1976), New York, Berkley Books, 1986; *Getty on Getty: A Man in a Billion*, conversations with Somerset de Chair, London, Cassell Publishers, 1989; *How to Be Rich*, London, W. H. Allen, 1966; *The Joys of Collecting*, London, Country Life, 1966; *My Life and Fortunes*, London, George Allen & Unwin, 1964); and

M. Gendel, "Interview with J. Paul Getty," *ArtNews*, September 1971, pp. 44–5; 59–60.

19 Lenzner, op. cit. (note 17), pp. 136, 139, 194, and *passim*, for Getty's love of power. For Getty's self-identification with ancient figures, especially Piso and Hadrian, see the Getty Museum *Guide*, pp. 4–7.

20 *As I See It*, op. cit. (note 18), pp. 234–5 and 259. It should be noted that the contents of the museum's upper floor are due to be moved to the Getty Center in nearby Brentwood, which, as of this writing, is nearing completion. The Malibu villa will eventually be devoted exclusively to ancient art.

21 See Lenzner, op. cit. (note 17), *passim*, on Getty's insecurity and longing for social distinction.

22 See especially *The Joys of Collecting*, op. cit. (note 18), a glossy, expensive book that flatters Getty as a grand collector. In it, his own trite pronouncements are framed by various authoritative texts, two of them commissioned from Louvre Museum curators and one from Columbia University art history professor Julius Held. In another book, *The Golden Age* (New York, Trident Press, 1968, pp. 97–103 and 111–12), Getty again sets out to extol the pleasures of art collecting, but the few attempts he makes to sound knowledgeable about the meaning of the art objects he has acquired are buried under numerous anecdotes about prices. Probably his *Europe in the Eighteenth Century* (privately printed, 1949) is his most convincing attempt to sound knowledgeable.

23 Lenzner, op. cit. (note 17), p. 195.

24 Ibid., p. 219.

25 The quest of the memorial-seeking collector can end in embarrassing failure. His collection may not be deemed good enough to get the concessions he seeks from a large, host museum. Or his private museum may fail to attract sufficient visitors or the kind of volunteer support that museums depend on. The saga of the Armand Hammer collection illustrates a number of the risks and pitfalls that face the collector with unrealistic ambitions. After being refused the conditions he wanted from the Los Angeles County Museum of Art, Hammer opened up his own museum, which quickly failed (see Robert A. Jones, "Battle for the Master-pieces," *Los Angeles Times Magazine*, 22 May, 1988, pp. 8–19; and William Williamson, "The March to Boutique Museums," *Los Angeles Times*, 22 January, 1988, pp. VI: 1, 18, 19, 24),

26 See Chapter 3, note 55 (concerning the Fletcher bequest).

Benjamin Altman, George Blumenthal, Mrs. H. O. Havemeyer, and Jules S. Bache, all of whom gave extraordinary collections to the Metropolitan Museum, could easily have enshrined themselves in historicist palaces or manor houses. The investment banker Blumenthal almost did. He and his wife Florence, admirers of Gardner's Fenway Court, had built their own mansion-museum-to-be around a Spanish Renaissance patio and filled it with art. At the end of his life, however, Blumenthal let the Met choose from it what it wanted (among other things, it took the patio) (Seligmann, op. cit. (note 9), pp. 83–4 and 142–7).

Jules Bache, another investment banker, actually opened his redecorated Fifth Avenue mansion as a museum in 1937 (admission was by application) before changing his mind (in 1943) and giving its contents to the Met (See Calvin Tomkins, *Merchants and Masterpieces: The Story of the Metropolitan Museum of Art*, New York, Dutton, 1973, pp. 218–22. For Bache's proposed museum, I consulted the Metropolitan Museum of Art's files, especially clippings from *Commonweal*, 14 May, 1937; the *New York Herald Tribune*, 29 April, 1937; and Alfred Frankfurter, "The Bache Gift: An Editorial," *ArtNews*, 8 May, 1937, pp. 9–10).

One of the most spectacular benefactions came from John D. Rockefeller II,

who, in a series of princely gestures, gave the Met the Cloisters, technically the museum's medieval branch, but actually an entire museum in itself of medieval art and architecture. Rockefeller not only donated much of its contents (including four medieval cloisters), but also paid for the building, and even donated its magnificent setting, the Fort Tryon area in northern Manhattan, which, as it happened, JDR II also owned (Tomkins, op. cit., ch. 19).

27 S. N. Behrman, *Duveen*, New York, Random House, 1955, pp. 232–3.

28 In Burton Hersh, *The Mellon Family: A Fortune in History*, New York, William Morrow, 1978, p. 279.

29 Thanks to Carol Ockman for pointing this out to me.

30 Lila Sherman, *Art Museums of America*, New York, William Morrow, 1980, pp. 263–4.

31 Besides Getty, other famous donors buried on the grounds of their house-museums include Henry and Isabella Huntington, and Mr. and Mrs. Robert Woods Bliss, the latter buried on the grounds of Dumbarton Oaks, Washington, DC (thanks to Al Frazer for this one). Peggy Guggenheim is buried in the garden of her Venetian palazzo (her dogs are also buried there, according to Geraldine Norman, "Peggy Guggenheim," *Independent* (London), 1 November, 1991, p. 3), and Bernard Berenson is entombed in a chapel at his villa I Tatti near Florence.

32 See Erwin Panofsky, *Tomb Sculpture* (1964), H. W. Janson (ed.), New York, Harry N. Abrams, 1992, ch. 1.

33 See Philippe Ariés, *The Hour of Our Death*, trans. H. Weaver, New York and Oxford, Oxford University Press, 1981; and his *Western Attitudes Toward Death: From the Middle Ages to the Present*, trans. P. Ranum, Baltimore and London, Johns Hopkins University Press, 1974. Ariés draws heavily from the work of Panofsky, op. cit. For mausolea, see Howard Colvin, *Architecture and the After-Life*, New Haven and London, Yale University Press, 1991, pp. 283–322, and Charles Saumarez Smith, *The Building of Castle Howard*, London and Boston, Faber & Faber, 1990, ch. 6. For family chapels and their striking similarities to donor memorial art museums, see Samuel K. Cohn, Jr., *Death and Property in Siena, 1205–1800: Strategies for the Afterlife*, Baltimore and London, Johns Hopkins University Press, 1988; and Francis Haskell, *Patrons and Painters: Art and Society in Baroque Italy*, New York and London, Harper & Row, 1971, pp. 3–9 and 65–72.

 Finally, Werner Muensterberger, in *Collecting: An Unruly Passion: Psychological Perspectives*, Princeton, NJ, Princeton University Press, 1994, pp. 56–62, studies the narcissistic needs that drive the formation of collections. He discusses the collecting and displaying of skulls in tribal societies and of saints' relics in western society in terms that have strong resonances for the kinds of donor memorial collections discussed in this chapter.

34 For the Dulwich Picture Gallery, see, *Dulwich Picture Gallery Catalogue* (1914), revised, 1926, introduction by Edward Cook; G.-Tilman Mellinghoff, "Soane's Dulwich Picture Gallery Revisited," in *John Soane*, London and New York, Academy Editions and St. Martin's Press, 1983; John Summerson, "Sir John Soane and the Furniture of Death," *Architectural Review*, March, 1978, vol. 163, pp. 147–55; Giles Waterfield, Introduction to *Collection for a King: Old Master Paintings from the Dulwich Picture Gallery* (exh. cat.), Washington, DC, and Los Angeles, National Gallery of Art and Los Angeles County Museum of Art, 1985; and Waterfield, *Soane and After: The Architecture of Dulwich Picture Gallery*, (exh. cat.), Dulwich Picture Gallery, 1987.

35 Several ancillary rooms, originally built to house the charity's almswomen, later became exhibition space.

36 By 1760, there were at least twenty mausolea in England alone, and more in

Scotland and Ireland. See Colvin, op. cit. (note 33), pp. 316–60; and Saumarez Smith, op. cit. (note 33), ch. 6. The more immediate precedent for the mausoleum at Dulwich College is the one Soane had already built in Desenfans's London house (see Summerson, op. cit. (note 34), pp. 150–1; and Waterfield, *Soane and After*, op. cit. (note 34), pp. 8–19). The new mausoleum was necessary because the house, a leasehold, could not be purchased.

37 See the comments by Hazlitt and others collected by Giles Waterfield, in *Rich Summer of Art: A Regency Picture Collection Seen through Victorian Eyes*, Dulwich Picture Gallery, 1988, pp. 15–18.

38 See especially Mellinghoff, op. cit. (note 34), pp. 87–8.

39 See Barbara Hofland, *Popular Description of Sir John Soane's House, Museum and Library*, London, 1835; and John Summerson, *Sir John Soane*, London, 1952, pp. 43 ff.

40 For the Huntington mausoleum and its architectural sources, see Diana G. Wilson, *The Mausoleum of Henry and Arabella Huntington*, San Marino, Cal., Huntington Library, 1989.

41 According to Mellinghoff, op. cit. (note 34), p. 881, the exception is Frederick Gilly's Monument to Frederick the Great, designed in 1797, also a combination tomb and art collection.

42 John L. Hess, *The Grand Acquisitors*, Boston, Houghton Mifflin Co., 1974, p. 31.

43 See Thomas Hoving, *The Second Century: The Comprehensive Architectural Plan for the Metropolitan Museum of Art*, New York, Metropolitan Museum of Art, 1971, pp. 44–7.

44 Quoted in Margaret Sterne, *The Passionate Eye: The Life of William R. Valentiner*, Detroit, Wayne State University Press, 1980, p. 92.

45 Leland M. Roth, *McKim, Mead & White, Architects*, London, Thames & Hudson, 1984, pp. 287–92.

46 George Wheeler, *Pierpont Morgan and Friends: The Anatomy of a Myth*, Englewood Cliffs, NJ, Prentice-Hall, 1973, p. 206.

47 The elaborate decorations are described in a Library brochure, *Mr. Morgan's Library: A Guide to the Period Rooms* (1991).

48 Morgan, the son of a wealthy international banker and highly educated, is almost universally praised by his biographers for his good taste. The famous exception is Roger Fry, who, not surprisingly, found him both ignorant and vain in matters of art (see Virginia Woolf, *Roger Fry: A Biography*, London, Hogarth Press, 1940, pp. 30 and 137).

49 See, for example, Richard Whelan, "Patronage," *Art in America*, November–December, 1978, pp. 25–7. According to *The WPA Guide to Washington, DC* (1937), published by the Federal Writers' Project of the Works Progress Administration for the District of Columbia, the museum was commonly referred to as "the Mellon Gallery" (1941 edition, p. 77).

50 For Andrew Mellon and the Mellon family, I consulted Harvey O'Connor, *Mellon's Millions, The Biography of a Fortune: The Life and Times of Andrew W. Mellon*, New York, John Day, 1933 (the first and still the best biography); David E. Finley, *A Standard of Excellence: Andrew W. Mellon Founds the National Gallery of Art at Washington*, Washington, DC, Smithsonian Institution Press, 1973; Hersh, op. cit. (note 28); David E. Koskoff, *The Mellons: The Chronicle of America's Richest Family*, New York, Thomas Y. Cromwell Co., 1978; and Behrman, op. cit. (note 4).

51 For Mellon's tax policies, see Hersh, op. cit. (note 28), pp. 220–45; and O'Connor, op. cit. (note 50), pp. 124–58.

52 Hersh and O'Connor devote large portions of their books to these aspects of Mellon's career.

53 See Hersh, op. cit., pp. 338–40. The government challenged Mellon's claim that he had given these gifts to the nation, not only because there was no evidence that a National Gallery was being planned but also because the nation had never seen the gifts he had allegedly given to it.

54 The new museum was to be primarily a collection of paintings, like the National Gallery in London, which Mellon greatly admired and after which the Washington National Gallery was modelled (Paul Mellon, with John Baskett, *Reflections in a Silver Spoon*, New York, William Morrow, 1992, p. 298).

55 Ralph M. Pearson, a professor at the New School for Social Research, characterized Mellon's gift to the nation as an act of benevolent dictatorship. "An old businessman and his four hundred million dollars. . . inflicted on a great nation its 'own' 'national gallery' forever more" ("A Greek Gift: Accepting the Mellon Collection on Mellon's Terms," *New Masses*, 30 March, 1927, p. 19).

56 For example, the building's new East Wing was paid for by contributions from Paul Mellon, Ailsa Mellon Bruce, and the Andrew W. Mellon Foundation (which these two set up). In addition Ailsa Bruce continued to give the museum extraordinary sums for the acquisition of important works, including the museum's only Leonardo da Vinci (Hersh, op. cit., p. 411).

57 *The WPA Guide to Washington, DC*, op. cit. (note 49), p. 78.

58 John Hudnut, "The Last of the Romans: Comment on the Building of the National Gallery of Art," *Magazine of Art*, April, 1941, vol. 34, p. 172. For a related reaction to the East Wing, see Carter Ratcliff, "Modernism for the Ages," *Art in America*, July-August, 1978, pp. 51–4.

59 National Capital Planning Commission, Frederick Gutheim, Consultant, *Worthy of the Nation: The History of Planning for the National Capital*, Washington, DC, Smithsonian Institution Press, 1977, especially pp. 135–75 and 216–18.

5 THE MODERN ART MUSEUM

1 From notes, taken at a reception for the trustees of the Museum of Modern Art, cited in Alice Goldfarb Marquis, *Alfred H. Barr, Jr.: Missionary for the Modern*, Chicago and New York, Contemporary Books, 1989, p. 229.

2 Much of the argument of this chapter is based on my article "The MoMA's Hot Mamas" (1989), reprinted in my *The Aesthetics of Power*, New York and Cambridge, Cambridge University Press, 1993, pp. 189–207; but my thinking about it began fifteen years ago when I wrote, in collaboration with Alan Wallach, "The Museum of Modern Art as Late Capitalist Ritual," *Marxist Perspectives*, Winter, 1978, pp. 28–51. I also borrowed ideas that I first expressed in "Virility and Domination in Early Twentieth-Century Vanguard Painting" (1973), in *Aesthetics of Power*, pp. 81–108.

3 I use the term "modern art" to refer to any mode of art-making that can be said to belong to twentieth-century art production. That is, I use it as a catch-all, a way of referring to the larger, undifferentiated field of activity that includes the forgotten and neglected as well as the famous and recognized. It is from that field of art production that all the various and specific art-historical narratives select their materials.

In my account, I frequently refer to the "dominant" or "conventional" art-historical narrative, by which I mean the one that has argued a linear history of "styles" and has either ignored or treated as peripheral the critical, oppositional impulse of modern art. Although it is used in other ways as well, the term "modernism" has came to be most associated with this kind of art history, which,

though now in disrepute in university culture, still structures numerous art museum installations and art history lectures.

 In recent decades, a considerable body of critical literature, much of it concerned with issues that were central to the Frankfort School and French post-structuralism, has used the terms "modernism" and "postmodernism" to pose questions about the role of modern art and art criticism in relation to the larger historic direction of late capitalist society (for a good introduction to the modernist/postmodernist debate, see Hal Foster (ed.), *The Anti-Aesthetic: Essays on Postmodern Culture*, Port Townsend, Wash., Bay Press, 1983; and Andreas Huyssen, *After the Great Divide: Modernism, Mass Culture, Postmodernism*, Bloomington and Indianapolis, Indiana University Press, 1986).

4 For a detailed account of the MoMA, see Russell Lynes, *Good Old Modern: An Intimate Portrait of the Museum of Modern Art*, New York, Atheneum, 1973. Lynes stresses Barr's dominant role in shaping the collection. See especially pp. 298–9. For Barr, see also Marquis, op. cit. (note 1).

5 Barr's art-historical approach was lucidly set forth in his many MoMA catalogues and other publications. See, for example, his *Cubism and Abstract Art*, New York, Museum of Modern Art, 1936, a publication that is remembered today mostly because of the brilliant review of it by Meyer Schapiro, "The Nature of Abstract Art," reprinted in Schapiro, *Modern Art: 19th and 20th Centuries: Selected Papers*, New York, Georges Braziller, 1978. See also Barr (ed.), *Painting and Sculpture in the Museum of Modern Art*, New York, Museum of Modern Art, 1942; Barr (ed.), *Masters of Modern Art*, New York, Museum of Modern Art, 1958.

6 From an interview with William Rubin, "Talking with William Rubin: 'Like Folding Out a Hand of Cards,'" *Artforum*, November, 1974, p. 47; and Rubin, "Painting and Sculpture," in *The Museum of Modern Art, New York: The History and the Collection*, New York, Harry N. Abrams, in association with the Museum of Modern Art, 1984, pp. 43–6. See also Marquis, op. cit. (note 1), pp. 314–16, for Barr's impact on academic art history.

7 I cannot, in this chapter, detail the development of MoMA. Rather, my emphasis is on the longevity of the original direction that Barr gave the museum. It is worth pointing out, however, that in the earlier years, the kind of modernism it promoted (in keeping with the times) was more historically optimistic and progressive in outlook than the later more dogmatically formalist version would be. The museum's new steel and glass building, opened in 1939, not to mention its creation of design, film, and photography departments, still breathed this kind of modernist optimism.

8 Thomas Hess, "Plant You Now, Dig You Later" (editorial), *ArtNews*, November, 1969. For another example, see "Talking With Rubin . . . ," op. cit. (note 6). Rubin's interviewers, Lawrence Alloway and John Coplans, find his installation too linear and biased toward Cubism. In 1984, when Rubin re-installed the permanent collection, critics once again complained about the museum's extreme narrowness. See, for example, Calvin Tomkins, "The Art World," *New Yorker*, 15 October, 1984, pp. 126–33.

9 See for examples Emile Male's classic study, *The Gothic Image* (1913), trans. Dora Nussey, New York, Evanston, and London, Harper & Row, 1958.

10 For the Greenberg essays most widely read in the 1960s and 1970s, see Clement Greenberg, *Art and Culture: Critical Essays*, Boston, Beacon Press, 1961.

11 Michael Fried, Introduction, *Three American Painters* (exh. cat.), Fogg Art Museum, Harvard University, 1965, p. 9.

12 Even in the more liberal variants of this history – in which modern art's progressive rejection of older illusionistic and narrative practices are seen as

expressive of utopian ideals or as avant-garde gestures challenging bourgeois sensibilities and values – there, too, innovative art translates into exemplary morality. That is, moral heroism can be as readily ascribed to artists who promote a utopian future or oppose bourgeois culture as to those who reach for a universal, transcendent sphere.

13 Namely Mrs. John D. (Abbey) Rockefeller, Jr., Mrs. Cornelius (Mary) J. Sullivan and Miss Lizzie P. Bliss. See Lynes, op. cit. (note 4).

14 A theme explored in depth in the still-classic study by Simone de Beauvoir, *The Second Sex* (1949), trans. H. M. Parshley, New York, Alfred A. Knopf, 1953.

15 I am leaving aside the question of what, if anything, they reveal about the individual psyches of those who produce them.

16 Philip Slater, in *The Glory of Hera*, Boston, Beacon Press, 1968, p. 321. See also Michelle Zimbalist Rosaldo, "Woman, Culture, and Society: A Theoretical Overview," in Rosaldo and L. Lamphere (eds.), *Woman, Culture, and Society*, Stanford, Cal., Stanford University Press, 1974, pp. 17–42. Because women and not men raise children, writes Rosaldo, boys and girls form identities differently. A boy often learns "to distrust or despise the world of his mother, to seek his manhood outside the home" (p. 28).

17 Alan Wallach and I have already noted the striking resemblance of this ordeal to certain primitive and ancient labyrinth rituals. See Duncan and Wallach, "The Museum of Modern Art. . .," op. cit. (note 2), pp. 37–44; 50, n. 25; and 51, n. 30.

I also wish to mention two outstanding studies, which came to my attention only late in my own writing process, in both of which I found strong support for my argument. They are Andreas Huyssen's, "Mass Culture as Woman: Modernism's Other," in op. cit. (note 3), pp. 44–62; and Mark A. Cheetham's *The Rhetoric of Purity: Essentialist Theory and the Advent of Abstract Painting*, Cambridge and New York, Cambridge University Press, 1991, especially pp. 115–28. Each in its own way recognizes modern art's pursuit of abstraction as a quest for a masculine-identified purity, and, simultaneously, a distancing from a female principle positioned as the "other."

18 Murial Dimen, *Surviving Sexual Contradictions*, New York, Macmillan, 1986, p. 35. An essay by John Freccero, "Autobiography and Narrative," in T. C. Heller, M. Sosna, and D. Wellbery (eds.), *Reconstructing Individualism: Autonomy, Individuality, and the Self in Western Thought*, Stanford, Cal., Stanford University Press, 1986, pp. 16–29, argues related ideas (about narratives of discovery and self-discovery as exercises in male identity).

19 See Leo Steinberg's ground-breaking reading of the work, "The Philosophical Brothel," in *Other Criteria*, New York and Oxford, Oxford University Press, 1972. In Steinberg's reading, the act of looking at these female figures visually recreates the act of genital penetration. In my view, his reading is highly insightful, although Steinberg himself has not been prepared to face its implications for women, namely that, anatomically speaking, they are left with a critical "disadvantage" (if that's the word) in experiencing the work's full meaning.

20 The alcove she occupies also contains two works by the British artist Francis Bacon, whose presence in the middle of the New York School also strikes an odd note.

21 See Douglas Fraser, "The Heraldic Woman: A Study in Diffusion," in D. Fraser (ed.), *The Many Faces of Primitive Art*, Englewood Cliffs, New Jersey, Prentice-Hall, 1966, pp. 36–99; Arthur Frothingham, "Medusa, Apollo, and the Great Mother," *American Journal of Archaeology*, 1911, vol. 15, pp. 349–77; Roman Ghirshman, *Iran, from the Earliest Times to the Islamic Conquest*, London, Penguin Books, 1954, pp. 340–3; Bernard Goldman, "The Asiatic Ancestry of

the Greek Gorgon," *Berytus*, 1961, vol. 14, pp. 1–22; Clark Hopkins, "Assyrian Elements in the Perseus–Gorgon Story," *American Journal of Archaeology*, 1934, vol. 38, pp. 341–58; and "The Sunny Side of the Greek Gorgon," *Berytus*, 1961, vol. 14, pp. 25–32; and Slater, op. cit. (note 16), pp. 16–21 and 318 ff.

22 More ancient than the devouring Gorgon of Greece and pointing to a root meaning of the image type, a famous Louristan bronze pin in the David Weill Collection honors an older, life-giving mother goddess. Flanked by animals sacred to her, she is shown giving birth to a child and holding out her breasts. Objects of this kind appear to have been the votive offerings of women (Ghirshman, op. cit. (note 21), pp. 102–4).

23 See Slater. op. cit. (note 16), on the Perseus myth, pp. 308–36; and for some similarities between ancient Greek and middle-class American males, pp. 449 ff.

24 Thomas B. Hess, *Willem de Kooning*, New York, George Braziller, 1959, p. 7. See also a passage by Hess on a de Kooning drawing of Elaine de Kooning in which the writer recognized the features of Medusa – a "menacing" stare, intricate, animated "Medusa hair" (*Willem de Kooning: Drawings*, New York and Greenwich, Conn., New York Graphic Society, 1972, p. 27).

25 As he said, "The *Women* had to do with the female painted through all the ages. . . . Painting the *Woman* is a thing in art that has been done over and over – the idol, Venus, the nude." Quoted in *Willem de Kooning: The North Atlantic Light. 1960–1983* (exh. cat.) Stedelijk Museum, Amsterdam, Louisiana Museum of Modern Art, Humlebaek, and Moderna Museet, Stockholm, 1983. Sally Yard, in "Willem de Kooning's Women," *Arts*, 53 (November, 1975), pp. 96–101, argues several sources for the Women, including Cycladic idols, Sumerian votive figures, Byzantine icons, and Picasso's *Demoiselles*.

26 *Willem de Kooning: The North Atlantic Light*, op. cit. (note 25), p. 77. See also Hess, *Willem de Kooning*, op. cit. (note 24), pp. 21 and 29.

27 Hess, *Willem de Kooning: Drawings*, op. cit. (note 24), p. 18.

28 On identity anxiety in males and pornography as an artifact in overcoming that anxiety, see the very interesting essay by John Stoltenberg, *Refusing to Be a Man: Essays on Sex and Justice*, Portland, Oregon, Breitenbush Books, 1989, pp. 48–54 (thanks to Carole Campana for this reference).

29 For instances of this in tribal cultures see Yolanda and Robert Murphy, *Women of the Forest*, New York and London, Columbia University Press, 1974, pp. 18–19, 87 ff; and Joan Bamberger, "The Myth of Matriarchy: Why Men Rule in Primitive Society," in Rosaldo and Lamphere, op. cit. (note 16), pp. 263–80.

30 *Woman I*'s arms, especially her right one, can also be read as a second, upper pair of legs, in which case, the mouth explicitly doubles as a second vagina – all of which is consistent with other de Kooning "women" in which faces with open, toothy mouths appear in the region of the lower torso.

31 For one of the most bombastic treatments of this kind, see Harold Rosenberg, *De Kooning*, New York, Harry Abrams, 1974. For a very different and extremely interesting view of the meaning of de Kooning's women see Peter Schjeldahl, "Female Trouble," *Village Voice*, 8 January, 1991, p. 79. The author considers the "Women" as gestures of competitive, self-asserting artistic machismo.

Perhaps the least adroit attempt to secure an unambiguous high-art identity for a de Kooning "Woman" could be seen in the Tate Gallery in 1991. There, next to *The Visit*, a wall label announced the following:

> The pose has its origins in "M. Bertin" by Ingres, one of de Kooning's favorite painters. . . . The title may refer to the "visit" of this figure or to the welcoming gesture of the final figure with arms akimbo.

32 I do not have, ready to hand, a full explanation of the historical causes of these male fears and fantasies. For a beginning in that direction, see my "Virility and Domination . . .," op. cit. (note 2).

33 For these and following comments on the public/private dichotomy and on changing concepts of individualism, I have drawn from a variety of sources, including Hannah Arendt, *The Human Condition*, Chicago and London, University of Chicago Press, 1958 (ch. 2 especially); Steven Lukes, *Individualism*, New York and Evanston, Harper & Row, 1973; Eli Zaretsky, *Capitalism, the Family and Personal Life*, New York and London, Harper & Row, 1976; Robert N. Bellah, Richard Madsen, William M. Sullivan, Ann Swidler, Steven M. Tipton, *Habits of the Heart: Individualism and Commitment in American Life*, Berkeley, Los Angeles, and London, University of California Press, 1985; Nancy Fraser, "What's Critical about Critical Theory," in S. Benhabib and D. Cornell (eds.), *Feminism as Critique: On the Politics of Gender*, Minneapolis, University of Minnesota Press, 1987, pp. 31–47; and Carol Pateman, "Feminist Critiques of the Public/Private Dichotomy," in S. I. Benn and G. F. Gaus (eds.), *Public and Private in Social Life*, New York, St. Martin's Press/London and Canberra, Croom Helm, 1983, pp. 281–303.

　　The disappearance of the public realm, and its absorption by the social or by mass culture, is a related theme that will be touched on later in this section.

34 For the culture of advertising, I have drawn from the following: Theodore Adorno and Max Horkheimer, "The Culture Industry: Enlightenment as Mass Deception," in *The Dialectic of the Enlightenment*, trans. J. Cumming, London, Verso, 1978, pp. 120–67; Stuart and Elizabeth Ewen, *Channels of Desire: Mass Images and the Shaping of American Consciousness*, New York, McGraw-Hill, 1982; Stephen Fox, *The Mirror Makers: A History of American Advertising and Its Creators*, New York, Vintage Books, 1985; Robert Goldman, "'We Make Weekends': Leisure and the Commodity Form," *Social Text*, Winter, 1983–4, pp. 84–103; Wolfgang Fritz Haug, *Critique of Commodity Aesthetics: Appearance, Sexuality and Advertising in Capitalist Society* (1971), Minneapolis, University of Minnesota Press, 1986; T. J. Jackson Lears, "From Salvation to Self-Realization: Advertising and the Therapeutic Roots of the Consumer Culture, 1880–1930," in R. Wightman Fox and T. J. J. Lears (eds.), *The Culture of Consumption: Critical Essays in American History, 1880–1980*, New York, Pantheon Books, 1983, pp. 3–38; Roland Marchand, *Advertising the American Dream: Making Way for Modernity, 1920–1940*, Berkeley, University of California Press, 1986; David M. Potter, *People of Plenty: Economic Abundance and the American Character*, Chicago and London, University of Chicago Press, 1954; Raymond Williams, "Advertising: The Magic System," in *Problems in Materialism and Culture*, London, Verso Editions & New Left Books, 1980, pp. 170–93; and Judith Williamson, *Consuming Passions: The Dynamics of Popular Culture*, London and New York, Marion Boyars, 1986.

35 Advertising, argues Roland Marchand, op. cit. (note 34), redefined citizenship, constructing "an image of a market democracy" which promises equal access to consumer products. "Freedom of choice came to be perceived as a freedom more significantly exercised in the marketplace than in the political arena" (pp. 63, 217, and 222). See also Potter, op. cit. (note 34), who argued that advertising, by definition, lacks social purpose. Its most essential characteristic is that it "cannot ever lose sight of the fact that it ultimately regards man as a consumer and defines its own mission as one of stimulating him to consume or to desire to consume" (p. 177).

36 Williams, op. cit. (note 34), p. 185.

37 Louis Dumont's notion of the "outworldly" individual strikes a resonant note

with what I am describing. The outworldly individual seeks to know himself in relation to God rather than to things of this world. His freedom is a freedom *from* the world, which he renounces as a condition of attaining full selfhood. Dumont contrasts him to the type of individual who achieves selfhood through the community and for whom freedom is the power to act *in* the world (*Essays on Individualism: Modern Ideology in Anthropological Perspective*, Chicago and London, University of Chicago Press, 1986, pp. 25–7).

38 Harold Rosenberg, "The American Action Painters" (1952), *The Tradition of the New*, New York and Toronto, McGraw-Hill, 1965, p. 30.

39 Barnett Newman, in Herschel B. Chipp (ed.), *Theories of Modern Art*, Berkeley, University of California Press, 1970, p. 553. Statements by Motherwell, Reinhardt, Still, and others to the same effect may be found in ibid., as well as in other collections of documents, e.g., Shapiro, op. cit. (note 5), and F. Frascina (ed.), *Pollock and After: The Critical Debate*, New York, Harper & Row (Icon Editions), 1985.

40 The pioneering studies here are Max Kozloff, "American Painting during the Cold War," *Artforum*, May, 1973, pp. 43–54, and Eva Cockroft, "Abstract Expressionism, Weapon of the Cold War," *Artforum*, June, 1974, pp. 39–41. Among others, Serge Guilbaut's *How New York Stole the Idea of Modern Art*, trans. A. Goldhammer, Chicago and London, University of Chicago Press, 1983, continued the debate. For overviews of the debate as well as reprints of relevant essays, see Francis Frascina (ed.), op. cit. (note 39); and David and Cecile Shapiro (eds.) *Abstract Expressionism: A Critical Record*, Cambridge, New York, Cambridge University Press, 1989.

41 Fox, op. cit. (note 34), p. 172.

42 Ibid., p. 182. See also Goldman, op. cit. (note 34).

CONCLUSION

1 For example, in the exhibition *Committed to Print*, of 1988, curated by Deborah Wye, who also prepared the exhibition catalogue; and, more recently, in *Dislocations*, (1992), a series of installations several of which (including Adrian Piper's, Chris Burden's, David Hammons') were deeply informed by social and political concerns. Hans Haacke's "Working Conditions," *Artforum*, Summer, 1981, pp. 56–61, treats the impact of corporate interests in art museums and is relevant here.

BIBLIOGRAPHY

Abercrombie, S., "Museum Calibre (The Linsky Collection)," *Interior Design*, July, 1985, 56: 212–21.

Abrams, M. H., *The Mirror and the Lamp*, New York, W. W. Norton, 1958.

Adams, P. R., "Towards a Strategy of Presentation," *Museum*, 1954, 7 (1): 1–7.

Adorno, T. and Horkheimer, M., "The Culture Industry: Enlightenment as Mass Deception," in *The Dialectic of the Enlightenment*, trans. J. Cumming, London, Verso, 1978, 120–67.

Akston, J. J., editorial, *Arts Magazine*, March, 1971.

Alexander, E. P., *Museum Masters: Their Museums and Their Influence*, Nashville, Tenn., American Association for State and Local History, 1983.

Allen, F. L., *The Great Pierpont Morgan* (1949), New York, Harper & Row, 1965.

Alpers, S., "The Museum as a Way of Seeing," in I. Karp and S. Levine (eds.), *Exhibiting Cultures: The Poetics and Politics of Museum Display*, Washington and London, Smithsonian Institution, 1991, 25–32.

Alsop, J., *The Rare Art Traditions*, New York, Harper & Row, 1982.

Anderson, B., *Imagined Communities: Reflections on the Origin and Spread of Nationalism*, London and New York, Verso, 1991.

Antin, M., *The Promised Land* (1912), Boston, Houghton Mifflin, 1969.

Arendt, H., *The Human Condition*, Chicago and London, University of Chicago Press, 1958.

Ariès, P., *The Hour of Our Death*. trans. H. Weaver, New York and Oxford, Oxford University Press, 1981.

—— *Western Attitudes Toward Death: From the Middle Ages to the Present*, trans. P. Ranum, Baltimore and London, Johns Hopkins University Press, 1974.

ART/artifact: African Art in Anthropology Collections (exh. cat.), with essays by Susan Vogel and others, New York, Center for African Art and Prestel Verlag, 1988.

Aulanier, C., *Histoire du Palais et du Musée du Louvre*, 9 vols., Paris, Editions des Musées Nationaux, 1947–64.

Bamberger, J., "The Myth of Matriarchy: Why Men Rule in Primitive Society," in M. Z. Rosaldo and L. Lamphere (eds.), *Woman, Culture, and Society*, Stanford, Cal., Stanford University Press, 1974, 263–80.

Bandinelli, R. B., *Rome: The Center of Power, 500 BC to AD 200*, trans. P. Green, New York, Braziller, 1970.

Barr, A. (ed.), *Cubism and Abstract Art*, New York, Museum of Modern Art, 1936.

—— *Masters of Modern Art*, New York, Museum of Modern Art, 1958.

—— *Painting and Sculpture in the Museum of Modern Art*, New York, Museum of Modern Art, 1942.

162

Bate, W. J., *From Classic to Romantic: Premises of Taste in Eighteenth-Century England*, New York, Harper & Bros., 1946.

Bazin, G., *The Museum Age*, trans. J. van Nuis Cahill, New York, Universe Books, 1967.

Beard, M., "Souvenirs of Culture: Deciphering (in) the Museum," *Art History*, 1992, 15: 505–32.

Beardsley, M. C., *Aesthetics from Classical Greece to the Present: A Short History*, University, Alabama, University of Alabama Press, 1975.

Beauvoir, S. de, *The Second Sex* (1949), trans. H. M. Parshley, New York, Alfred A. Knopf, 1953.

Behrman, S. N., *Duveen*, New York, Random House, 1955.

Bell, C., *Ritual Theory, Ritual Practice*, New York and Oxford, Oxford University Press, 1992.

Bellah, R. N., Madsen, R., Sullivan, W. M., Swidler, A., and Tipton, S. M., *Habits of the Heart: Individualism and Commitment in American Life*, Berkeley, Los Angeles, and London, University of California Press, 1985.

Benson, E. M., "The Nature of a Gift – The Frick Collection," *American Magazine of Art*, February, 1936, 29: 101.

Biasini, E., Lebrat, J., Bezombes, D., and Vincent, J.-M., *Le Grand Louvre: A Museum Transfigured, 1981–1993*, Milan and Paris, Electra France, 1989.

Blashfield, E. H., *Mural Painting in America*, New York, Charles Scribner's Sons, 1913.

Blodgett, G., "Frederick Law Olmsted: Landscape Architecture as Conservative Reform," *Journal of American History*, 1976, 67: 869–89.

Blum, A., *Le Louvre: Du Palais au Musée*, Geneva, Paris, and London, 1946.

Bodner, J., "Culture Without Power: A Review of John Higham's *Strangers in the Land*," *Journal of American Ethnic History*, Fall 1990/Winter 1991, 80–6.

Bogart, M. H., *Public Sculpture and the Civic Ideal in New York City, 1890–1930*, Chicago, University of Chicago Press, 1989.

Bourdieu, P., *Distinction: A Social Critique of the Judgement of Taste* (1979). trans. R. Nice, London and New York, Routledge & Kegan Paul, 1984.

—— and Darbel, A., *L'Amour de l'art: Les Musées d'art européens et leur public*, Paris, Editions de Minuit, 1969.

Boyer, P., *Urban Masses and Moral Order in America, 1820–1920*, Cambridge, Mass., and London, Harvard University Press, 1978.

Briggs, A., *The Making of Modern England, 1783–1867: The Age of Improvement*, New York, Harper & Row, 1965.

Burden, C., "Anything But a Cheap Affair," *The Art Gallery*, May, 1971, 22–4.

Burt, N., *Palaces for the People: A Social History of the American Art Museum*, Boston and Toronto, Little Brown, 1977.

Cabanne, P., *The Great Collectors*, London, Cassell, 1963.

Caffin, C. H., "Municipal Art," *Harper's Monthly*, April, 1900, reprinted in H. Wayne Morgan (ed.), *Victorian Culture in America, 1865–1914*, Itasca, Ill., F. E. Peacock, 1973, 53–62.

Cantarel-Besson, Y. (ed.), *La Naissance du Musée du Louvre*, vol. 1, Paris, Ministry of Culture, Editions des la Réunion du Musées Nationaux, 1981.

Carter, M., *Isabella Stewart Gardner and Fenway Court*, Boston and New York, Houghton Mifflin Co., 1925.

Caygill, M. *The Story of the British Museum*, London, British Museum Publications, 1981.

Cheetham, M. A., *The Rhetoric of Purity: Essentialist Theory and the Advent of Abstract Painting*, Cambridge and New York, Cambridge University Press, 1991.

Chicago, Art Institute *Annual Reports*.

Chipp, H. (ed.), *Theories of Modern Art*, Berkeley, University of California Press, 1970.

Clark, K., "The Ideal Museum," *ArtNews*, January, 1954, 52: 28–31.

Clifford, J., "On Collecting Art and Culture," in *The Predicament of Culture: Twentieth-Century Ethnography, Literature, and Art*, Cambridge, Mass. and London, Harvard University Press, 1988, 215–51.

Cockroft, E., "Abstract Expressionism, Weapon of the Cold War," *Artforum*, June, 1974, 39–41.

Cohen, A. *Two-Dimensional Man: An Essay on the Anthropology of Power and Symbolism in Complex Society*, Berkeley, Cal., University of California Press, 1974.

Cohn, Jr, S. K., *Death and Property in Siena, 1205–1800: Strategies for the Afterlife*, Baltimore and London, Johns Hopkins University Press, 1988, 103–56.

Colley, L., "Whose Nation? Class and National Consciousness in Britain, 1750–1830," *Past and Present*, November, 1986, 113: 97–117.

Colvin, H., *Architecture and the After-Life*, New Haven and London, Yale University Press, 1991.

La Commission du Muséum et la Création du Musée du Louvre (1792–3), documents collected and annotated by A. Tuetey and J. Guiffrey, *Archives de l'art français*, 1909, 3.

Cook, E., Introduction to the *Catalogue, Dulwich Picture Gallery* (1914), revised, 1926.

Corrigan, P. and Sayer, D., *The Great Arch: English State Formation as Cultural Revolution*, Oxford and New York, Basil Blackwell, 1985.

Dal Co, F., "From Parks to the Region: Progressive Ideology and the Reform of the American City," in G. Ciucci, *et al.*, *The American City: From the Civil War to the New Deal*, Cambridge, Mass., Massachusetts Institute of Technology Press, 1979, 143–297.

Dana, J. C., *The Gloom of the Museum*, Woodstock, Vt, Elm Tree Press, 1917.

—— "The Museum as an Art Patron," *Creative Art*, March, 1919, 4 (3): xxiii–xxvi.

—— *The New Museum*, Woodstock, Vt, Elm Tree Press, 1917.

Deegan, M., *American Ritual Dramas: Social Rules and Cultural Meanings*, New York, Westport, Conn., and London, Greenwood Press, 1988.

De Forest, R., "The Notable Bequest of Isaac D. Fletcher," Metropolitan Museum of Art *Bulletin*, 1917, 12: 216–18.

Dimaggio, P., "Cultural Entrepreneurship in Nineteenth-Century Boston: The Creation of an Organized Base for High Culture in America," *Media, Culture and Society*, 1982, 4: 33–50; 303–22.

Distelberger, R., "The Hapsburg Collections in Vienna during the Seventeenth Century," in O. Impey and A. MacGregor (eds.), *The Origins of Museums: The Cabinet of Curiosities in Sixteenth and Seventeenth Century Europe*, Oxford, Clarendon Press, 1985.

Dimen, M., *Surviving Sexual Contradictions*, New York, Macmillan, 1986.

Dobson, J. M., *Politics in the Gilded Age: A New Perspective on Reform*, New York, Washington, London, Praeger, 1972.

Douglas, M., *Natural Symbols* (1973), New York, Pantheon Books, 1982.

—— *Purity and Danger*, London, Boston, and Henley, Routledge & Kegan Paul, 1966.

—— and Isherwood, B., *The World of Goods: Towards an Anthropology of Consumption* (1979), New York and London, W. W. Norton, 1982.

Dumont, L., *Essays on Individualism: Modern Ideology in Anthropological Perspective*, Chicago and London, University of Chicago Press, 1986.

Duncan, C., *The Aesthetics of Power*, New York and Cambridge, Cambridge University Press, 1993.

BIBLIOGRAPHY

—— "The MoMA's Hot Mamas," *Art Journal*, Summer, 1989, 171–8.

—— *The Pursuit of Pleasure: The Rococo Revival in French Romantic Art*, New York and London, Garland Publishing, 1976.

—— and Wallach, A., "The Museum of Modern Art as Late Capitalist Ritual," *Marxist Perspectives*, Winter, 1978, 28–51.

—— and Wallach, A., "The Universal Survey Museum," *Art History*, December, 1980, 3: 447–69.

Dyce, W., *The National Gallery, Its Formation and Management, Considered in a Letter to Prince Albert*, London, 1853.

Ettema, M. J., in J. Blatti (ed.), *Past Meets Present: Essays about Historic Interpretation and Public Audiences*, Washington, DC, and London, Smithsonian Institution Press, 1987, 62–85.

Ewen, S. and Ewen, E., *Channels of Desire: Mass Images and the Shaping of American Consciousness*, New York, McGraw-Hill, 1982.

Exercises at the Dedication of the Ferguson Fountain of the Great Lakes, Chicago, 9 September, 1913. Published by the Trustees of the Art Institute of Chicago.

Federal Writers' Project of the Works Progress Administration for the District of Columbia, *The WPA Guide to Washington, DC* (1937), 1941 edition.

Finley, D. E., *A Standard of Excellence: Andrew W. Mellon Founds the National Gallery of Art at Washington*, Washington, DC, Smithsonian Institution Press, 1973.

Foggo, G., *Report of the Proceedings at a Public Meeting Held at the Freemason's Hall on the 29th of May, 1837*, London, 1837.

Foster, H. (ed.), *The Anti-Aesthetic: Essays on Postmodern Culture*, Port Townsend, Wash., Bay Press, 1983.

The Founding of the Henry E. Huntington Library and Art Gallery: Four Essays, San Marino, California, Huntington Library, 1969.

Fox, D. M., *Engines of Culture: Philanthropy and Art Museums*, State Historical Society of Wisconsin for the Department of History, University of Wisconsin, 1963.

Fox, S., *The Mirror Makers: A History of American Advertising and Its Creators*, New York, Vintage Books, 1985.

Frascina, F. (ed.), *Pollock and After: The Critical Debate*, New York, Harper & Row (Icon Editions), 1985.

Fraser, D., "The Heraldic Woman: A Study in Diffusion," in D. Fraser (ed.), *The Many Faces of Primitive Art*, Englewood Cliffs, NJ, Prentice-Hall, 1966, 36–99.

Fraser, N., "What's Critical about Critical Theory," in S. Benhabib and D. Cornell (eds.), *Feminism as Critique: On the Politics of Gender*, Minneapolis, University of Minnesota Press, 1987, 31–47.

Freccero, J., "Autobiography and Narrative," in T. C. Heller, M. Sosna, and D. Wellbery (eds.), *Reconstructing Individualism: Autonomy, Individuality, and the Self in Western Thought*, Stanford, Cal., Stanford University Press, 1986, 16–29.

Frederickson, G. M., *The Inner Civil War: Northern Intellectuals and the Crisis of the Union*, New York, Harper & Row, 1968.

"Mr. Frick as a Patron of Culture," *Literary Digest*, 10 December, 1919, 63: 29–30.

"The Frick Collection of Art Becomes the Public's Property," *Current Opinion*, January, 1920, 68: 100–2.

Fried, M., Introduction, *Three American Painters* (exh. cat.), Fogg Art Museum, Harvard University, 1965.

Frothingham, A., "Medusa, Apollo, and the Great Mother," *American Journal of Archaeology*, 1911, 15: 349–77.

Fullerton, P., "Patronage and Pedagogy: The British Institution in the Early Nineteenth Century," *Art History*, 1982, 5 (1): 59–72.

165

Gaehtgens, T. W., "The Berlin Museum after Reunification," *The Burlington Magazine*, January, 1994, 106: 14–20.

Garvey, T., *Public Sculptor: Loredo Taft and the Beautification of Chicago*, Urbana and Chicago, University of Illinois Press, 1988.

General Guide, Trustees of the Wallace Collection, London, 1989.

Gennep, A. van, *The Rites of Passage* (1908), trans. M. B. Vizedom and G. L. Caffee, Chicago, University of Chicago Press, 1960.

Gerrit, H., "The Lehman Wing," *ArtNews*, September, 1975, 74: 35–9.

Getty, J. P., *As I See It: The Autobiography of J. Paul Getty*, New York, Berkley Books, 1986.

—— *Europe in the Eighteenth Century*, privately printed, 1949.

—— *Getty on Getty: A Man in a Billion*, conversations with Somerset de Chair, London, Cassell Publishers, 1989.

—— *The Golden Age*, New York, Trident Press, 1968.

—— *How to Be Rich*, London, W. H. Allen, 1966.

—— *The Joys of Collecting*, London, Country Life, 1966.

—— *My Life and Fortunes*, London, George Allen & Unwin, 1964.

—— "Interview with J. Paul Getty," by M. Gendel, *ArtNews*, September, 1971, 44–5; 59–60.

Getty (J. Paul) Museum, *Guide to the Villa and Its Gardens*, Malibu, Cal., 1988.

—— *Handbook of the Collections*, Malibu, Cal., 1986.

Ghirshman, R., *Iran, from the Earliest Times to the Islamic Conquest*, London, Penguin Books, 1954.

Gilman, B. I., *Museum Ideals of Purpose and Method*, Cambridge, Boston Museum of Fine Arts, 1918.

Girouard, M., *Life in the English Country House: A Social and Architectural History*, New Haven and London, Yale University Press, 1978.

Goldman, B., "The Asiatic Ancestry of the Greek Gorgon," *Berytus*, 1961, 14: 1–22.

Goldman, R., "'We Make Weekends': Leisure and the Commodity Form," *Social Text*, Winter, 1983–4, 84–103.

Gould, C., *Trophy of Conquest: The Musée Napoléon and the Creation of the Louvre*, London, Faber & Faber, 1965.

Graña, C., "The Private Lives of Public Museums," *Trans-Action*, 1967, 4 (5): 20–5.

Green, N., "Dealing in Temperaments: Economic Transformation of the Artistic Field in France during the Second Half of the Nineteenth Century," *Art History*, 10, March, 1987, 59–78.

Greenberg, C., *Art and Culture: Critical Essays*, Boston, Beacon Press, 1961.

Guilbaut, S., *How New York Stole the Idea of Modern Art*, trans. A. Goldhammer, Chicago and London, University of Chicago Press, 1983.

Haacke, H., "Working Conditions," *Artforum*, Summer, 1981, 56–61.

Hale, J. R., *England and the Italian Renaissance: The Growth of Interest in Its History and Art*, London, Arrow Books, 1963.

Hammack, D., *Power and Society: Greater New York at the Turn of the Century*, New York, Russell Sage Foundation, 1982.

Harris, J. S., *Government Patronage of the Arts in Great Britain*, Chicago and London, University of Chicago Press, pp. 13–14.

Harris, N., "The Gilded Age Revisited: Boston and the Museum Movement," *American Quarterly*, 1962, 14: 545–66.

Harvey, G., *Henry Clay Frick, The Man*, New York, Scribner's Sons, 1928.

Haskell, F., *Patrons and Painters: Art and Society in Baroque Italy*, New York and London, Harper & Row, 1971.

—— *Rediscoveries in Art: Some Aspects of Taste, Fashion and Collecting in England and France*, Ithaca, NY, Cornell University Press, 1976.

Haug, W. F., *Critique of Commodity Aesthetics: Appearance, Sexuality and Advertising in Capitalist Society* (1971), Minneapolis, University of Minnesota Press, 1986.

Haynes, J., *Kensington Palace*, London, Department of the Environment, Royal Parks and Palaces, 1985.

Hazlitt, W., "The Elgin Marbles" (1816), in P. P. Howe (ed.), *The Complete Works*, New York, AMS Press, 1967, 18: 100–3.

—— *Sketches of the Principal Picture-Galleries in England*, London, Taylor & Hessey, 1824.

Henry, G., "The Lehman Wing," *ArtNews*, September, 1975, 74, 35–9.

Hersh, B., *The Mellon Family: A Fortune in History*, New York, William Morrow, 1978.

Hess, J. L., *The Grand Acquisitors*, Boston, Houghton Mifflin Co., 1974.

Hess, T. B., "Plant You Now, Dig You Later" (editorial), *ArtNews*, November 1969.

—— *Willem de Kooning*, New York, George Braziller, 1959.

—— *Willem de Kooning: Drawings*, New York and Greenwich, Conn., New York Graphic Society, 1972.

Hilton, T., *Guardian*, 2 October, 1991, 36.

Hobbs, R., "Museum Under Siege," *Art In America*, October, 1981, 17–25.

Hobsbawm, E. J., *Nations and Nationalism*, Cambridge and New York, Cambridge University Press, 1990.

Hodgson, M., "Art: A Taste for Treasures," *Harper's Bazaar*, June, 1984, 117; 150–2; 180–1.

Hofland, B., *Popular Description of Sir John Soane's House, Museum and Library*, London, 1835.

Holst, N. von, *Creators, Collectors and Connoisseurs*, trans. B. Battershaw, New York, G. P. Putnam's Sons, 1967.

Holt, E. G., *The Triumph of Art for the Public*, Garden City, New York, Anchor Press/ Doubleday, 1979.

Hopkins, C., "Assyrian Elements in the Perseus–Gorgon Story," *American Journal of Archaeology*, 1934, 38: 341–58.

—— "The Sunny Side of the Greek Gorgon," *Berytus*, 1961, 14: 25–32.

Horowitz, H. L., *Culture and the City: Cultural Philanthropy in Chicago from the 1880s to 1917*, (1976), Chicago and London, University of Chicago Press, 1989.

House of Commons, *Report from the Select Committee on Arts, and Their Connection with Manufacturers*, in *Reports*, 1836, IX.l; X.1.

—— *Report from the Select Committee on the National Gallery*, in *Reports*, 1853, XXXV.

Hoving, T., "The Chase, The Capture," in Hoving (ed.), *The Chase, The Capture: Collecting at the Metropolitan*, New York, Metropolitan Museum of Art, 1975, 1–106.

—— *The Second Century: The Comprehensive Architectural Plan for the Metropolitan Museum of Art*, New York, Metropolitan Museum of Art, 1971.

"How to Put Together a Museum in 29 Days," *ArtNews*, December, 1976, 19–22.

Howe, W. E., *A History of the Metropolitan Museum of Art*, New York, Metropolitan Museum of Art, 1912.

Hudnut, J., "The Last of the Romans: Comment on the Building of the National Gallery of Art," *Magazine of Art*, April, 1941, 34: 169–73.

Hughes, P., *The Founders of the Wallace Collection*, London, Trustees of the Wallace Collection, Manchester Square, 1981.

Huyssen, A., *After the Great Divide: Modernism, Mass Culture, Postmodernism*, Bloomington and Indianapolis, Indiana University Press, 1986.

Impey, O. and MacGregor, A. (eds.), *The Origins of Museums: The Cabinet of*

Curiosities in Sixteenth and Seventeenth Century Europe, Oxford, Clarendon Press, 1985.

Ivins, W. M., "Of Museums," *The Arts*, January, 1923, 31.

Jones, H. M., *The Age of Energy: Varieties of American Experience, 1865–1915*, New York, Viking Press, 1971.

Jones, R. A., "Battle for the Masterpieces," *Los Angeles Times Magazine*, 22 May, 1988, 8–19.

Josephson, M., *The Robber Barons: The Great American Capitalists, 1861–1901* (1934), New York, Harcourt, Brace & World, 1962.

Kant, I., *Critique of Judgment* (1790), trans. J. H. Bernard, New York, Hafner Publishing, 1951.

Kantor, H. A., "The City Beautiful in New York," *New York Historical Society Quarterly*, 1973, 67: 148–71.

Kaufmann, T. da Costa, "Remarks on the Collections of Rudolf II: The Kunstkammer as a Form of Representation," *Art Journal*, 1978, 38, 22–8.

Koskoff, D. E., *The Mellons: The Chronicle of America's Richest Family*, New York, Thomas Y. Cromwell Co., 1978.

Koven, S., "The Whitechapel Picture Exhibitions and the Politics of Seeing," in D. Sherman and I. Rogoff (eds.), *Museum Culture: Histories, Discourses, Spectacles*, Media & Society, 6, Minneapolis, University of Minnesota Press, 1994, 22–48.

Kozloff, M., "American Painting during the Cold War," *Artforum*, May, 1973, 43–54.

Kramer, H., "The Lehman Pavilion," *New York Times*, 25 May, 1975, VI: 12–20; 24.

Kuspit, D., "The Magic Kingdom of the Museum," *Artforum*, April, 1992, 58–63.

Lafont de Saint-Yenne, *Réflexions sur quelques causes de l'état présent de la peinture en France*, The Hague, 1747, in *Collection Deloynes*, 2, Bibliothèque Nationale, Paris.

Leach, E., "Ritual," *International Encyclopedia of the Social Sciences*, 13, David Sills (ed.), Macmillan Co. and The Free Press, 1968, 521–6.

—— "Two Essays Concerning the Symbolic Representation of Time," in *Rethinking Anthropology*, London, University of London, Athlone Press, and New York, Humanities Press, 1961, 124–36.

Lears, T. J. J., "From Salvation to Self-Realization: Advertising and the Therapeutic Roots of the Consumer Culture, 1880–1930," in R. Wightman Fox and T. J. J. Lears (eds.), *The Culture of Consumption: Critical Essays in American History, 1880–1980*, New York, Pantheon Books, 1983, 3–38.

—— *No Place of Grace: Antimodernism and the Transformation of American Culture, 1880–1920*, New York, Pantheon Books, 1981.

Lenzner, R., *The Great Getty: The Life and Loves of J. Paul Getty – Richest Man in the World*, New York, Crown Publishers, 1985.

Lerman, L. *The Museum: One Hundred Years and The Metropolitan Museum of Art*, New York, Viking Press, 1969.

Leslie, C. R., *Handbook for Young Painters* (1854), London, 1887.

"A Lesson in Museum Architecture," *The Studio*, January 1940, 119: 20–1.

Lloyd, C., "John Julius Angerstein, 1732–1823," *History Today*, June, 1966, 16: 373–9.

Loring, C. G., "A Trend in Museum Design," *Architectural Forum*, December, 1927, 47: 579.

Lukes, S., *Individualism*, New York and Evanston, Harper & Row, 1973.

—— "Political Ritual and Social Integration," in *Essays in Social Theory*, New York and London, Columbia University Press, 1977, 52–73.

Lynes, R., *Good Old Modern: An Intimate Portrait of the Museum of Modern Art*, New York, Atheneum, 1973.

McClellan, A., *Inventing the Louvre: Art, Politics, and the Origins of the Modern Museum in Eighteenth-century Paris*, Cambridge, Cambridge University Press, 1994.

MacDonald, W. L., *The Parthenon: Design, Meaning, and Progeny*, Cambridge, Mass., Harvard University Press, 1976.

McFadden, S. "Teheran Report," *Art in America*, October, 1981, 9–16.

MacGregor, A. (ed.), *The Late King's Goods, Collections, Possessions and Patronage of Charles I in the Light of the Commonwealth Sale Inventories*, London and Oxford, Alistair McAlpine in association with Oxford University Press, 1989.

Male, E., *The Gothic Image* (1913), trans. Dora Nussey, New York, Evanston, and London, Harper & Row, 1958.

Malraux, A., *Museum without Walls*, trans. S. Gilbert and F. Price, Garden City, NY, Doubleday & Co., 1967.

Manieri-Elia, M., "Toward an 'Imperial City': Daniel Burnham and the City Beautiful Movement," in G. Ciucci, *et al.*, *The American City: From the Civil War to the New Deal*, Cambridge, Mass., MIT Press, 1979, 1–142.

Marchand, R., *Advertising the American Dream: Making Way for Modernity, 1920–1940*, Berkeley, University of California Press, 1986.

Marquis, A. G., *Alfred H. Barr, Jr.: Missionary for the Modern*, Chicago and New York, Contemporary Books, 1989.

Martin, G., "The National Gallery in London," *Connoisseur*, April, 1974, 185: 280–7; May, 1974, 186: 24–31, and June, 1974, 187: 124–8.

May, H. F., *The End of American Innocence: A Study of the First Years of Our Own Time, 1912–1917*, Chicago, Quadrangle Books, 1964.

Mead, M., "Art and Reality From the Standpoint of Cultural Anthropology, *College Art Journal*, 1943, 2(4): 119–21.

Mellinghoff, G.-T., "Soane's Dulwich Picture Gallery Revisited," in Architectural Monographs, *John Soane*, London and New York, Academy Editions and St. Martin's Press, 1983.

Mellon, P. with Baskett, J., *Reflections in a Silver Spoon*, New York, William Morrow, 1992.

Mills, C. W., *The Power Elite*, New York, Oxford University Press, 1959.

Minihan, J., *The Nationalization of Culture*, New York, New York University Press, 1977.

Moore, S. F. and Myerhoff, B., "Secular Ritual: Forms and Meanings," in Moore and Myerhoff (eds.), *Secular Ritual*, Assen/Amsterdam, Van Gorcum, 1977, 3–24.

Mr. Morgan's Library: A Guide to the Period Rooms, New York, Pierpont Morgan Library, 1991.

Morgenstern, J., "Getty's Little Palace in Malibu," *ArtNews*, March, 1977, 76: 72–5.

Moyano, S., "Quality vs. History: Schinkel's Altes Museum and Prussian Arts Policy," *Art Bulletin*, 1990, 72: 585–608.

Muensterberger, W., *Collecting: An Unruly Passion: Psychological Perspectives*, Princeton, NJ, Princeton University Press, 1994.

Munhall, E., in The Frick Collection, *Masterpieces of the Frick*, New York, Frick Collection, 1970, 3–118.

Municipal Affairs, published by the New York Reform Club, 1897–1901.

Murphy, Y. and Murphy, R., *Women of the Forest*, New York and London, Columbia University Press, 1974.

Museum of Modern Art, *Committed to Print* (exh. cat.), 1988. Catalogue essay by Deborah Wye.

The Nation, 12 January, 1905, 80: 27–8.

National Capital Planning Commission, F. Gutheim, Consultant, *Worthy of the*

Nation: The History of Planning for the National Capital, Washington, DC, Smithsonian Institution Press, 1977.

Nesbitt, G. L., *Benthamite Reviewing: The First Twelve Years of the Westminster Review, 1824–1836*, New York, Columbia University Press, 1934.

New York, Metropolitan Museum of Art *Annual Reports*.

New York, Metropolitan Museum of Art *Bulletin*.

Nguyen, K., "Gilt Complex," *Connoisseur*, September, 1991, 75–7.

Noble, D., *The Progressive Mind, 1890–1917*, Chicago, Rand McNally, History of American Thought and Culture, 1970.

Norman, G., "Peggy Guggenheim," *Independent* (London), 1 November, 1991, 3.

O'Connor, H., *Mellon's Millions, The Biography of a Fortune: The Life and Times of Andrew W. Mellon*, New York, John Day, 1933.

Panofsky, E., *Tomb Sculpture* (1964), H. W. Janson (ed.), New York, Harry N. Abrams, 1992.

Parliamentary Debates (Commons), 13 April, 1832, New Ser., 12: 467–70; and 23 July, 1832, New Ser., 14: 643–5.

Passavant, J. D., *Tour of a German Artist in England*, London, 1836.

Pateman, C., "Feminist Critiques of the Public/Private Dichotomy," in S. I. Benn and G. F. Gaus (eds.), *Public and Private in Social Life*, New York, St. Martin's Press/London and Canberra, Croom Helm, 1983, 281–303.

Pears, I., *The Discovery of Painting: The Growth of Interest in the Arts in England, 1680–1768*, New Haven and London, Yale University Press, 1988.

Pearson, R. M., "A Greek Gift: Accepting the Mellon Collection on Mellon's terms," *New Masses*, 30 March, 1927, 19.

Perkin, H. J., *The Origins of Modern English Society, 1780–1880*, London, Routledge & Kegan Paul, 1969.

Peterson, J. A., "The City Beautiful Movement: Forgotten Origins and Lost Meanings," *Journal of Urban History*, 1976, 2: 415–34.

Pevsner, N., *A History of Building Types*, Princeton, NJ, Princeton University Press, 1976.

Pocock, J. G. A., *Politics, Language and Time: Essays on Political Thought and History*, London, Methuen, 1972.

Potter, D. M., *People of Plenty: Economic Abundance and the American Character*, Chicago and London, University of Chicago Press, 1954.

Pye, J. *Patronage of British Art*, London, 1845.

Ratcliff, C., "Modernism for the Ages," *Art in America*, July–August, 1978, 51–4.

Rensselaer, M. G. van, "The Art Museum and the Public," Museum of Modern Art *Bulletin*, 1917, 12: 57–64.

Robinson, C. M., *Modern Civic Art; or The City Made Beautiful*, New York, G. P. Putnam's Sons, 1904.

Rosaldo, M. Z., "Woman, Culture, and Society: A Theoretical Overview," in M. Z. Rosaldo and L. Lamphere (eds.), *Woman, Culture, and Society*, Stanford, Cal., Stanford University Press, 1974, 17–42.

Rosenberg, H., "The American Action Painters" (1952), *The Tradition of the New*, New York and Toronto, McGraw-Hill, 1965.

—— *De Kooning*, New York, Harry Abrams, 1974.

Rosensweig, R. and Blackmar, E., *The Park and the People: A History of Central Park*, Ithaca and London, Cornell University Press, 1992.

Roth, L. M., *McKim, Mead & White, Architects*, London, Thames & Hudson, 1984.

Rubin, W., "Painting and Sculpture," in *The Museum of Modern Art, New York: The History and the Collection*, New York, Harry N. Abrams, in association with the Museum of Modern Art, 1984, 43–6.

—— (interview with), "Talking with William Rubin: 'Like Folding Out a Hand of Cards,'" *Artforum*, 1974, November, 46–53; and October, 51–7.

Ruckstuhl, F. W., "Municipal Sculpture from the American Point of View," *Craftsman*, 1904, 7: 239–62.

Russell, J., "Desegregating the Lehman Gift," *New York Times*, 15 April, 1979, D 25.

—— "Linsky Collection Open at Met," *New York Times*, 22 June, 1984, C22.

Rydell, R. W., *All the World's a Fair: Visions of Empire at American International Expositions, 1876–1916*, Chicago and London, University of Chicago Press, 1984.

Salles, G., "The Museums of France," *Museum*, 1948–9, 1–2: 10, 92.

Satterlee, H. L., *J. Pierpont Morgan: An Intimate Portrait*, New York, Macmillan, 1939.

Schapiro, M., "The Nature of Abstract Art," reprinted in M. Schapiro, *Modern Art: 19th and 20th Centuries: Selected Papers*, New York, Georges Braziller, 1978.

Schildt, G., "The Idea of the Museum," in L. Aagaard-Mogensen (ed.), *The Idea of the Museum: Philosophical, Artistic, and Political Questions*, Problems in Contemporary Philosophy, 6, Lewiston, NY/Queenston, Ontario, Edwin Mellen Press, 1988.

Schjeldahl, P., "Female Trouble," *Village Voice*, 8 January, 1991, 79.

Secrest, M., *Being Bernard Berenson: A Biography*, Harmondsworth and New York, Penguin Books, 1980.

Seligmann, G., *Merchants of Art: 1880–1960: Eighty Years of Professional Collecting*, New York, Appleton-Century-Crofts, 1961.

Shapiro, D. and Shapiro, C. (eds.), *Abstract Expressionism: A Critical Record*, Cambridge, New York, Cambridge University Press, 1989.

Shapiro, M. S., "The Public and the Museum," in M. S. Shapiro and L. W. Kemp (eds.), *Museums: A Reference Guide*, New York, Greenwood Press, 1990, 231–61.

Sherman, D. J., "Quatremère/Benjamin/Marx: Museums, Aura, and Commodity Fetishism," in D. Sherman and I. Rogoff (eds.), *Museum Culture: Histories, Discourses, Spectacles*, Media & Society, 6, Minneapolis and London, University of Minnesota Press, 1994, 123–43.

—— *Worthy Monuments: Art Museums and the Politics of Culture in Nineteenth-Century France*, Cambridge, Mass., and London, Harvard University Press, 1989.

Sherman, L., *Art Museums of America*, New York, William Morrow, 1980.

Slater, P., *The Glory of Hera*, Boston, Beacon Press, 1968.

Smith, C. S., *The Building of Castle Howard*, London and Boston, Faber & Faber, 1990.

Sproat, J. G., *"The Best Men": Liberal Reformers in the Gilded Age*, New York, Oxford University Press, 1978.

Steinberg, L, *Other Criteria*, New York and Oxford, Oxford University Press, 1972.

Sterne, M., *The Passionate Eye: The Life of William R. Valentiner*, Detroit, Wayne State University Press, 1980.

Steyn, J., "The Complexities of Assimilation in the 1906 Whitechapel Gallery Exhibition 'Jewish Art and Antiquities,'" *Oxford Art Journal*, 13(2): 1990, 44–50.

Stoltenberg, J., *Refusing to Be a Man: Essays on Sex and Justice*, Portland, Oregon, Breitenbush Books, 1989.

Strong, D., *Roman Art*, Baltimore, Penguin Books, 1976.

Summerson, J., *Sir John Soane*, London, 1952.

—— "Sir John Soane and the Furniture of Death," *Architectural Review*, March, 1978, 163: 147–55.

Swanberg, W. A., *Citizen Hearst: A Biography of William Randolph Hearst*, New York, Macmillan, 1986.

Taylor, F. H., *Babel's Tower: The Dilemma of the Modern Museum*, New York, Columbia University Press, 1945.

Thomas, P. W., "Charles I of England: A Tragedy of Absolutism," in *The Courts of Europe: Politics, Patronage and Royalty, 1400–1800*, A. G. Dickens (ed.), London, Thames & Hudson, 1977.

Thompson, E. P., "The Peculiarities of the English," in *The Poverty of Theory and Other Essays*, New York and London, Monthly Review Press, 1978, 245–301.

Tomkins, C., "The Art World," *New Yorker*, 15 October, 1984, 126–33.

—— *Merchants and Masterpieces: The Story of the Metropolitan Museum of Art*, New York, Dutton, 1973.

Tomlinson, J., "A Report from Anton Raphael Mengs on the Spanish Royal Collection in 1777," *Burlington Magazine*, February, 1993.

Tomsich, J., *A Genteel Endeavor: American Culture and Politics in the Gilded Age*, Stanford, California, Stanford University Press, 1971.

Tonelli, E. A., "The Art Museum," in M. S. Shapiro and L. W. Kemp (eds.), *Museums: A Reference Guide*, New York, Greenwood Press, 1990, 31–58.

Trachtenberg, A., *The Incorporation of America: Culture and Society in the Gilded Age*, New York, Hill & Wang, 1982.

Trevor-Roper, H., *Princes and Artists: Patronage and Ideology at Four Habsburg Courts 1517–1633*, London, Thames & Hudson, 1976.

Turner, V., *Dramas, Fields, and Metaphors: Symbolic Action in Human Society*, Ithaca and London: Cornell University Press, 1974.

—— "Frame, Flow, and Reflection: Ritual and Drama as Public Liminality," in *Performance in Postmodern Culture*, M. Benamou and C. Caramello (eds.), Center for Twentieth Century Studies, University of Wisconsin–Milwaukee, 1977, 33–55.

—— "Variations on a Theme of Liminality," in S. F. Moore and B. Myerhoff, (eds), *Secular Ritual*, Assen/Amsterdam, Van Gorcum, 1977, 36–52.

Vanderbilt, K., *Charles Eliot Norton: Apostle of Culture in a Democracy*, Cambridge, Mass., Harvard University Press, 1959.

Veblen, T., *Theory of the Leisure Class*, New York, Mentor Books, 1953.

Waagen, G. F., *Treasures of Art in Great Britain (1838)*, trans., Lady Eastlake, London, 1854–7.

Wacker, C. H., "The Plan of Chicago – Its Purpose and Development," in *Art and Archaeology*, September–October, 1921, 12: 101–10.

Walker, J., *Self-Portrait with Donors*, Boston and Toronto, Little, Brown, 1974, xiii.

Wallace Collection Catalogues: Pictures and Drawings, London, Trustees of the Wallace Collection, 16th edn, 1968.

Wallach, A. and Duncan, C., "The Museum of Modern Art as Late Capitalist Ritual," *Marxist Perspectives*, Winter, 1978, 28–51.

—— and Duncan, C., "The Universal Survey Museum," *Art History*, 1980, 3: 447–69.

Warden, P. G. and Romano, D. G., "The Course of Glory: Greek Art in a Roman Context at the Villa of the Papyri at Herculaneum," *Art History*, 1994, 17: 228–54.

Waterfield, G., Introduction to *Collection for a King: Old Master Paintings from the Dulwich Picture Gallery* (exh. cat.), Washington, DC, and Los Angeles, National Gallery of Art and Los Angeles County Museum of Art, 1985.

—— *Rich Summer of Art: A Regency Picture Collection Seen through Victorian Eyes*, Dulwich Picture Gallery, 1988.

—— *Soane and After: The Architecture of Dulwich Picture Gallery* (exh. cat.), Dulwich Picture Gallery, 1987.

Weinstock, C., "The Frick Formula," *Art Front*, 2(3), 3 February, 1936.

Wheeler, G., *Pierpont Morgan and Friends: The Anatomy of a Myth*, Englewood Cliffs, NJ, Prentice-Hall, 1973.

Whelan, R., "Patronage," *Art in America*, November–December, 1978, 25–7.

Whitehill, W. M., *Museum of Fine Arts, Boston. A Centennial History*, 2 vols., Cambridge, Mass., The Belknap Press of Harvard University Press, 1970.

Whitley, W. T., *Art in England, 1821–1827*, Cambridge, Cambridge University Press, 1930.

—— *Artists and Their Friends in England, 1700–1799* (1928), New York and London, Benjamin Blom, 1968, vol. 1.

Wiebe, R., *The Search for Order, 1877–1920*, New York, Hill & Wang, 1967.

Willem de Kooning: The North Atlantic Light, 1960–1983 (exh. cat.), Stedelijk Museum, Amsterdam, Louisiana Museum of Modern Art, Humlebaek, and Moderna Museet, Stockholm, 1983.

Williams, R., "Advertising: The Magic System," in *Problems in Materialism and Culture*, London, Verso Editions & New Left Books, 1980, 170–93.

—— *The Country and the City*, New York, Oxford University Press, 1973.

—— *Culture and Society, 1780–1950*, New York, Harper & Row, 1966.

—— *Keywords: A Vocabulary of Culture and Society*, New York, Oxford University Press, 1976.

Williamson, J., *Consuming Passions: The Dynamics of Popular Culture*, London and New York, Marion Boyars, 1986.

Williamson, W., "The March to Boutique Museums," *Los Angeles Times*, 22 January, 1988, VI: 1; 18; 19; 24.

Wilson, D. G., *The Mausoleum of Henry and Arabella Huntington*, San Marino, Cal., Huntington Library, 1989.

Wilson, D. M., *The British Museum: Purpose and Politics*, London, British Museum Publications, 1989.

Wilson, R. G., "The Great Civilization," in Brooklyn Museum, *The American Renaissance, 1876–1917* (exh. cat.), New York, Pantheon Books, 1979, 11–70.

Wittlin, A., "Exhibits: Interpretive, Under-Interpretive, Misinterpretive," in E. Larrabee (ed.), *Museums and Education*, Washington, DC, Smithsonian Institution Conference on Museums and Education, 1968, 95–114.

—— *The Museum: Its History and Its Tasks in Education*, London, Routledge & Kegan Paul, 1949.

Woolf, V., *Roger Fry: A Biography*, London, Hogarth Press, 1940.

Yamaguchi, M., "The Poetics of Exhibition in Japanese Culture," in I. Karp and S. Levine (eds.), *Exhibiting Cultures: The Poetics and Politics of Museum Display*, Washington and London, Smithsonian Institution, 1991, 57–67.

Yard, S., "Willem de Kooning's Women," *Arts*, 53 (November, 1975), 96–101.

Zaretsky, E., *Capitalism, the Family and Personal Life*, New York and London, Harper & Row, 1976.

Zeller, T., "The Historical and Philosophical Foundations of Art Museum Education in America," in N. B. Mayer and S. Mayer, (eds.), *Museum Education: History, Theory and Practice*, Reston, Va, National Art Education Association, 1989, 10–89.

Zolberg, V. L., "Tensions of Mission in American Museum Education," in P. J. Dimaggio (ed.), *Non-Profit Enterprise in the Arts: Studies in Mission and Constraint*, New York and Oxford, Oxford University Press, 1986, 184–98.

INDEX*

* Numerals in bold indicate pages with figures